PERSUASIVE IMAGES

PERSUASIVE

Posters of War

and Revolution

from the

Hoover

Institution

Archives

Peter Paret

Beth Irwin Lewis

Paul Paret

IMAGES

Princeton University Press

Princeton, New Jersey

Library of Congress Cataloging-in-Publication Data

Hoover Institution on War, Revolution, and Peace.
 Persuasive images : posters of war and
revolution from the Hoover Institution Archives /
Peter Paret, Beth Irwin Lewis, Paul Paret.
 p. cm.
 Includes bibliographical references and index.
 ISBN 0-691-03204-1
 1. World War, 1914–1918—Posters. 2. World
War, 1939–1945—Posters. 3. Soviet Union—
History—Revolution, 1917–1921—Posters.
4. War posters. I. Paret, Peter. II. Lewis, Beth
Irwin, 1934– . III. Paret, Paul, 1968– . IV. Title.
D522.25.H66 1992
940.5′022′2—dc20 92-4388

Printed in Hong Kong

10 9 8 7 6 5 4 3 2 1

Contents

Introduction

Posters and Modern History

In early March of 1945 American and British troops broke through the German defenses west of the Rhine, crossed the river, and fanned out in the countryside beyond. By the 21st of the month, the Third U.S. Army under General Patton was within twenty miles of Frankfurt. Among the feeble means of armed and psychological resistance scraped together by a collapsing regime was a poster that had been designed and printed some months earlier and was now posted again on walls and buildings throughout the heavily bombed city.

The poster shows three figures standing on a pile of rubble, the undamaged Frankfurt cathedral behind them. At the center is an adolescent boy in the uniform of an air force helper, holding a pickax (Fig. 1). He is flanked by a young woman in overalls with a gas mask hanging on her chest, her lower right arm bandaged, and by an older man in a worker's cap, who holds a hammer in his left hand and a flagstaff with a swastika in his right. The three represent the remains of the city's population, whose men between the ages of sixteen and the late forties were away fighting on shrinking fronts. The three figures are drawn in black, as are the broken boards and bricks on which they stand, the cathedral, the swastika, and the first two words of the poster's text: "Frontstadt Frankfurt" (Frankfurt, city in the front lines). The rest of the design on a white background is in red: the cloth of the flag around the black swastika in the white circle, the boy's arm band, and the remaining two words at the bottom of the poster: "wird gehalten!" (will be held!). Also in red are flame-like shapes that curl upward from the text on both sides of the poster. The overt message is one of defiance and determination, but the image is of despair and confusion. The cathedral, obviously introduced as a symbol of the city, clashes with the pagan swastika—their association in an official poster would have been highly unlikely just twelve months earlier. The figures in the poster seem as hopeless and defeated as do people in photographs taken in the last months of the war, when three-quar-

ters of the center of Frankfurt had been destroyed. What may be most startling about the poster is how the flames that surround the little group, as though they were ancient Hebrews or modern Jews in a fiery furnace, almost blend with the red of the flag at the upper edge of the poster. Could the artist by associating the flames with the flag, which itself is split like a representation of fire, have been implying that the flag and what it stands for was responsible for the flames? However we interpret this particular conjunction, it is clear that the poster's heroic and threatening message was not supported by its image. It would be interesting to know how the Nazi officials who commissioned the poster reacted to it before they fled the city they had sworn to defend; but it is certain that the poster's verbal message was rejected by the overwhelming majority of the people to whom it was addressed.

The puzzle surrounding the poster is intensified by the identity of the artist, Hans Schweitzer. In the 1920s and during the Third Reich, Schweitzer, who used the pseudonym Mjölnir (a Norse word signifying hammer of Thor, the God of Thunder and War), was a well-known National Socialist artist, creator of virulently anti-semitic cartoons and of posters that were often harsh and violent. As a high-ranking functionary in the Propaganda Ministry he helped organize the exhibition "Degenerate Art" in 1937. Was this poster seven and one-half years later a conscious or unconscious admission of defeat? Can it be interpreted as evidence of the disillusionment of even the Party faithful? Is the man with the hammer Schweitzer himself? Or should it rather be seen as a document of National Socialist nihilism, which continued a hopeless war in order to destroy the German people who had not proved worthy of the vision of the Third Reich? However we interpret the poster, in its message, design, and sparse use of color—colored inks being almost unattainable in the last months of the war—the poster is a true artifact of the ultimate stage of Germany's destruction and defeat. It may be that here, as with all posters, what matters most is not to arrive at firm an-

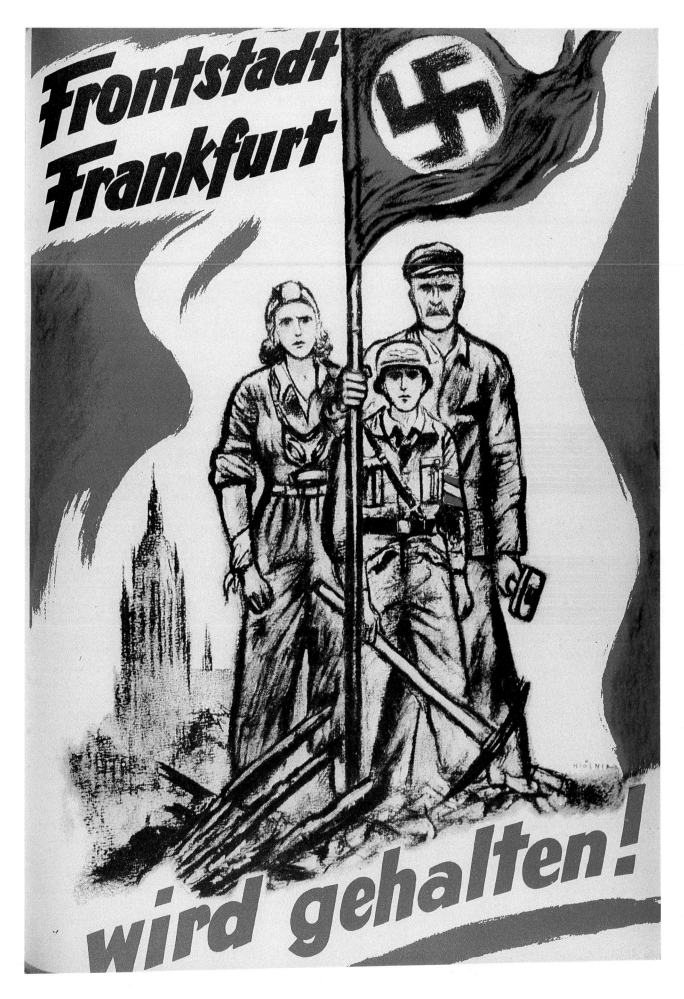

swers about their several meanings but to understand that, regardless how assertive they appear, posters raise questions. Recognizing the questions and responding to them becomes easier once we have looked at large numbers of posters, compared one with another, noted similarities and differences, and placed them in the context of our knowledge of history and our historical imagination. Behind each poster lie two converging lines: the political or cultural development to which it refers, and the aesthetic development it represents. The poster itself is the point at which the two lines meet.[1]

■

The poster as we know it today was a creation of the nineteenth century, of its technological innovations and its social, economic, and political transformations. The introduction of inexpensive, multi-copy processes of color printing and the development of bright printer's inks made posters technically feasible; the change from a traditional, largely rural way of life to the mobile mass societies of the industrial age made them economically desirable and at times even necessary.

In simpler form and smaller print runs posters had existed far earlier. They were used by political factions during the French Revolution, by the military to recruit in eighteenth-century Europe and America, as anti-Spanish handbills and broadsheets by the Dutch during the Revolt of the Netherlands. Even when few could read, there was usually someone around to spell out and explain the text, and even the unlettered could puzzle out the poster's message if an image accompanied the words. Often these posters addressed a segment of the population—for example, poor young men who might be willing to enlist as soldiers. Later posters, by contrast, tended to seek out the general public.

Such a public began to emerge with the political upheavals of the end of the eighteenth century and with the coming of the Industrial Revolution. Economic and political life lost its geographic segmentation and became less hierarchical, privilege and deference diminished, and as the attitudes and wishes of the mass of the population took on new significance, the road lay open for new means of communicating with the public at large. Just as small newspapers published for the educated reader of the federalist and Napoleonic eras gave way to the mass-circulation popular press, so the handbills and proclamations of patriarchal society evolved into the modern poster.

Taken one by one, and leaving aside technical refinements, the modern poster does not differ much from its predecessors. Recruiting posters mounted outside taverns in the towns and villages of Picardy or Lanquedoc (Fig. 2), or posters announcing the arrival of a travelling circus in Hartford or Columbus in antebellum America, resemble posters with similar messages today, even though early recruiting posters rarely exhibited the strident patriotism of later specimens. The essential difference between posters before and after the Industrial Revolution was a matter of quantity. From the later nineteenth century on, the print runs of individual posters were far greater, as was the number of different posters designed. Once a proclamation or handbill had been a minor element of everyday life. A century later the poster had grown into a permanent visual and psychological presence for the tens, and eventually hundreds, of millions of potential viewers that constitute modern society.

The growth of this society coincided with the triumph of the nation-state. Competition between states affected and intensified economic competition, not only of state against state but within each country as well. In commerce and culture, as in politics and war, the poster was used increasingly to define one's position—to praise the quality of one's products in words and image or give visual expression to patriotism—and also to operate as a weapon against rivals and enemies. From the last decades of the nineteenth century to the end of the Second World War, the poster was one of the most visible and constant signs of the struggle for an audience, for customers and political supporters, and of

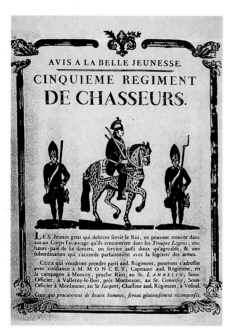

AVIS A LA BELLE JEUNESSE.
CINQUIEME RÉGIMENT
DE CHASSEURS.

LES Jeunes gens qui desirent servir le Roi, ne peuvent trouver dans aucun Corps l'avantage qu'ils rencontrent dans les *Troupes Légères*; une haute-paie de six deniers, un service aussi doux qu'agreable, & une subordination qui s'accorde parfaitement avec la legereté des armes.

Ceux qui voudront prendre parti aud. Régiment, pourront s'adresser avec confiance à M. M O N C E Y, Capitaine aud. Régiment, en la campagne à Moncey, proche Rioz; au Sr. *LANBELIN*, Sous-Officier, à Valleroy-le-Bois, près Monbozon; au Sr. *Converfey*, Sous-Officier à Monbozon; au Sr *Jacquot*, Chasseur aud. Régiment, à Vesoul.

Ceux qui procureront de beaux hommes, seront généreusement récompensés.

the clash between states and ideologies. Its dominance ended only with the wider use of radio broadcasts, newsreels, and the emergence of television. Until then, posters were the battle flags of commercial, cultural, and political rivalries—symbols that themselves were part of the conflict. For us they represent both physical remnants of the times in which they were created and historical documents that help us understand these times.

Early examples of the modern poster began to appear in European and American cities in the 1860s and '70s. Printed at first in black and then increasingly in color on large-sized paper, often combining text with image, they advertised theatrical and musical performances and goods for sale. Within two decades they had become a commonplace feature of the urban scene, and through copies that have survived we can see the environment they addressed and reflected. They document not only aspects of the cultural and economic life where goods and services met with potential customers, but also with what may be called the public area of party politics. When war broke out in Europe in 1914 the political role of the poster expanded enormously. Posters became testimony to the crisis of Western civilization that lasted until 1945, and beyond. Finally, posters document their own history, not only as instruments of persuasion but as aesthetic objects, products of artistic creativity that interact with the changing styles of Western art.

∎

Commerce and culture, politics and ideology, the great wars in the first half of the twentieth century, the history of the poster itself—all of these posters illustrate and document. But as with other kinds of documentation, posters rarely provide complete and unambiguous testimony. Often their various components—text, image, design, and color—are not completely in accord. As the example of Mjölnir's appeal to defend Frankfurt to the death has shown us, a poster's statement or image may be open to more than one interpretation, either at the time or by later viewers not familiar with the circumstances under which the poster was created. Nor can it simply be assumed that a poster speaks with one voice. The designer is employed to express a specific message and may have to work with a prescribed slogan or motif; even his range of colors may be dictated. The details of the genesis of a poster are rarely known, and the extent to which a poster expresses either a general opinion or an idiosyncratic view cannot always be sorted out. Finally, reliable information about the number of copies printed and distributed may not be available; more often than not, the effectiveness of a particular poster is difficult to determine.

Posters depend upon an ability to attract and inform, and as urban society in the nineteenth century became more hurried, poster designers had to adjust to the new, less leisurely conditions. When the young Parisian lithographer Jules Chéret began to publish his pioneering posters in the late 1860s, the medium's potential for intrusiveness was barely understood. Still, contemporary observers soon noted the magic of Chéret's colorful prints pasted on construction scaffolding and house walls, which burst through the gray monotony of the urban scene. Chéret's early posters were no more than a step or two removed from the traditional pattern of information crammed into the available space, with little concern for reaching into the passing crowd and inducing people to stop and receive the message. An announcement of an 1868 performance of an operetta by Jacques Offenbach consists almost entirely of detailed sketches of the cast, shown in characteristic scenes from the work, across which the place and time of the performance and other such information is printed in a standard commercial typeface. None of this is particularly attractive or created for impact at a distance. But in the center of the poster, the operetta's leading lady in flowing silvery robes, drawn to a larger scale than the rest of the cast, provides a strong visual and emotional focus. Over the next decades, Chéret pursued the potential of this arrangement until, in 1893, in his poster of the dancer

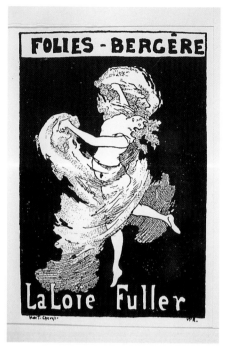

Loïe Fuller of the Folies Bergère—perhaps his most famous work—he achieved a powerful impact, whether seen close-up or at a distance, with the simplest possible design and a narrow range of colors (Fig. 3 and Poster 3). Against a blue-black background the dancer floats, her veils—which change from yellow to orange to grey under invisible electric lights—whirling around her body. Her red hair draws our eyes to the legend in red that runs along the top and bottom of the poster; the letters, especially those at the top, have sinuous curves which repeat the curves of the woman's body. The drawing of Loïe Fuller remains surprisingly realistic and three-dimensional, but the overall effect is one of unity of image, typography, and color, of simplicity, and of a wonderful, gay elegance.

On the whole, the most powerful and seductive posters continue to be those that create a strong, unified impression, not dependent on a careful perusal but to be taken in quickly by people hurrying past or stopping briefly. The desired effect may be achieved by simple or complex designs, and has never been linked to any particular aesthetic style. Poster designers have always borrowed from various artistic directions. In turn, their strongest work has had an impact on artists, as Chéret seems to have influenced Seurat and, especially, Toulouse-Lautrec, whose posters achieved a degree of psychological analysis and aesthetic daring that Chéret neither could nor would have wanted to equal.

■

The interaction between art and poster design has been enriching for both, if not always fully successful. Impressionism rarely worked well in posters, perhaps because its coloristic variations and allusiveness were difficult to integrate with lettering that had to stand out clearly. Typography combined more easily with expressionism, but the style was too complex and remote from popular taste—and even from comprehension—to be effective, except in watered-down adaptations. On the other hand, poster designers

borrowed successfully from various types of abstract art, from cubism, and especially from the many versions of art nouveau. The decorative, intellectually undemanding appeal of art nouveau lent itself perhaps too easily to poster design, and posters became among the most significant products of the style, both at the turn of the century and in its 1960s revival. But as important as the art poster and posters influenced by art movements have been, they have never been dominant, except possibly in books on the design and history of posters. In the commercial and political world, a conventional poster style, derived from Victorian book illustrations, easel paintings, or modest shop-window advertisements, remained ubiquitous, even at a time when modern poster design reached a first high point in France and later in Great Britain and Central Europe. This dichotomy between the innovative and the traditional continued throughout the First and Second World Wars. It remains far from certain that the more aesthetically interesting posters have invariably been the most effective.

A particular poster's impact can rarely be measured accurately. Quantity and number of printings indicate a contemporary estimate of a poster's appeal, as do comments by observers and critics. But much of this is highly subjective. The medium as a whole, however, has generally been regarded as effective. This was particularly true during the First World War when governments, with only limited means of mass communication at their disposal, resorted heavily to the use of posters. Consequently, the investment of manpower and other resources in their production was large.

Among thousands of posters printed, some were perceived as having had a particularly strong impact, though today the reasons for this are not always clear. What was it about Joseph Pennell's science-fiction vision of a Manhattan smashed to rubble that caused it to be reproduced in two million copies? The frequent reprinting of posters by Jules Abel Faivre suggests that his manner of personalizing the national struggle and his sketch-like technique struck a chord among the

French public. Similarly, Lucian Bernhard's war loan posters have been credited with helping to make the later German loan drives so successful. Bernhard's sparse, earthy colors and the Gothic typeface he adapted for these posters—traditionally Germanic, but with a legibility that made them very modern—seem to have suited the country's mood at the time. But in the absence of systematic market research these remain no more than reasonable assumptions.

In the Second World War the need for posters was no longer as apparent, and yet they continued to be produced in great numbers. Besides newspapers, the primary means of mass communication then available to governments—probably less so in the Soviet Union than elsewhere—were the radio and newsreel, which became extremely important tools for shaping popular opinion. Official announcements posted in public places and factories continued to play a major role, as did posters. They appealed for volunteers, instructed in air-raid precautions, and sought to intensify hatred of the enemy. But posters had become clearly a subsidiary means of communication, although they lost none of their documentary and evidentiary power. More research is needed on the relative effectiveness of the various media campaigns of domestic and foreign propaganda, on efforts to inform and influence public opinion, but a great deal of available official and unofficial evidence indicates the auxiliary role to which posters were limited. It is telling, for instance, that posters are scarcely discussed in the top-secret reports on the German home front that the Security Service of the SS issued to the most senior officials of the government and party. The reports covering the years from 1938 to 1945 include hundreds of pages on the public's reaction to newspaper coverage of the war, to German and Allied radio broadcasts, and to the newsreels, which had such a vivid impact that many people went to the cinema only to see them and left when the feature film began. But posters are not mentioned, except for very few references—for instance, an observation that the "screeching posters" of Ger-

man occupation authorities in France were counter-productive.[2]

To a far greater degree than the democracies, fascist and communist dictatorships used posters to define and assert their authority. In war as in peace, posters were one element in the arsenal of symbols and symbolic images with which individuals were always surrounded. In his memoirs, the philologist Victor Klemperer, a man who survived both Nazi persecution and Allied bombing, recalls the unchanging dullness of German wartime posters: They were "always cut from the same pattern. We were always shown the same type of brutal and jaw-clenched, taut fighter. . . . Physical strength, the fanaticized will, muscles, hardness, and the undoubted absence of any thought were the characteristic features of these advertisements."[3]

Of course there were exceptions to this pattern—for example, the brilliant poster "Shhh!" that warned against loose talk, not because the enemy might be listening, but to protect the ideological cohesion of the German people against rumors and complaints. Another exception, which even impressed Klemperer, was the anarchic poster figure of *Kohlenklau* (grabber of coal), a dangerously asocial thief of a rationed and increasingly scarce commodity who was utilized as the centerpiece of a campaign against stealing and the black market (Fig. 4). The image and name of *Kohlenklau* entered the language, and if the Third Reich had lasted longer he might have become a mythical figure. It tells us something not only about the character of the Nazi regime and daily life in wartime Germany but about the role of the poster as an intermediary between the government and the public, that the greatest popular success of any German poster during the Second World War was not a representation of ideology, military victory, or the triumph of the will, but rather the badly drawn image of a sneak thief.

■

Early in its history, the modern poster became something to study, preserve, and collect. The first articles and books on posters appeared in the

Da ist er wieder!

Sein Magen knurrt, sein Sack ist leer, und gierig schnüffelt er umher. An Ofen, Herd, an Hahn und Topf, an Fenster, Tür und Schalterknopf holt er mit List, was Ihr versaut. Die Rüstung ist damit beklaut, die auch Dein bißchen nötig hat, das er jetzt sucht in Land und Stadt.

Fasst ihn!

In den Zeitungen steht mehr über ihn!

3,500,000 of us are STARVING in Europe HELP US

10% of the receipts from the total sales on Saturday, Feb. 19th at all

HUYLER STORES in the United States

go to The EUROPEAN RELIEF COUNCIL Herbert Hoover, Chairman.

MARION EMMONS

1880s; clubs were formed and exhibitions held, the term "art poster" gained currency, and soon posters were printed on better paper with greater care for serious collectors and for people who wanted to decorate their rooms with examples of this new applied art. Beginning in France and Great Britain, these new developments quickly spread throughout the western world. In the middle of the First World War, the leading German journal devoted to the history and design of posters increased its print run from 2800 to 4000 copies and still could not meet the demand. By the beginning of 1921, the German Society of Friends of the Poster had some 5000 members. If it was primarily the poster as an aesthetic object that attracted interest, attention was also paid to the poster's ability to reflect and explain current events. During the war, exhibitions that contrasted posters of one's own society with those of others were organized in several countries, to illustrate the values one held and for which one fought as well as to elucidate the nature of the enemy. At the same time, people had begun to recognize that posters were potentially important historical documents.

The major poster collections in the United States and Europe originated from this new awareness. Among the earliest in this country was the collection begun by Herbert Hoover. In 1914, Hoover, then a private citizen, decided to collect government reports, propaganda, and other material from both the Allied and Central Powers to document the war that had just broken out. The Commission for Relief in Belgium, which he founded and directed, became the first agency of his collecting activities, which were expanded when he was appointed United States Food Administrator and, subsequently, Director General of the American Relief Administration in Europe. Officials of these organizations collected printed and manuscript materials in the countries in which they worked (Fig. 5). In 1918 they were reinforced by a small group of academics from Hoover's alma mater, Stanford University, whose work was financed by grants from Hoover. Their leader, Professor E. D. Adams of the Department of History, "set up headquarters in Paris and dispatched his young scholars to every corner of Europe. Dr. Adams and his main collaborators laid the foundation for much of the present [archival] collection by acquiring previously unobtainable government documents and materials on the various revolutions of 1917–1919, and on the new states established by the Peace Conference."[4] Their activities ranged from picking up single items in the streets, in offices, and at political meetings, to negotiating with governments and private individuals for the gift or sale of large collections. Professor Frank Golder, who began the collections of Imperial, revolutionary, and Soviet Russian materials, which constitutes one of the most valuable parts of the Hoover Archives, is described by another American in Petrograd at the time as being "very careful to get all the posters that the anar-

chists and others are passing around in the street."[5] In 1920, Golder, by this time in Berlin, bought over 2300 German proclamations and posters issued in the capital between August 1914 and April 1920 from Emil Grimm, one of the major German poster collectors.[6]

Since those days, Herbert Hoover's collection of documents has grown from a few rooms in the Stanford University Library to the large archive and library on recent and current history. Housed in their own buildings, they form the core of the Hoover Institution on War, Revolution and Peace on the Stanford campus. The poster collection has grown along with the rest of the archives. Today it consists of some 75,000 posters—including duplicates and copies of posters in different dimensions—as well as nearly 40,000 purely typographical announcements. As political documents, as works of popular culture—if efforts to influence large numbers of people may count as that—and as objects that are often of great aesthetic interest, these thousands of images form a world of design, color, and message that opens a window on the larger world of the past.

Notes

1. A further analysis of this poster can be found in Peter Paret, "God's Hammer—A National Socialist Propagandist," *Proceedings of the American Philosophical Society*, vol. 136, No. 2 (1992).
2. *Meldungen aus dem Reich, 1938–1945*, ed. Heinz Boberach, Herrsching, 1984, vol. 15, p. 5887.
3. Victor Klemperer, *Die unbewältigte Sprache*, Darmstadt [1966], p. 96.
4. *The Library of the Hoover Institution on War, Revolution and Peace*, ed. Peter Duignan, Stanford, 1985, p. 4.
5. Diary of W. L. Darling, an American member of the Commission of Advisory Railway Experts serving in Russia in 1917. Entry of 22 ? 1917. Box 26005-10v, Hoover Institution Archives.
6. Letter of Emil Grimm to Ralph H. Lutz, 8 January 1921. Grimm collection, Hoover Institution Archives.

Note on the Posters

The posters that follow have been chosen from a single collection, and the nature of the holdings has influenced our choices. The poster collection of the Hoover Archives is very strong overall, and exceptional in some areas—for instance, France in the First World War, the United States, and Russia. The German holdings are outstanding in their breadth even if not all great German designers are equally represented. There is one poster by John Heartfield, but several dozen by Ludwig Hohlwein and Lucian Bernard. The Spanish collection is good on both the Loyalist and Nationalist side, but lacks posters of the International Brigade. A few areas such as Italy, or France during the 1930s and the Second World War, are relatively small. In selecting posters for this book it was therefore not always possible to avoid a gap or to achieve the ideal balance of subject matter, design, country of origin, and date of publication. On the other hand, a greater number of posters could be chosen from a particularly rich area. As in other forms of historical inquiry, there is much to be said for the policy of following where the material leads. This policy has been broken only once. The Hoover Archives contain few posters published before 1914. Because this earlier period forms an essential background for the posters printed during and after the First World War, the nine illustrations in the "Prologue: Before 1914" include three posters from other collections.

Historical as well as aesthetic considerations have guided the selections. The posters represent events that occurred and styles that were current between the Belle Époque and the reconstruction of Europe after the Second World War, and are shown in thematic groups arranged in broadly chronological order. Illustration and text are closely integrated to form a narrative of word and image in which each poster speaks for itself but is also a link in a thematic and interpretive chain. Introductions to chapters and legends for the posters have been kept to a minimum. They offer basic information on the origin of each poster, on its political context and motive, and may add a comment or two on its design or its impact. Much more could be said about most posters in this volume, but the text is meant to suggest rather than be exhaustive. It is there to help readers develop impressions of the poster as a work of applied art and as an agent of persuasion and control, and in this way to gain a fresh perspective on the history of our century.

Following pages: During the presidential elections of 1932, passersby in a working class district of Berlin look at a National-socialist poster that has just been pasted on an advertising pillar.

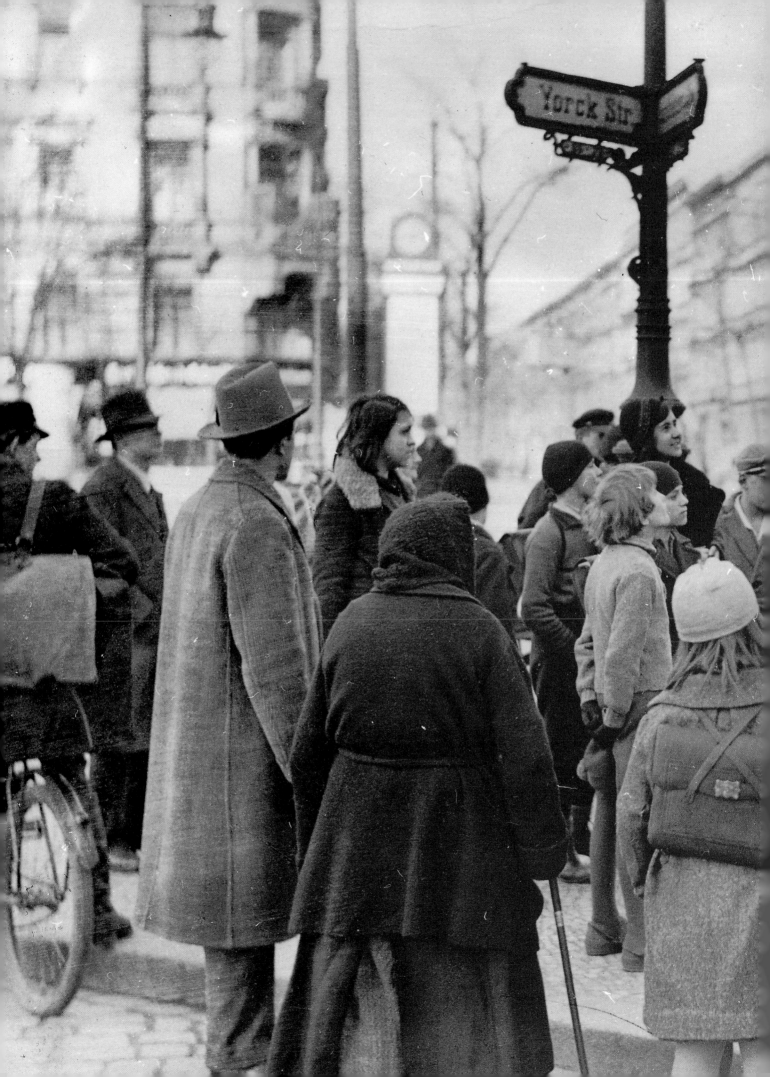

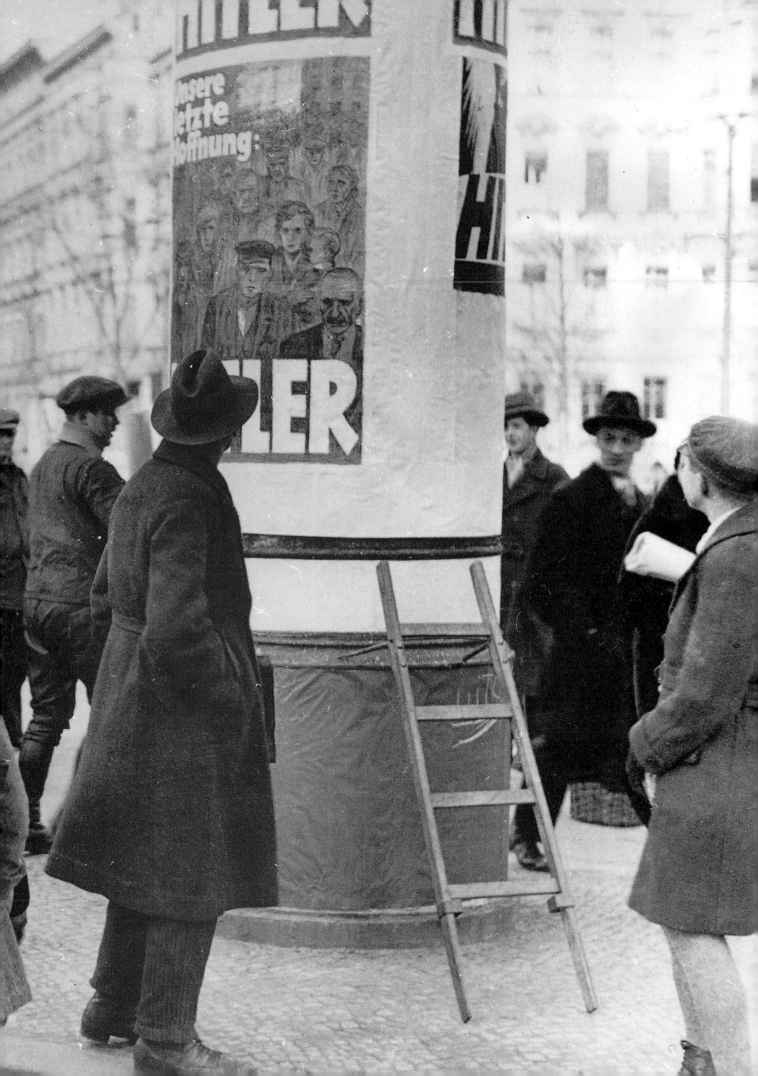

PERSUASIVE IMAGES

Prologue
Before 1914

Just as war did not come out of nowhere in 1914 but was brought about by developments that reached far back in the preceding century, so the posters with which every belligerent state appealed for men and money, denounced the enemy, and tried to maintain morale emerged from an existing commercial setting. Many of the designers who had made the modern poster into a significant aesthetic and social force created war posters between 1914 and 1918. Some continued to be productive in the interwar years, adding their voice to the ideological and political quarrels of the time; the work of a few even showed up in the flood of violent posters after the outbreak of a second and more destructive world war in 1939.

By the 1890s designers had learned how to convey messages in a manner that, however complex its aesthetic elements, spoke clearly and was easily understood even from a distance. Not that all posters had left fussy designs and prolix language behind. Even Jules Chéret, whose 1893 poster of the American dancer Loïe Fuller (Poster 3) is a magnificent and influential example of the new approach, subsequently created a number of posters that returned to earlier baroque or diffused modes. Among wartime posters, as will be seen, the old and the new also coexisted, and typographical announcements without images experienced a revival. Even if not universally exploited, however, the breakthrough to modernity proved decisive for the poster's further development.

The new simplicity, some critics thought, suited the simplistic message of advertising. But not all ambiguities had disappeared. The favorite strategy of commercial posters to employ the values of small elites in order to appeal to the mass of potential lower-middleclass customers continued. The Bavarian nobleman who inspired the hunter on Ludwig Hohlwein's poster (Poster 8) was unlikely himself to have his suits made at a firm that advertised itself on billboards as a British "sporting tailor," but his image drew in customers from less elevated circles. Patriotism and nationalism, too, which posters from 1914 on proclaimed as absolutes, were to reveal unexpected, deadly ambiguities. Hohlwein, incidentally, is among those designers who worked throughout the next forty years, in his case ending with strident appeals to support the Führer.

The posters in this section were designed between the early 1890s and the year the war broke out. In an aesthetic vocabulary that was by then widely understood, the posters expressed, as they still convey to us today, aspects of a culture whose sophistication was not diminished by its inability to solve peaceably the problems of international coexistence.

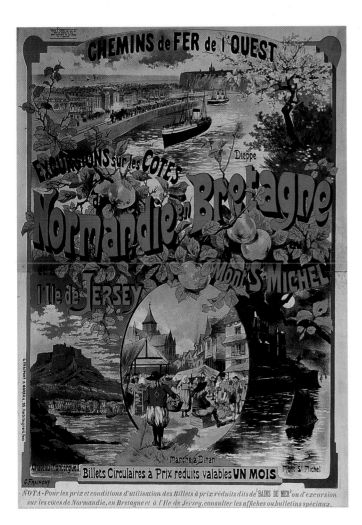

1. Excursions to the Normandy Coast . . .
France. Before 1891. Gustave Fraipont.

Image and text are only beginning to free themselves from the profusion of detail that characterizes the early poster and inhibits its impact from a distance. The message is pitched to two social levels: it advertises resorts favored by the well-situated bourgeoisie, but also appeals to people who must economize by announcing the availability of reduced fares.

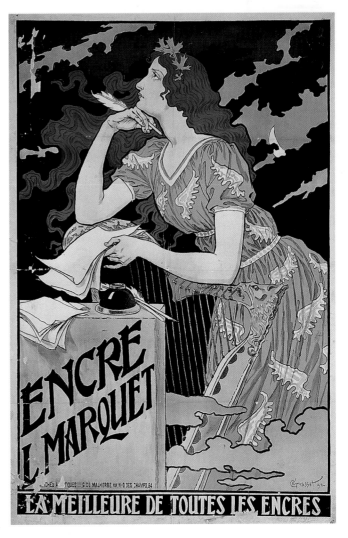

2. L. Marquet ink. The best of all inks.
France. 1892. Eugène Grasset.

An elegant, stylized advertisement by an important designer of the period, reminiscent of the theatrical medievalism of the Pre-Raphaelites.

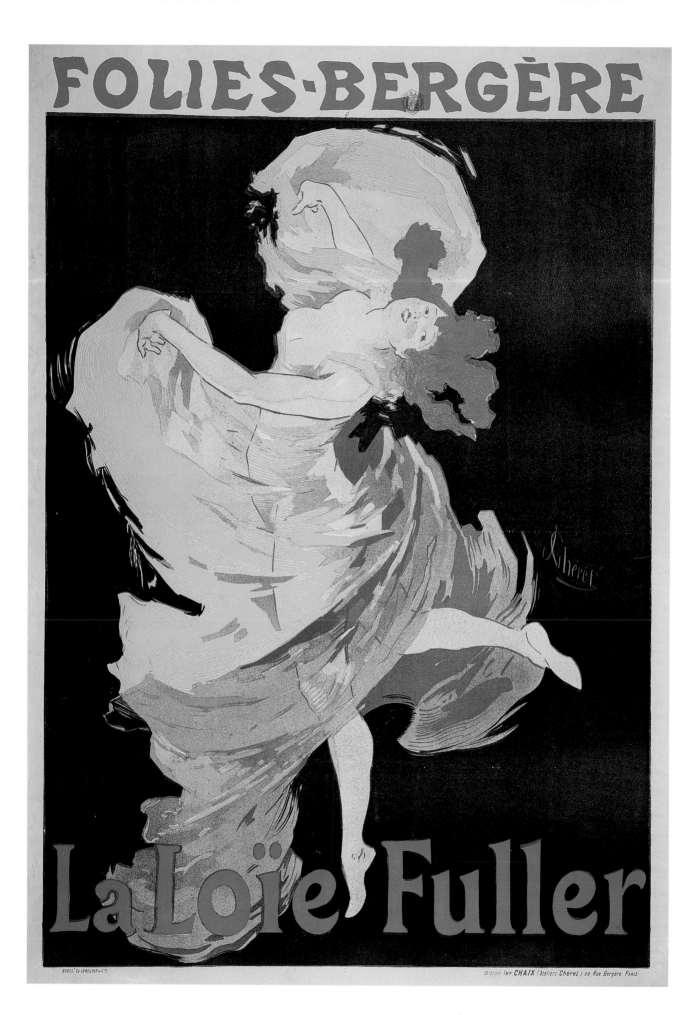

3. Folies Bergère—La Loïe Fuller.
France. 1893. Jules Chéret.

One of Chéret's best, and best-known, posters, which helped set new standards of aesthetic excellence and clarity of message. Note also the black-and-white version of this poster by "W. R." (Fig. 3 above).

4. Pure, sterilized milk.
France. 1894. Théophile-Alexandre Steinlen.

Steinlen's design, at once idyllic and sophisticated, hides an ambiguity that reinforces the message. Either the little girl is merely testing the milk before giving it to the cats, whose curved bodies continue the billowing lines of her red dress, or she is depriving the cats by drinking the milk herself. In either case the quality of the advertised product is emphasized.

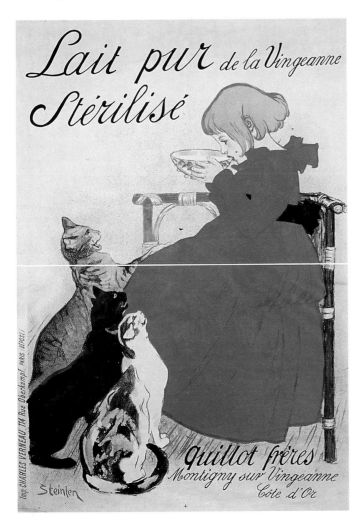

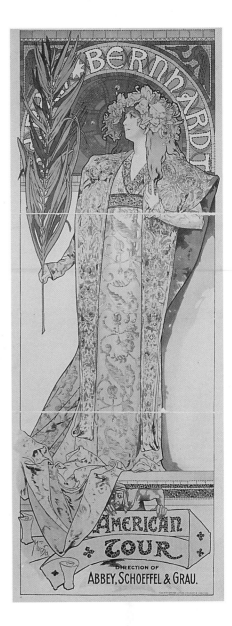

5. Sarah Bernhardt. American Tour.
France. 1895. Alphonse Mucha.

One of several posters Mucha designed for the great actress; this one to publicize her American tour. Before a curved panel bearing her name—a motif Mucha often used—Mme. Bernhardt is placed in statuesque stillness, like a modern-day, stained-glass saint.

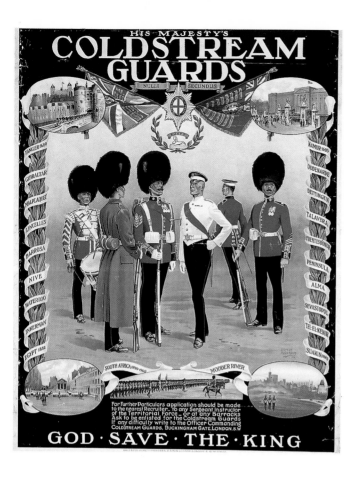

6. His Majesty's Coldstream Guards.
Great Britain. After 1902. Ernest Ibbetson.

The poster suggests a traditional military world of service and duty, and of an equally timeless social self-assurance, which for generations had beat back every foreign challenge. The world of contemporary warfare is not in evidence. Although the regiment had served in the Boer War and was familiar with such modern realities as the machine gun, the entrenching tool, and khaki uniforms, officers and other ranks are shown in the full panoply of a vanishing age. The poster's fantasy image conforms well with its old-fashioned, fussy design.

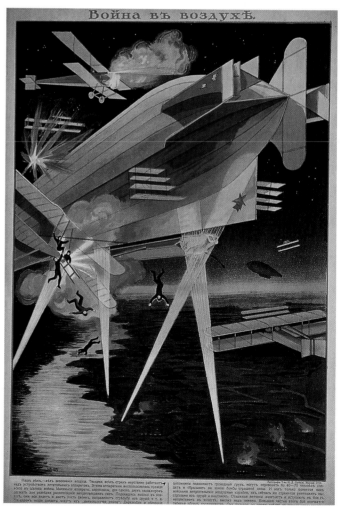

7. The air war.
Russia. 1914.

If the preceding poster romanticises war, this one expresses a futuristic fantasy in terms that from a distance approach a geometric abstraction. On long legs formed by the cones of four searchlights, the dirigible stalks over enemy territory. Planes attack the monster, but are not faring well. The plane on the upper left is on fire; a second beneath it is disintegrating, its doomed crew falling through space.

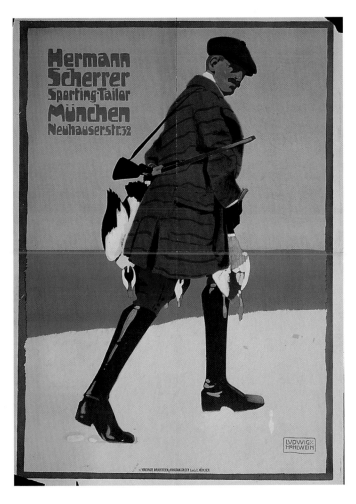

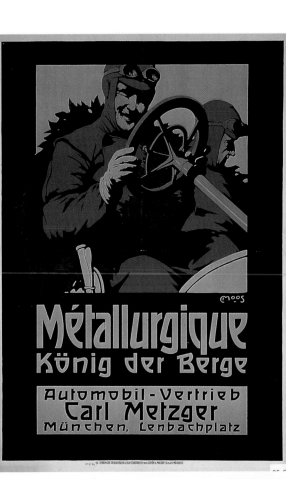

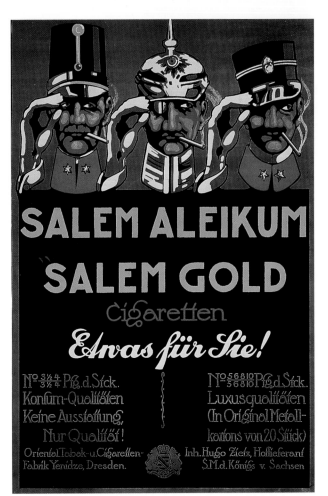

8. Hermann Scherrer. Sporting-Tailor.
Germany. 1907. Ludwig Hohlwein.

9. Metallurgique—König der Berge.
Germany. 1908 or earlier. Carl Moos.

10. Salem Aleikum. Salem Gold Cigaretten.
Germany. c.1913.

These three posters, carried out in different styles, exemplify the high design standards achieved in Germany in the years before the war and illustrate the broad commercial appeal of elite symbols. The last poster combines the elements of military masculinity and elegance with good-natured caricature in the portraits of the Austrian, German, and Italian officers in dress uniform. The three men represent the Triple Alliance, an alliance that was to prove illusory when war broke out in 1914 and Italy remained neutral before entering the war on the side of Great Britain and France the following year.

Part I

The First World War

1.
The Outbreak of War

In August 1914, every major European power was ready for war, and everywhere mobilization and deployment of troops, and their supply, as they advanced to the frontiers and beyond proceeded with relative efficiency. The administrative and logistic preparations of earlier decades proved themselves. Within a few months, however, it became apparent that a new kind of war, characterized by the massive use of materiel, movement measured in yards rather than miles and gained at the cost of extremely heavy casualties, was beginning to define itself. On all fronts, official doctrine and actual practice began to be altered by improvisation and innovation.

The posters of the first year of the war reflect and are themselves a product of this coming together of the old and new. Mobilization announcements, instructions for reservists to report to their units, declarations closing frontier zones to travel—all printed long before war was declared—were punctually distributed. But the surprising developments at the front also required improvisation in the message and design of posters. As the fighting in the west froze into a war of position, and mobile operations in the vastness of Poland and Russia failed for the time being to achieve a decisive victory, governments began to search for ways of maintaining the enthusiasm and determination that everywhere had marked the public mood in the opening weeks of the war, and to ask for support of new programs organized to send food and warm clothing to the troops in the field, help the wounded, and give whatever aid possible to prisoners taken by the enemy. Above all, it soon became essential to appeal to the population for money to help finance the war and, in Great Britain, which still had a volunteer army, for men to fight it.

Advertisements may attempt to deny reality, but can do so convincingly only up to a point. After a few months, the posters of all warring nations revealed signs that the first sweep of public enthusiasm was being replaced by a more sober resolve to back one's soldiers in a conflict that was not likely to end in quick victory.

Those posters that continued to present their society as being at the peak of patriotic fervor sounded an obviously false note. Posters were probably more successful in helping maintain the dislike and fear of the enemy, in deepening the essential division between "us" and "them." British posters played up the need for men and resources to defeat an inhuman enemy, while French and German posters preferred to stress the determination, heroism, and, eventually, the suffering of their troops. In all countries, as well, it took time to set up central agencies that would coordinate the various appeals and messages and bring them under one roof. Throughout the war, controls became firmer and more comprehensive. The inevitable rivalry and conflicts between ministries and competing agencies notwithstanding, it is possible to identify by the middle of 1915 centrally guided propaganda policies in every country. Except perhaps in the United States after 1917, complete unanimity was never reached. Everywhere, however, posters, which were being printed and distributed in ever increasing numbers, expressed reasonably well-defined programs of political marketing and persuasion.

11. **General mobilization order.**
France. 1909/1914.

This was printed in 1909, with a space left open for filling in the date of the first day of mobilization (Sunday, 2 August 1914). In typeface and layout, the poster closely resembles official French proclamations of 50 and 75 years earlier.

ARMÉE DE TERRE ET ARMÉE DE MER

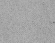

ORDRE
DE MOBILISATION GÉNÉRALE

Par décret du Président de la République, la mobilisation des armées de terre et de mer est ordonnée, ainsi que la réquisition des animaux, voitures et harnais nécessaires au complément de ces armées.

Le premier jour de la mobilisation est le *Dimanche 2 Août 1914*

Tout Français soumis aux obligations militaires doit, sous peine d'être puni avec toute la rigueur des lois, obéir aux prescriptions du **FASCICULE DE MOBILISATION** (pages coloriées placées dans son livret).

Sont visés par le présent ordre **TOUS LES HOMMES** non présents sous les Drapeaux et appartenant :

1° à l'**ARMÉE DE TERRE** y compris les **TROUPES COLONIALES** et les hommes des **SERVICES AUXILIAIRES**;

2° à l'**ARMÉE DE MER** y compris les **INSCRITS MARITIMES** et les **ARMURIERS** de la **MARINE.**

Les Autorités civiles et militaires sont responsables de l'exécution du présent décret.

Le Ministre de la Guerre, *Le Ministre de la Marine,*

IMPRIMERIE NATIONALE — 3283-113-1909.

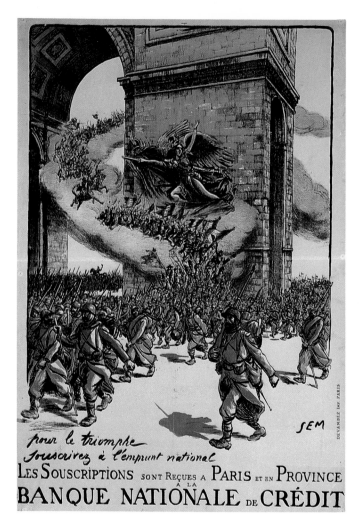

12. To triumph, subscribe to the national war loan!
France. c.1915. Sem (Serge Goursat).

Posters could not be designed and printed quickly enough to catch the patriotic enthusiasm that swept through the societies of all belligerents at the beginning of the war. Here that mood is reflected in a later work: from the sky, soldiers of the Napoleonic Empire surge through the Arc de Triomphe to inspire and march alongside the modern nation in arms.

13. A benefit for the families of fallen soldiers.
Russia. 1914. Vladimir Vasnetsov.

14. The great European war.
Russia. c.1915.

The scene from a medieval legend stands for the new struggle between right and wrong. Another variant on the use of symbols drawn from legends, fairy tales, and the Bible to clothe the war in terms that all could understand. The poster's subtitle, "The great battle of the Russian hero with the German serpent," summarizes the motifs scattered through the poster. A medieval Russian knight (his image will reappear in Soviet posters of the Second World War, see Poster 226) rides over the twisting body of the many-headed monster representing the Central Powers. He has already cut off its Austrian head, wounded the neck of the German, and is about to attack the Turk, who screams in terror. In the left background is a damaged French cathedral, its desecration marking the Germans as enemies of Christ.

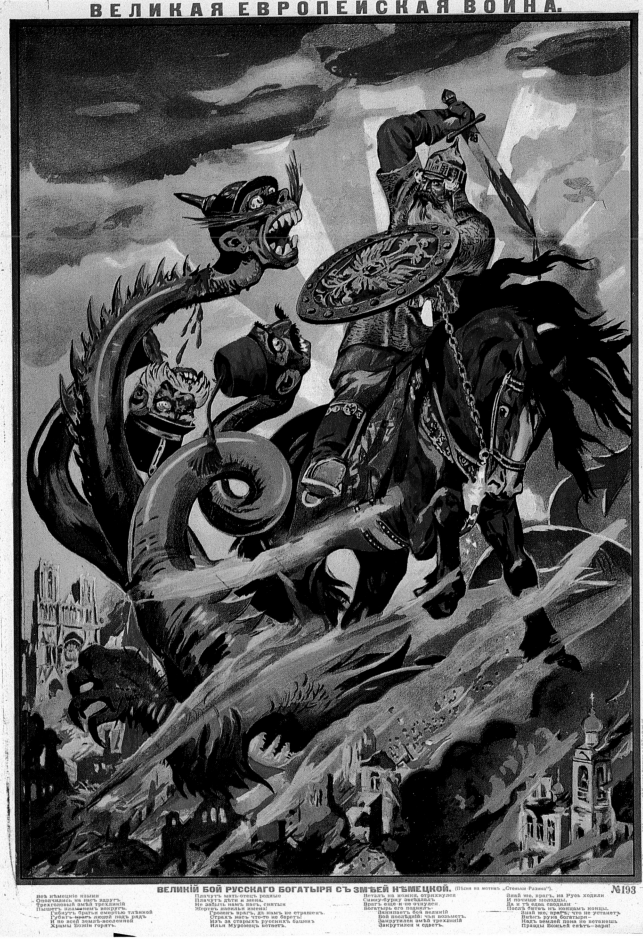

15. The German Anti-Christ.
Russia. 1914–15.

The Kaiser, astride a wild boar, rides over the devastated countryside like a modern horseman of the apocalypse, ridiculous and threatening at the same time.

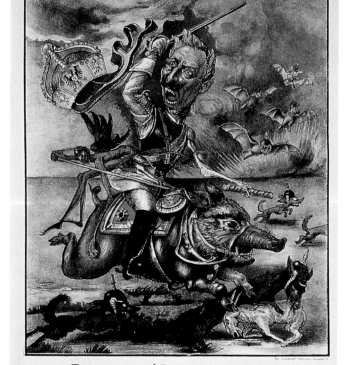

16. Belgians are you ready?
Belgium. 1914. James Thiriar.

The Belgian cock confronts the marauding German eagle.

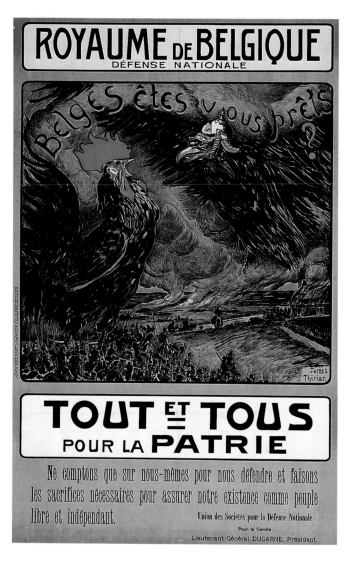

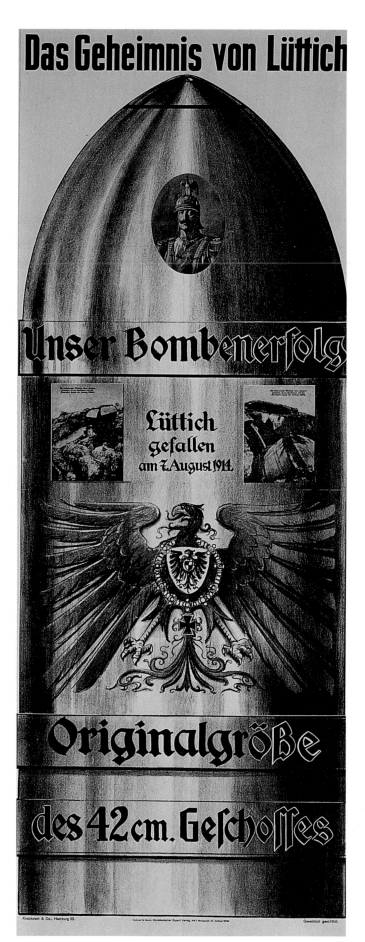

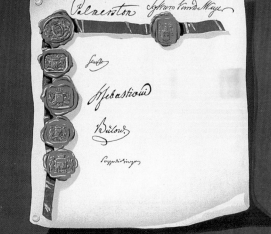

17. The Secret of Liège.
Germany. 1914.

The poster, in the original printed in the same size as one of the 42-centimeter shells that destroyed the Belgian forts at Liège, celebrates a significant German victory in the first days of the war, which for a time seemed to promise that the German offensive, based on the Schlieffen Plan, would succeed.

18. The "Scrap of Paper."
Great Britain. 1915.

In justifying the invasion of Belgium, an essential element in the Schlieffen Plan, the German chancellor referred to the international guarantee of the country's neutrality as a "scrap of paper." This phrase, together with reports and fictions of German atrocities, became the mainstay of anti-German propaganda throughout the war.

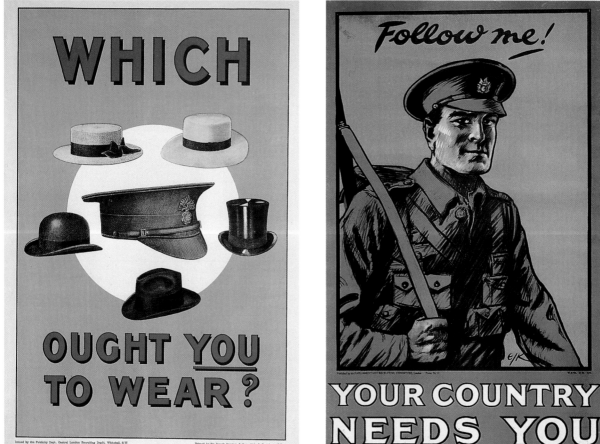

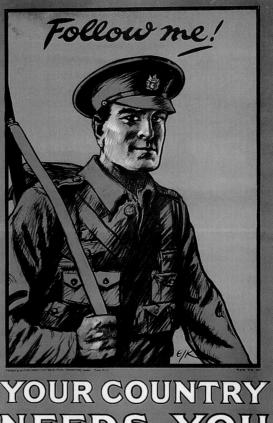

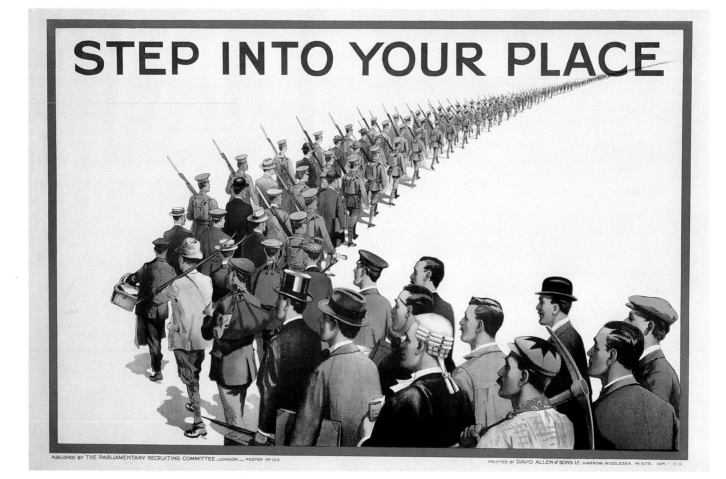

19. Which ought *you* to wear?
Great Britain. 1914–15.

20. Step into your place.
Great Britain. 1915.

21. Follow me!
Great Britain. 1914. E.K.

*Until Parliament introduced conscription in May
1916, Great Britain was the only major power
in Europe that relied on voluntary enlistments.
Of these early recruiting posters, two are in the
tradition of old-fashioned commercial advertise-
ments, while the third attempts a more mod-
ern and integrated design.*

22. Belgian Red Cross Fund.
Great Britain.

*A British appeal to help Belgian wounded sol-
diers and civilian war victims.*

23. Red Cross Collection, 1914.
Germany. 1914. Ludwig Hohlwein.

*The earliest of Hohlwein's posters appealing for
help for wounded German soldiers and prison-
ers of war.*

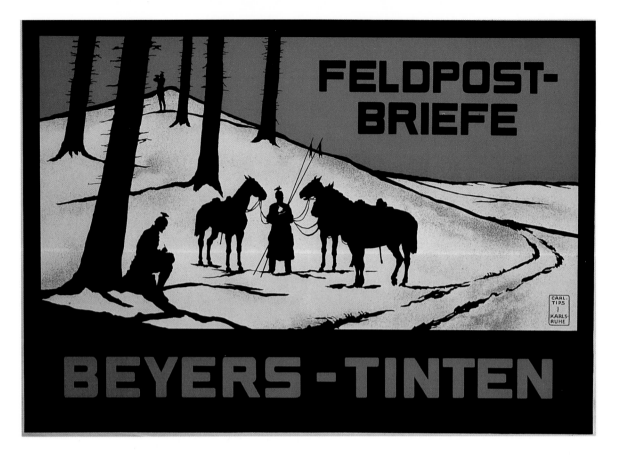

24. Letters to the Front.
Germany. c.1915. Carl Tips.

The idyllic silhouette of three lancers on patrol, one of whom is writing a message, forms the backdrop for an advertisement that combines the brand name of an ink company with an appeal to send letters to soldiers facing the enemy. Front and homeland are linked by means of the same activity. That the silhouette is not a cutout but is outlined and filled in with ink reinforces the integration of design and commercial message.

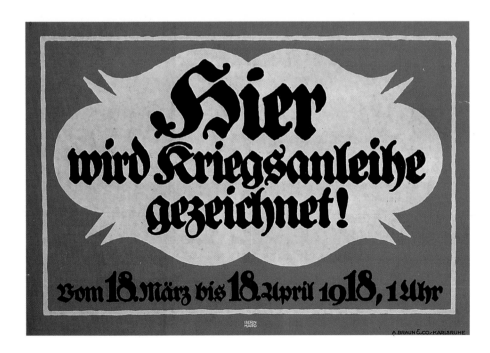

25. War Loan Bonds are sold here!
Germany. 1918. Lucian Bernhard.

Bernhard designed his first war-loan poster in 1915. The variant of German black-letter type that he developed for the posters became familiar and well-liked. This example, from the last year of the war, is representative of his many appeals in which the lettering itself becomes the message.

26. The beer from the spring hops has arrived; the enemy is surrendering.
Hungary. 1914. Foldes.

Another commercial exploitation of the war. Allied soldiers—among them a French poilu, a Scotsman, and a Russian—would rather drink beer than fight, and are surrendering to beer-drinking Hungarian troopers and their German ally.

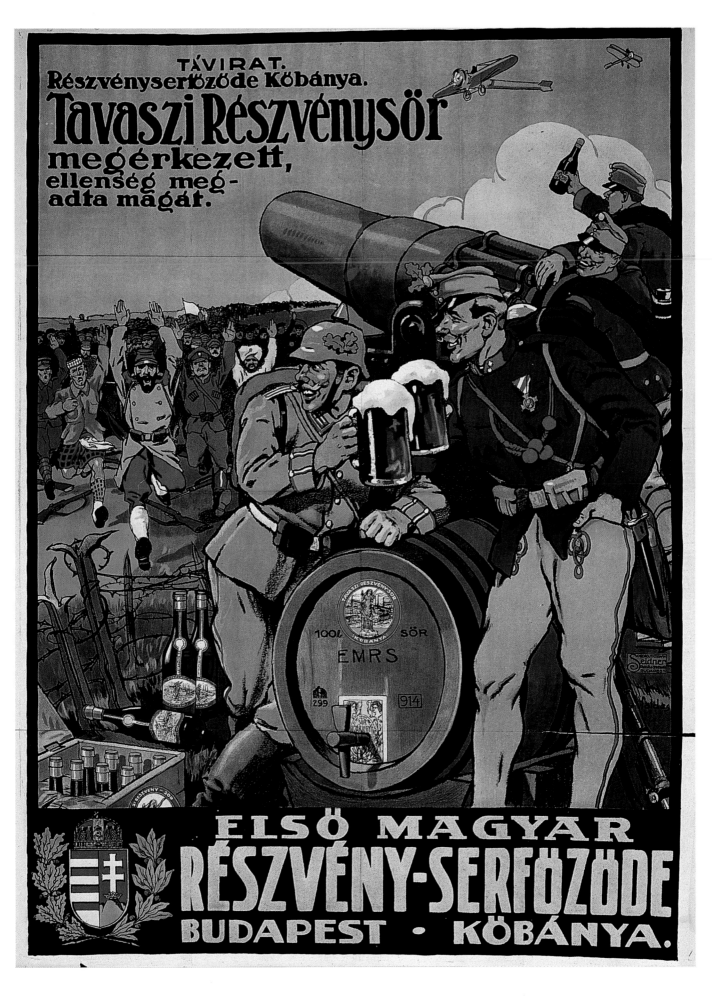

2.

The Enemy

Within days after the war began, reports of German atrocities appeared in the press. First given visual expression by cartoonists, the theme was quickly taken up by English poster designers and remained a staple of British, and eventually American, propaganda for the remainder of the war. A pronounced sexual motif underlay accusations that not only treaties but also standards of common decency were being violated: posters showed women and girls as the victims of German aggression, being attacked, raped, mutilated, and killed. Accusations of assault on women by German soldiers reinforced and helped explain the German government's assault on international law—both were actions of a barbaric people who had invaded peaceful countries and now imposed their will on defenseless civilians.

Great Britain and the United States resorted to atrocity propaganda more frequently than did the French—not only to lend impetus to war loan sales but for enlistment purposes, a consideration that did not apply in countries with conscript armies. Occasionally French posters also employed atrocity themes, but in general they tended to treat the enemy impersonally or with ridicule. Atrocity posters very likely helped the Allied war effort; there can be no doubt that they had a strong impact in Germany.

Germans never learned to defend themselves effectively against the accusation of being Huns, in part because they found these attacks incomprehensible. They rarely adopted horror strategies in turn or accused the Allies themselves of atrocities. More frequent themes were Anglo-Saxon hypocrisy and Gallic fatuity; on the whole, however, images of the enemy did not play a major role in German posters of the First World War. It made a difference that—except for a few weeks at the beginning of the war—no part of the Reich was occupied by the enemy, and it is no accident that the first true German equivalents of Allied horror propaganda did not appear until the war was lost, when French soldiers—usually black colonial troops—were shown ravishing German women in the occupied Rhineland.

National Socialism, which was based on the myth of diabolically powerful sub-human groups—Jews, Communists, international bankers—prospered by positing enemies capable of every imaginable atrocity, including the eradication of the German race. Hitler and Goebbels were convinced that German propaganda in the First World War had been tame and inept, and saw to it that in the Second World War Germany used the atrocity theme with a virulence that outdid even the vulgar horrors of British and American posters between 1914 and 1918.

27. Remember Belgium.
U.S.A. 1918. Ellsworth Young.

Rape and carnage by German soldiers—the quintessential atrocity poster.

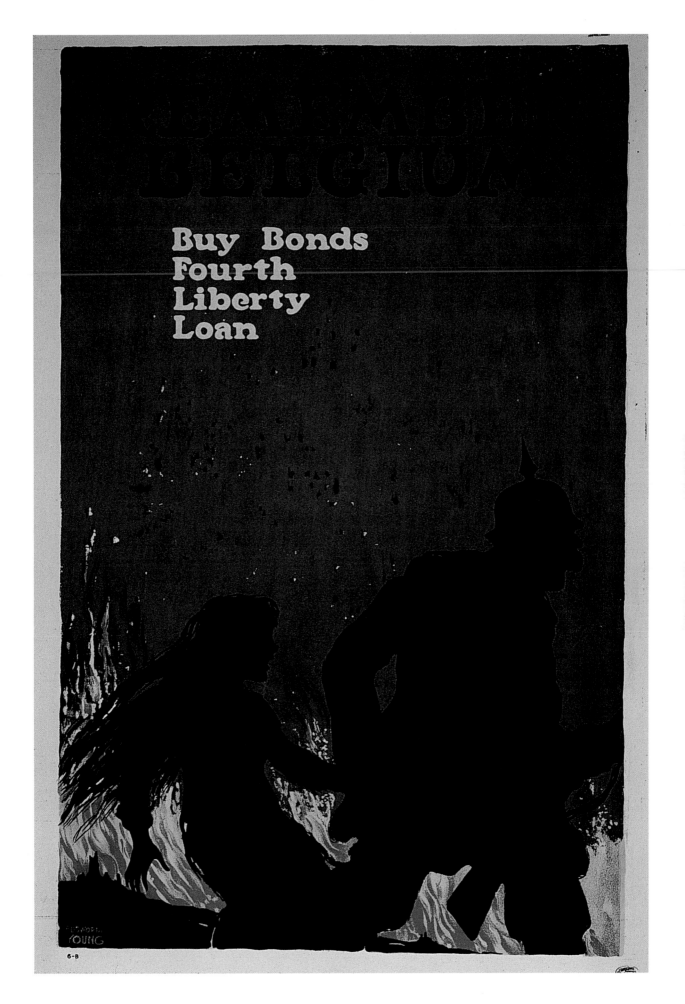

Buy Bonds
Fourth
Liberty
Loan

28. Red Cross or Iron Cross?
Great Britain. David Wilson.

Posters sometimes showed women as seductresses or spies (Poster 266), but this is one of the rare posters in either war in which a woman appears as vicious and inhuman.

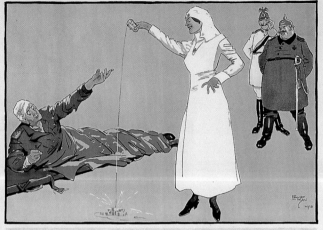

RED CROSS OR IRON CROSS?

WOUNDED AND A PRISONER
OUR SOLDIER CRIES FOR WATER.
THE GERMAN "SISTER"
POURS IT ON THE GROUND BEFORE HIS EYES.
THERE IS NO WOMAN IN BRITAIN
WHO WOULD DO IT.
THERE IS NO WOMAN IN BRITAIN
WHO WILL FORGET IT.

29. Men of Britain! Will you stand this?
Great Britain. 1915.

In December 1914, German naval units shelled British coastal defenses in Scarborough on the Yorkshire coast, killing or wounding many inhabitants. The raid shocked British public opinion, but was a military and political failure for the Germans. It caused the British navy to improve its defenses and added impetus to the atrocity campaign against Germany.

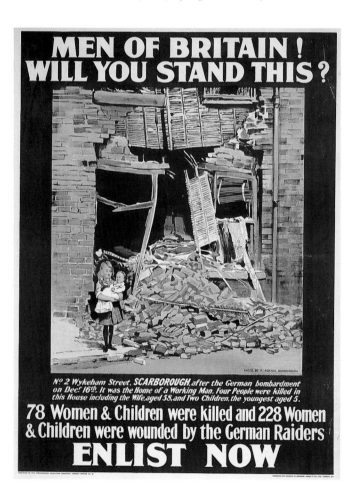

MEN OF BRITAIN!
WILL YOU STAND THIS?

Nº 2 Wykeham Street, SCARBOROUGH, after the German bombardment on Decʳ 16ᵗʰ. It was the Home of a Working Man. Four People were killed in this House including the Wife, aged 58, and Two Children, the youngest aged 5.

78 Women & Children were killed and 228 Women & Children were wounded by the German Raiders
ENLIST NOW

30. To prevent this—buy War Savings Certificates now.
Great Britain. 1918. F. Gregory Brown.

By 1918 the German army had long discarded the spiked helmet, but posters continued to use it throughout the war as an effective anti-German symbol. Here the helmets are worn by soldiers guarding and mistreating slave laborers in a factory.

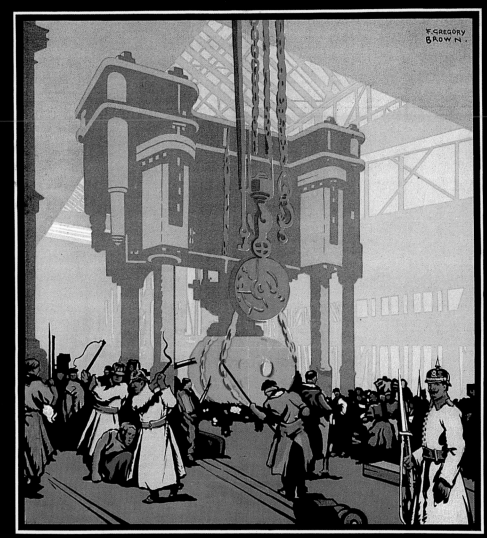

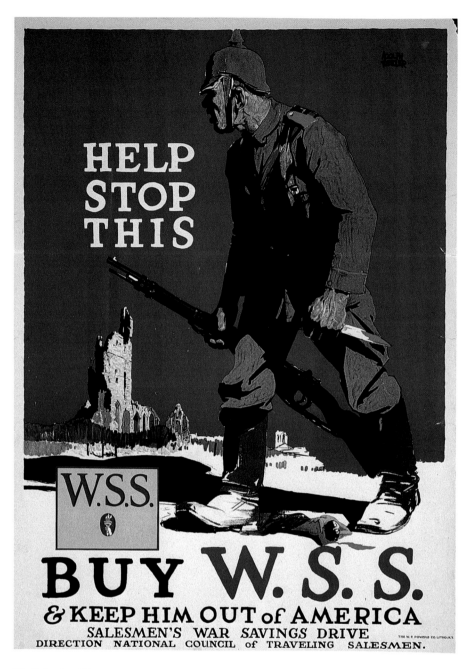

31. Help stop this.
U.S.A. 1918. Adolph Treidler.

A variant of Poster 27.

32. Destroy this mad brute.
U.S.A. c.1917. H. R. Hopps.

The old-fashioned, circus-poster character of the design combines strangely with its ideological message. However effective it may have been in motivating young men to enlist, its image certainly made a long-lasting impression on some Germans; it was to be used again, this time by Nazi propagandists, at the beginning of the Second World War (Poster 204).

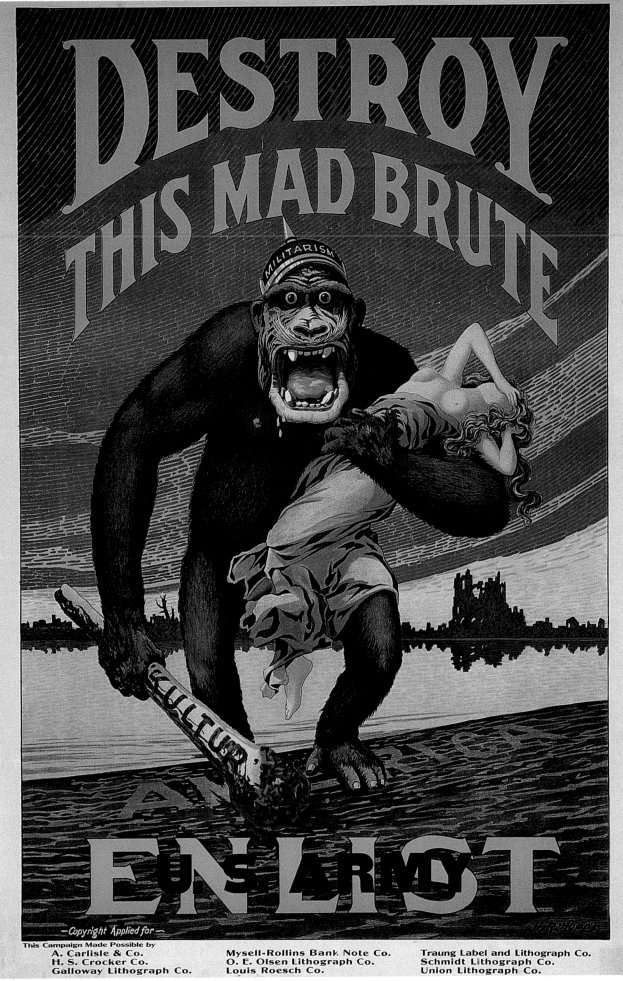

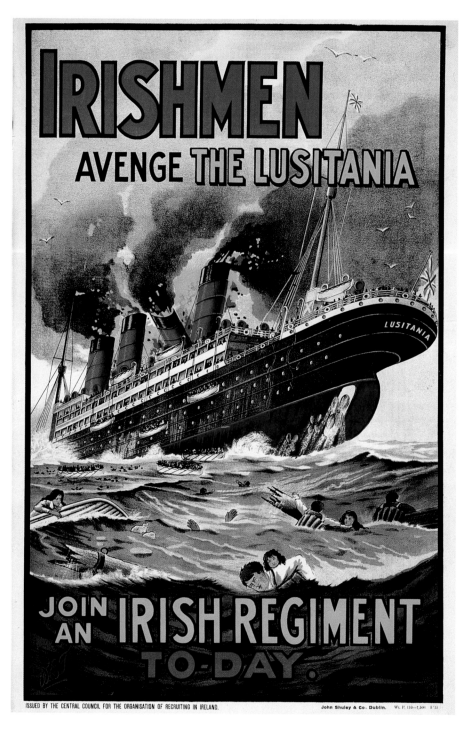

33. Irishmen avenge the Lusitania.
Great Britain. 1915. W.E.T.

34. Enlist.
U.S.A. 1915. Fred Spear.

35. The freedom of the sea.
Great Britain. c.1915. Wilnot Lunt & W.F.B.

After the invasion of Belgium, the torpedoing of the Lusitania was the second most powerful incident utilized in anti-German propaganda. Spear's painting of a mother and her baby sinking to the bottom of the sea combines salon art with symbolist elements; it is at once cloyingly sentimental and evocative. It was published in a small edition, and at first had little impact. But over the years it has become one of the best known American posters of the First World War. Posters 33 and 35 are couched in more primitive aesthetic idioms. The four Germans who threaten the freedom of the seas in Poster 35 represent the Kaiser, Admiral Tirpitz, the Crown Prince, and an officer who combines the features of Hindenburg and Ludendorff.

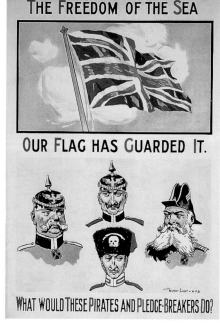

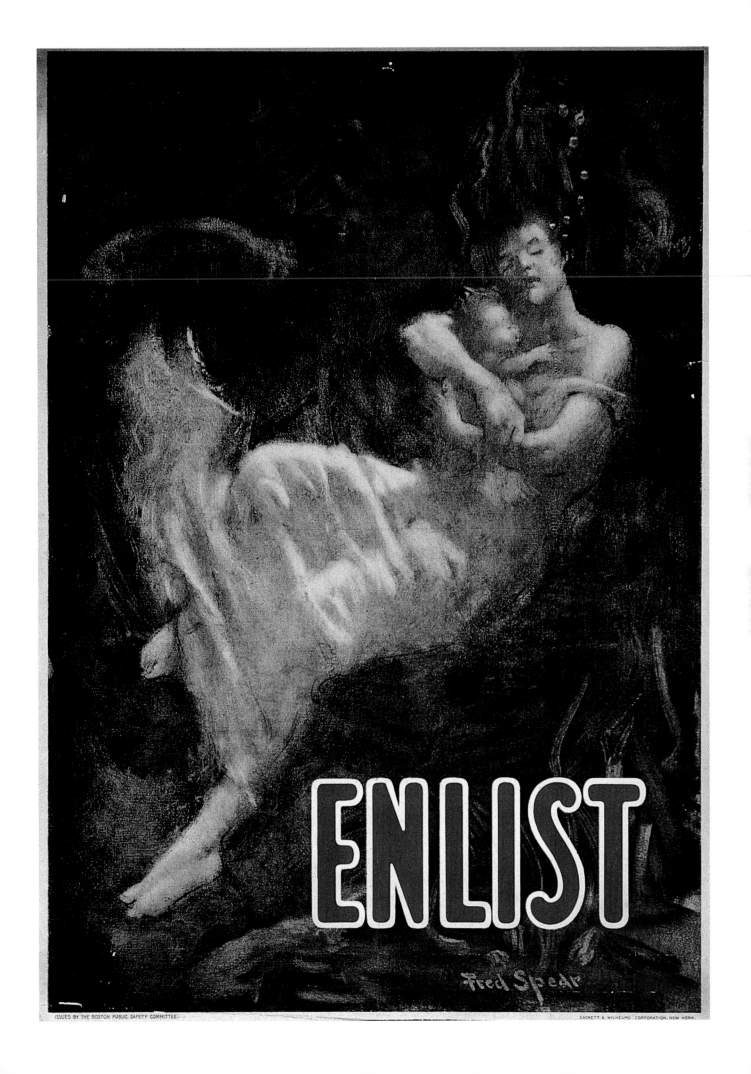

ENLIST

Fred Spear

ISSUED BY THE BOSTON PUBLIC SAFETY COMMITTEE.

SACKETT & WILHELMS CORPORATION, NEW YORK.

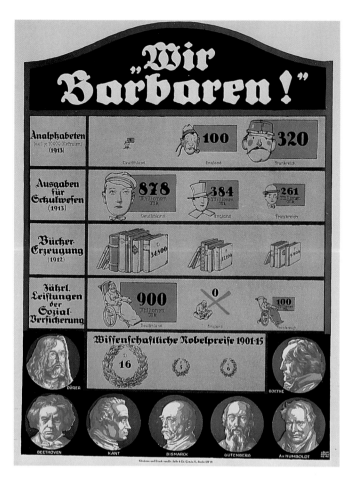

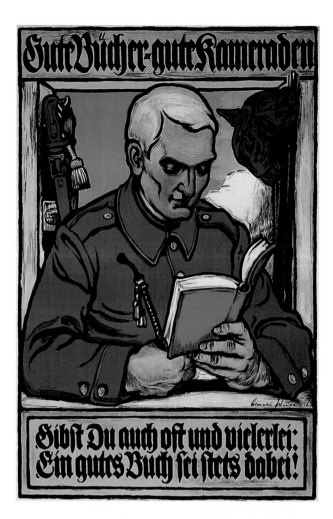

36. "We barbarians!"
Germany. 1916. Louis Oppenheim.

Germany has fewer illiterates, spends more on education, prints more books, has a better social security system, and its scientists have won more Nobel prizes than those of Great Britain and France. By opposing the accusation of barbarism with such a list of cultural achievements, this poster, which combines high seriousness with a tepid design, suggested to the German public that Allied propaganda and Allied policy in general were unjust. This poster is an example of the factual approach that Hitler and Goebbels derided as soft and ineffectual.

37. Good books—good comrades.
Germany. 1916. Arnold Weise.

38. Remember our good men in gray. Christmas 1915.
Germany. 1915. C. Schmidt.

39. Four rest homes behind the front for soldiers from Bremen.
Germany. c.1915. Magda Koll.

These three posters were not a direct response to the Allied assertion of German barbarism, but they did convey the image German society had of its soldiers, or believed it should have had. The appeals to buy books for men at the front, to send them Christmas parcels, and to contribute to their rest and recuperation programs demonstrated a firm bond between front and homeland. In a time of national crisis, so the message has it, human values persist.

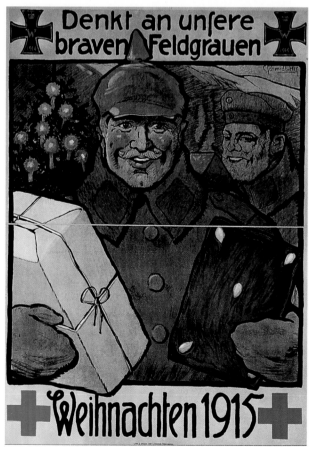

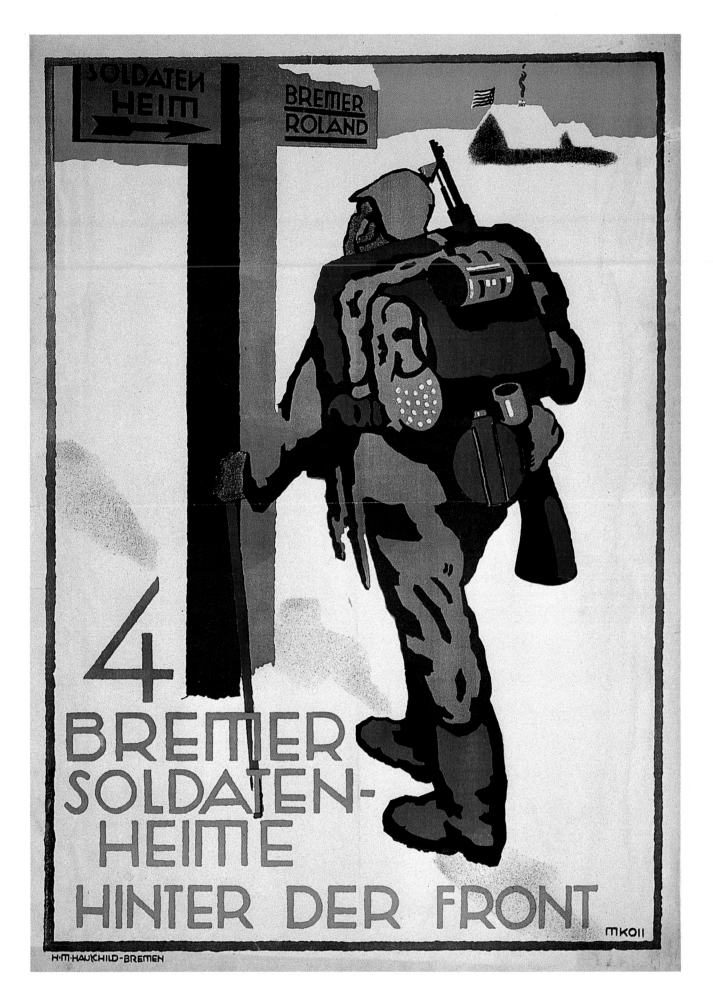

3.

Combat

As the war went on, posters increasingly depicted combat. It is hardly surprising that they did so almost entirely from a civilian perspective. Many posters, especially on the Allied side, treated combat symbolically, as a setting for such national symbols as patron saints, heraldic beasts, or female representations of the nation such as Marianne or Columbia storming forward to victory. It was easier, and at least in the early years less disturbing to the public, to glorify the idea of combat than to show its reality. As the war went on, more realistic treatments of the fighting crept into posters, some indication of the real rather than glorified violence and destructiveness, reminding the public of its patriotic duty and demonstrating that the hardships of life at home could not compare with the conditions under which one's soldiers fought and too often died.

It was rare, however, for a poster to succeed in its aim at realism. Nearly all posters were designed by men or women who lacked personal experience of war, and even those who were sent to a theater of operations as war artists went only for brief periods as observers and stayed mainly in rear areas. The most basic fact that soldiers had to face about war at the western front—exposure to terrible living conditions and to extreme danger not for a few days but over long periods of time—remained unknown to them. The reality of war in the trenches was, in any case, so overwhelming that even those with pronounced creative talents who did experience it needed time to give the experience an appropriate aesthetic expression. With few exceptions—the works of Max Beckmann in Germany and of C. R. W. Nevenson in England come to mind—the most powerful war art dated from the years after the war. Posters, a medium in which the feelings of the designer had to be subordinated, or at least accommodated, to the official message, could hardly aspire to achieve a truth that had escaped most paintings and graphics at the time.

Posters using themes of combat tended generally to remain on the surface of their subject, and yet some did manage to convey a portion of the truth. Inspiration and an ability to identify with men existing in extreme danger helped a few poster designers to convey something of reality—what a trench looked like, the effect of shelling on a village or clump of trees, wounded and even dead soldiers, and, perhaps most impressive and disturbing, the impact of the war on those who, for the moment, still survived.

40. For the flag! For victory!
France. 1917. Georges Scott.

The poster idealizes combat as a patriotic ceremony. The mythic figure of Marianne, with Gallic headgear, sword, and belt-buckle, waving a tattered tricolor in front of banked rows of flag-bearers and drummers, exhorts the French public to do its duty and buy war bonds.

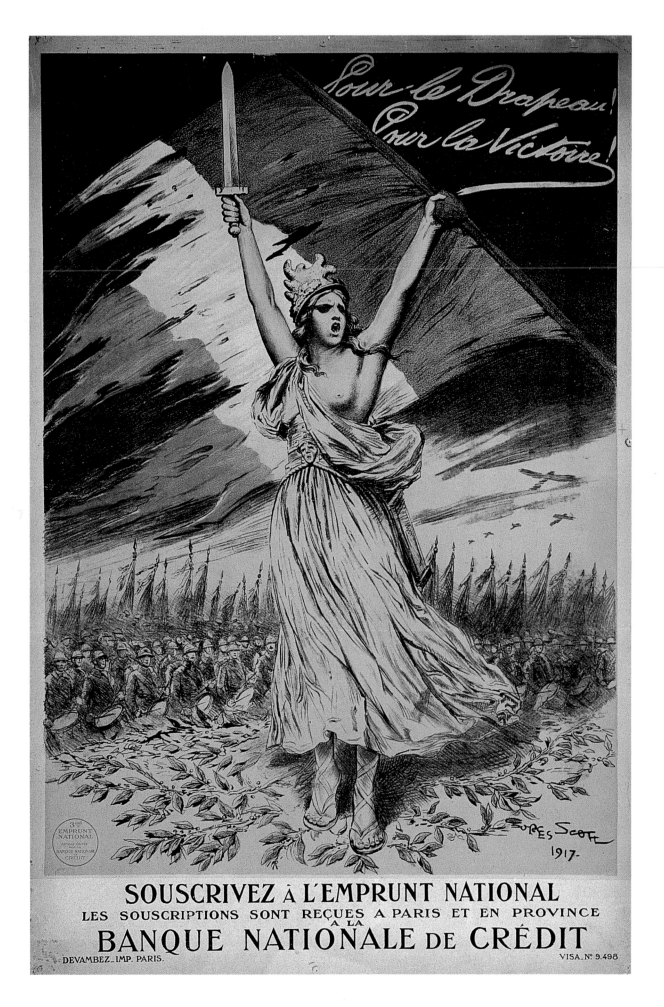

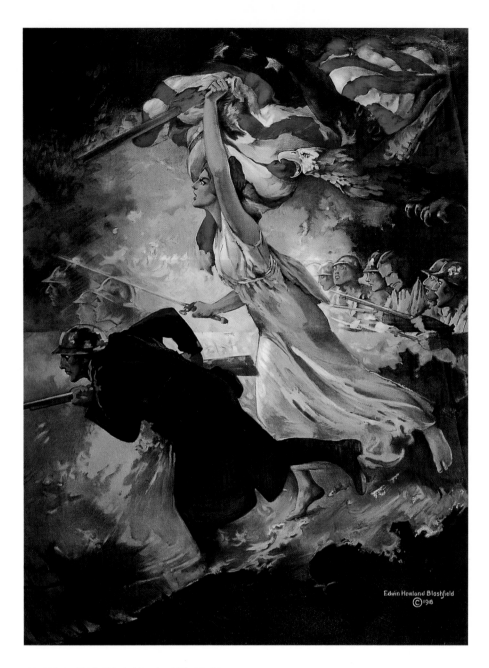

41. U.S.A. 1918. Edwin Howland Blashfield.

An American variant of the previous poster; the artist has not moved far from his French model. The helmets of his soldiers are closer to the French than to the American design, and the female figure leading soldiers to battle wears a red Phrygian cap, a symbol of the French Revolution.

42. Subscribe to the 5 1/2% war loan.
Russia. 1916. Vassily Vereshchagin.

In contrast to the first two posters, the others in this section attempt with varying degrees of success to treat the war in a more realistic manner. In this poster by the well-known historical painter Vereshchagin, four Russian infantrymen behind a snow bank are firing at the enemy.

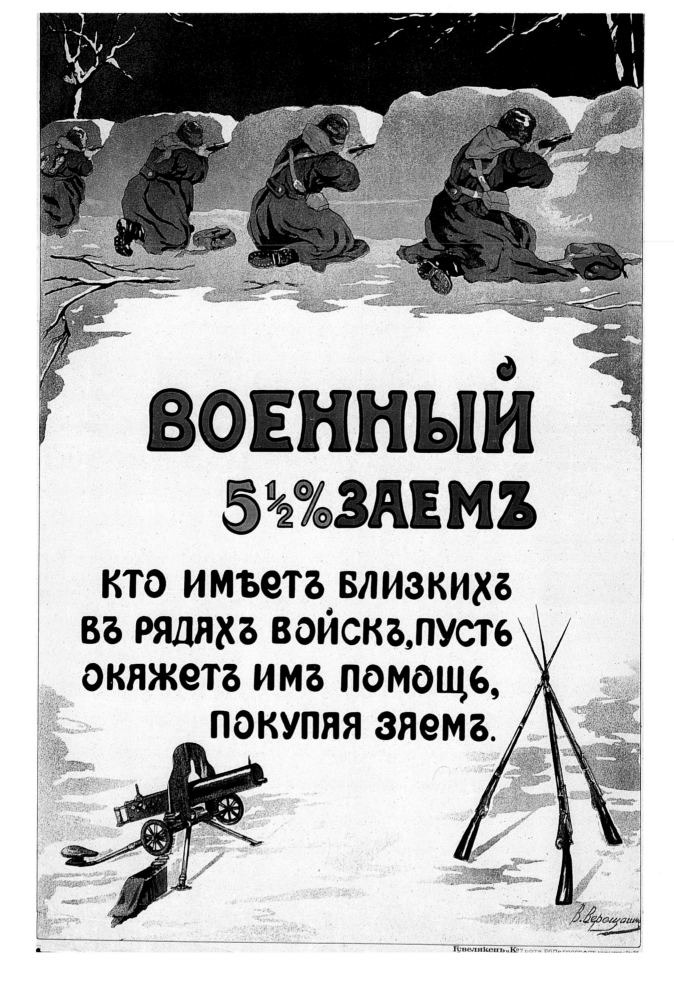

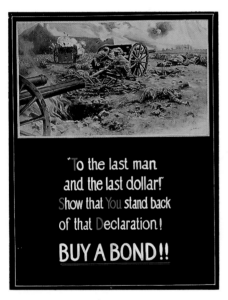

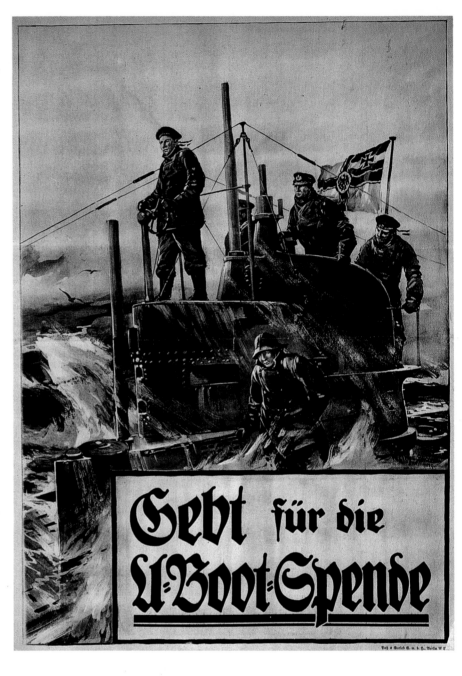

43. "To the last man and the last dollar!"
U.S.A. 1917–18. S. Begg.

*This American war-loan poster made use of a
British painting that emphasized the cost of
combat, but did so with an old-fashioned scene
that had little relevance to the Western front;
duels between unprotected field guns firing at
point-blank range might have occurred at the
very beginning of the war, but not by this date.*

44. Give to the submarine fund.
Germany. 1917. Willy Stöwer.

*The painting, a late example of nineteenth-
century German historical art by an artist
whose work was admired by the Kaiser, man-
ages to convey something of the isolation and
bleakness of a submarine patrol in foul
weather.*

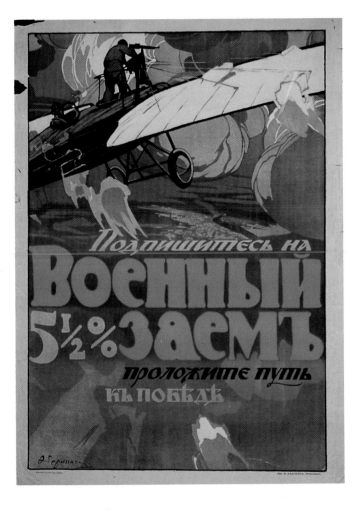

45. Subscribe to the 5 1/2% war loan and pave the way to victory.
Russia. 1916. Ernst Gerling.

The aircraft in this poster is not Russian. The design is based on a photograph of a French Deperdussin monoplane that was frequently reproduced in magazines before the war.

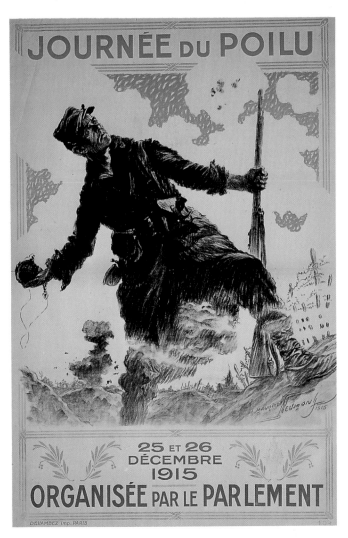

46. Day of the infantryman.
France. 1915. Maurice Neumont.

Poilu—"shaggy" or "hairy"—quickly became the term commonly used for the French soldier at the front. The German equivalent, sounding the same affectionately realistic note, was Frontschwein—"pig at the front" or "pig in the trenches." Here a poilu, about to throw a grenade, towers over the viewer like a modern idol. He is too obviously a posed figure, but the poster did not pretend that trench warfare was either a pleasant or a glorious activity.

47. At Neuve Chapelle your friends need you. Be a man.
Great Britain. c.1915. Frank Brangwyn.

One of several lithographs by Brangwyn that struck the British public as daringly realistic. Its realism has, however, less to do with combat, which Brangwyn's posed and gesturing figures fail to portray convincingly, than with the discomfort and squalor of life in the trenches.

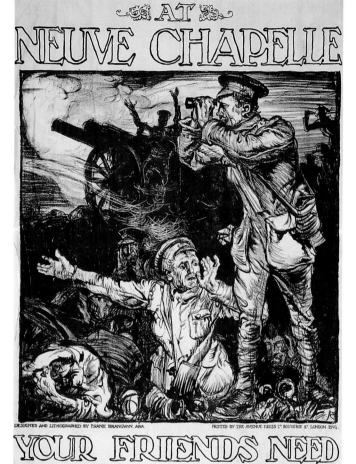

48. His Liberty Bond paid for in full.
U.S.A. 1917. William Allen Rogers.

The life that the soldier "gave" to his country has one more use: To admonish the passerby to give money to finance the war.

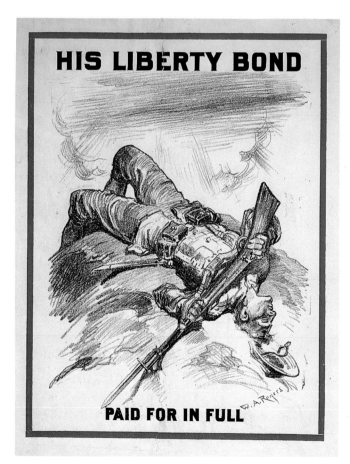

49. Second Red Cross War Fund.
U.S.A. c.1918. McClelland Barclay.

Symbolism and realism are completely integrated in this strong design. The bodies of the wounded man and of the man who carries him form a red cross that extends into a crucifix which seems to project out of the poster, bringing the agony of war to the viewer.

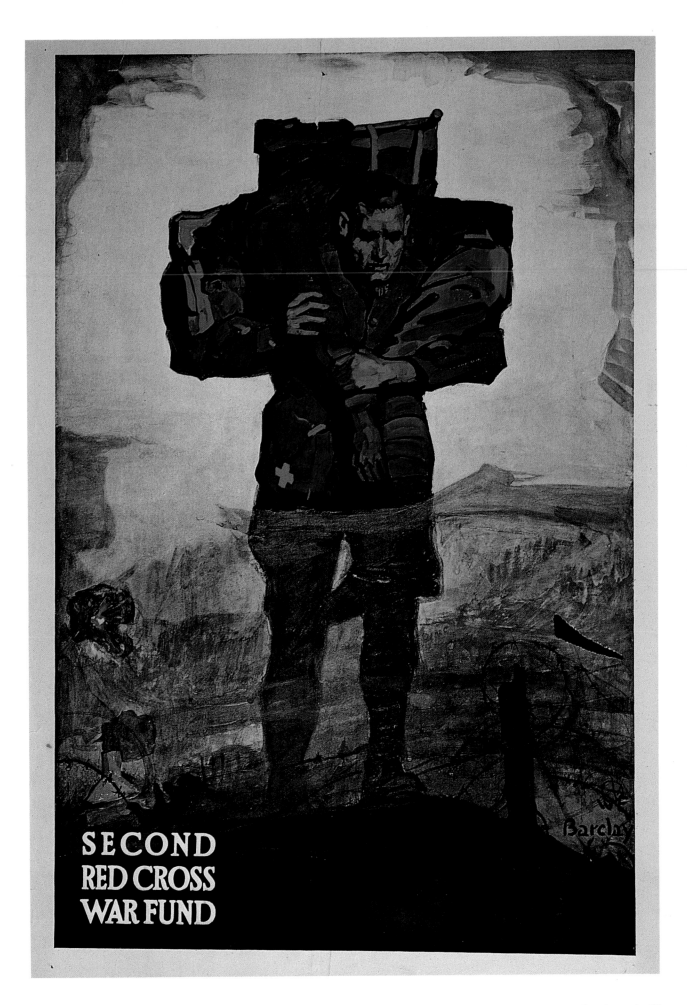

SECOND
RED CROSS
WAR FUND

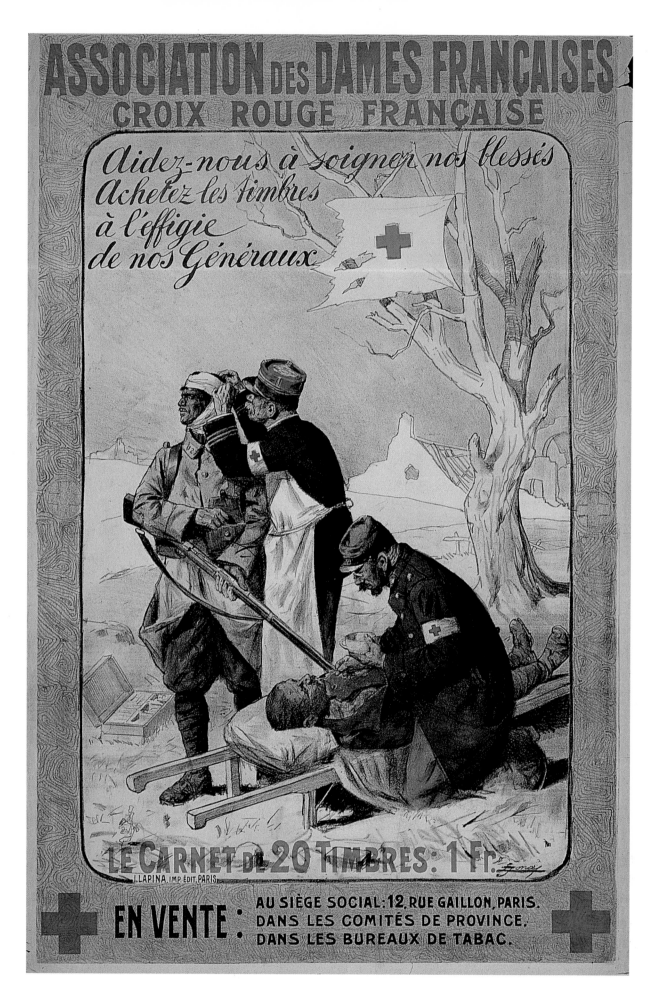

50. Help us to care for our wounded.
France. Lucien Jonas.

The relative realism of this scene of a first-aid station is spoiled by the cheap rhetoric of the infantryman who, as his head is still being bandaged, reaches into his cartridge pouch, ready to return to battle.

51. Serbia Day, 25 June 1916.
France. 1916. Théophile-Alexandre Steinlen.

Between October and December of 1915, an Austro-Hungarian offensive, supported by German and Bulgarian troops, occupied Serbia. Steinlen's sketch, which conveys something of the sadness people experience when they are torn from their homes, appealed for help for Serbian refugees who crossed into Albania.

52. For the last quarter hour, help me!
France. 1918. Sem (Serge Goursat).

This poster offers a different view of war—heavily loaded French infantry march past General Foch over shell-pitted ground won from the retreating German army. The elegant vigor and neatness of the hurrying figures are barely compromised by a few touches of surface realism.

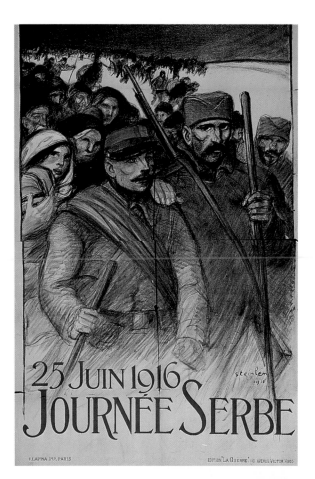

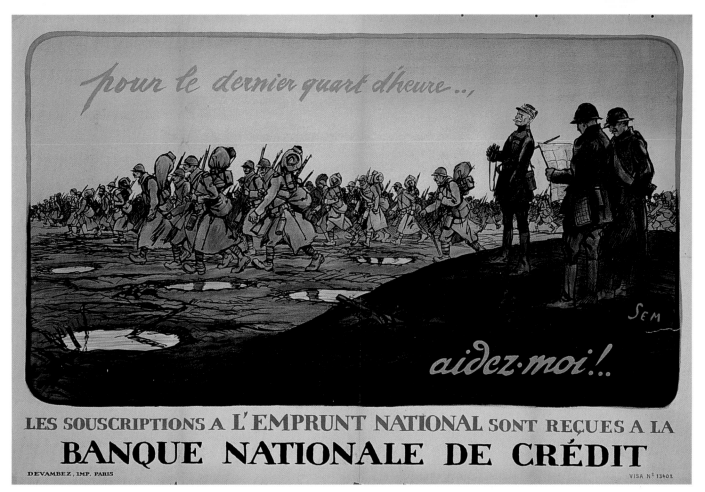

4.

Self-Images

The use designers made of scenes of combat led to images of soldiers meant to symbolize the highest values of one's society. Images were created that were often superficial, but at times revealed a more rigorous effort at self-interpretation. Posters that hewed closely to official rhetoric had little to contribute to this search. At most, their patriotic legends and the ways these differed from the myths of other societies offer some insights into the nature of political ideology and its function in the relationship between government and governed.

Posters whose designers refused to follow a superficial model and who took the task of interpretation seriously are more enlightening. Though they did not cross the limits of the acceptable, and were themselves influenced by the values and indoctrination of their societies, some at least tried to think through issues and come to conclusions that transcended slogans and clichés. If posters in every country attributed bravery and determination to their fighting men, differences in treatment nevertheless emerged. French posters often emphasized traits that for generations had been part of the French self-image: individualism, quickness, enthusiasm, esprit. The best blended such timeless attributes with new challenges posed by modern, industrialized war. German posters preferred to strike a more somber note, even as early as 1914. Although German soldiers fought on foreign territory for the entire war, with a few exceptions in the early months, it was only in the rarest of circumstances that German posters presented them as conquerors. Instead, they were shown as guardians who held back the almost overwhelmingly powerful enemies that surrounded their country.

As the war continued and it became less likely that the Central Powers could break the strategic stalemate, these differences increased. In the later years of the conflict, German and Austrian posters often added a note of sadness, even tragedy, to the determined expression on the faces of their soldiers. This was hardly the result of a conscious shift in propaganda policy, but rather a response to the chang- ing atmosphere. The years of effort and suffering were also reflected in the posters of other nations. Only American posters still retained self-images of demonstrative, even boastful, self-confidence—not an inexplicable stance for a society that in comparison to Europe was only slightly touched by the war.

53. We'll get them!
France. 1916. Jules Abel Faivre.

One of the most famous French posters of the First World War expresses in contemporary terms pride and confidence in the traditional combative spirit of the French soldier.

On les aura !

2ᴱ **EMPRUNT**
DE
LA DÉFENSE NATIONALE

Souscrivez

DEVAMBEZ IMP. PARIS

Fate tutti
il vostro dovere!

LE SOTTOSCRIZIONI AL **PRESTITO** SI RICEVONO PRESSO IL

CREDITO ITALIANO

G. MODIANO & C. - MILANO

54. Do your duty!

Italy. c.1917. Achille Luciano Mauzan.

This Italian variation of the common motif of a figure looking straight at the viewer, his finger pointing or beckoning, was in its many versions the most widely distributed of all Italian war posters. Perhaps because the artist, though living in Italy, was not himself Italian and was thus something of an outsider, the strength of its message does not match that of Poster 53. It is all rhetoric, without historical tradition or psychological substance, an official insistence on people's heroism and discipline, as demanding as the soldier's gesture.

СПѢШИТЕ
КУПИТЬ!

ВОЕННЫЙ 5½% ЗАЕМЪ

ЧТОБЫ ПРЕОДОЛѢТЬ
ВРАГА.

55. Hurry and buy the 5 1/2% war loan.
Russia. 1916. G. Semenov.

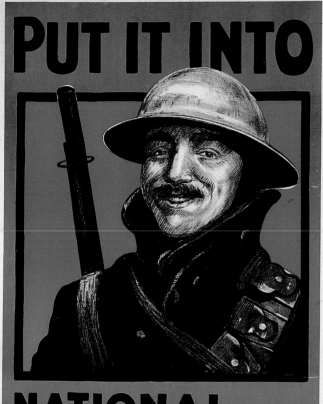

PUT IT INTO NATIONAL WAR BONDS

POSTER N° 515. ISSUED BY THE NATIONAL WAR SAVINGS COMMITTEE SALISBURY SQUARE, E.C.4. (384) 5,000 V⁄₅. H.H. L⁰ E.2500.

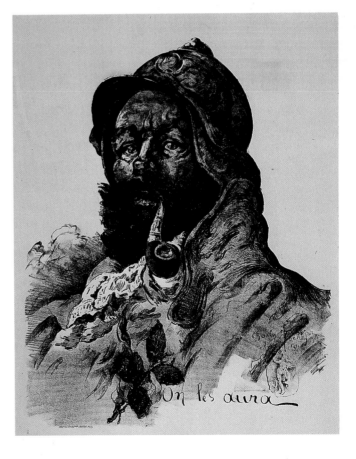

57. We'll get them.
France. 1916. Charles Toche.

These three posters base their call for financial and moral support on the courage, steadfastness, and—in the case of the British Tommy—cheerfulness of the common soldier.

58. Help us win!
Germany. 1917. Fritz Erler.

In probably the most widely distributed German poster of the war, an infantryman, with the steel helmet introduced in 1916, a gas mask on his chest, and two "potato masher" grenades in his pouch, looks out between cut barbed wire into the unknown. The barbed wire suggests a crown of thorns, but also the fortress mentality deeply ingrained in Germany at the time: the country is surrounded by enemies and is fighting a defensive war to break out of the encirclement. The mystical determination emanating from the soldier's shining eyes established a motif that German political and war posters were to take up repeatedly until 1945.

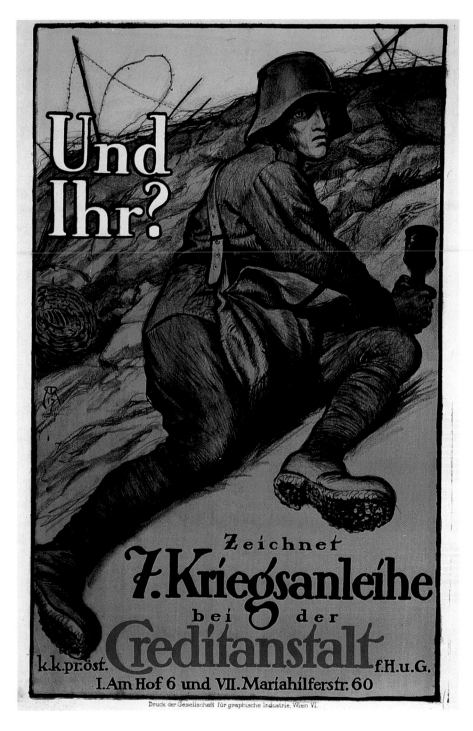

59. And you?
Austria. 1917. Alfred Roller.

Austrian posters increasingly made use of symbols of peace—white doves, goddesses with palm fronds or cornucopias—and of realistic battle scenes. The wary infantryman, crouching in a trench, grenade at the ready, is a depressed if still unyielding relative of Germany's steadfast guardian in Erler's poster.

60. And you?
Germany. Fritz Erler.

In a variation of Erler's great poster of 1917 the air force machine gunner is wounded, but is not prepared to give up the fight.

61. Subscribe to the 8th Austrian war loan.
Austria. 1918. W. Kühn.

Oak leaves—symbols of heroism and victory— decorate the flag bearer's cap and staff, but his face expresses neither triumph nor much confidence. He could as well belong to a retreating army; the image conveys an overwhelming sense of gravity and sadness.

62. As dawn breaks, the soldier standing in the trench dreams of victory and home.
France. c.1917. Jean Droit.

The soldier's quiet determination and self-confidence are the counterpart of his comrade on the attack in Poster 53.

DEBOUT DANS LA TRANCHÉE QUE L'AURORE ÉCLAIRE, LE SOLDAT RÊVE À LA VICTOIRE ET À SON FOYER. POUR QU'IL PUISSE ASSURER L'UNE ET RETROUVER L'AUTRE, SOUSCRIVEZ AU 3ᵉ EMPRUNT DE LA DÉFENSE NATIONALE

63. Come on!
U.S.A. 1918. Walter Whitehead.

A dead German, the obligatory and long abandoned spiked helmet by his side, lies on the ground. An American soldier, his leg grazed, his helmet dented, steps over the corpse, ready to take on the next enemy. The difference in the emotional message sent by the bellicose American soldier and by the poilus in Posters 62 and 64 is a clue to the experiences of the two countries in the war and to their diverging policies afterwards.

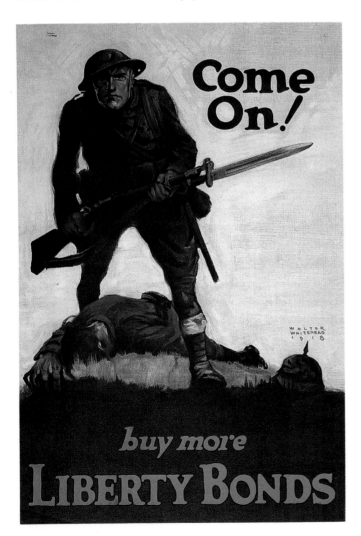

64. They shall not pass!
France. 1918. Maurice Neumont.

This image, designed in 1917, was not issued until the German spring offensive of 1918 had been halted. It warns the French public against German peace feelers. The poilu, who has again stopped the Germans on the Marne as he had in 1914, is by now an almost inhuman figure. He has become a part of the debris of war around his feet and of the French soil out of which he grows and to which he may return at any moment.

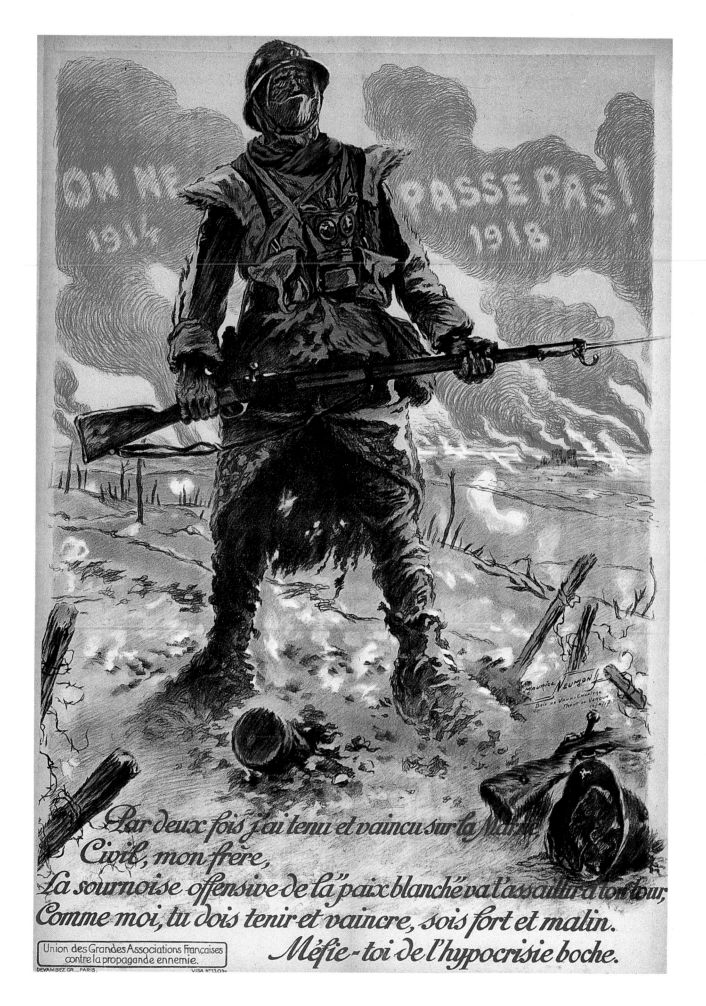

5.

Appeals to Serve

The heroic image of masculinity—from stoic cheerfulness to somber determination—was an essential ingredient in the posters of all the warring powers, but the identification of virility with war was most explicit in countries that relied on volunteers. Both in Britain, in the first year and a half, and the United States, posters appealed to idealized masculine traits as men were urged to show their sportsmanship in the greatest game in the world, to fight for the honor of their women, and to demonstrate their toughness in the ultimate test of courage. Those who did not march off to war with their peers, the posters implied, were not only cowardly, but also impotent. From medieval knights in hand-to-hand combat with the powers of evil to brawny youths firing machine guns, the posters displayed a vision of individual masculine heroism that rose above the unspoken dehumanization and degradation of trench warfare.

The posters' "mobilization by shame" was most often conveyed through images of women. Women as symbols of the nation beckoned young men to follow their call; young women seduced or taunted men to prove their manliness; women and children expected to be protected. This transformation of woman from the traditional ideal of domestic angel, dedicated to caring for her family, into the motherly authority or the sexually enticing goddess demanding that men sacrifice themselves suggests the large shifts in gender roles that took place during the war.

The demands of the long, drawn-out war gave women everywhere new opportunities. Not only did an increasing number enter industry and construction, accelerating a process that had begun before the war, but women also served as volunteers in auxiliary military units on both the eastern and western fronts by the last years of the war. Although leaders of the pre-war women's movements helped organize and promote these services, the contribution of women to the war effort did not result in fundamental changes in their position after the war. As men were demobilized, women were required to give up their jobs and return to the home. Nevertheless, their presence in new sectors of the work force and the officially sanctioned portrayal of working women in the recruiting posters of the war years established new images and new expectations of women that enlarged and challenged the pre-war ideals of femininity.

66. Britain needs you at once.
Great Britain. 1915.

Saint George vanquishing the enemy dragon was a recurrent symbolic image of the nation in posters of all the belligerents. This tightly structured and static heraldic design contrasts with detailed Russian narrative presentations (Posters 14 and 142).

65. Take up the sword of justice. Join now.
Great Britain. 1915.

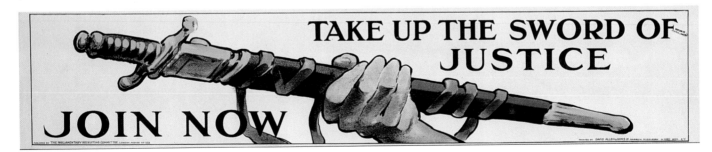

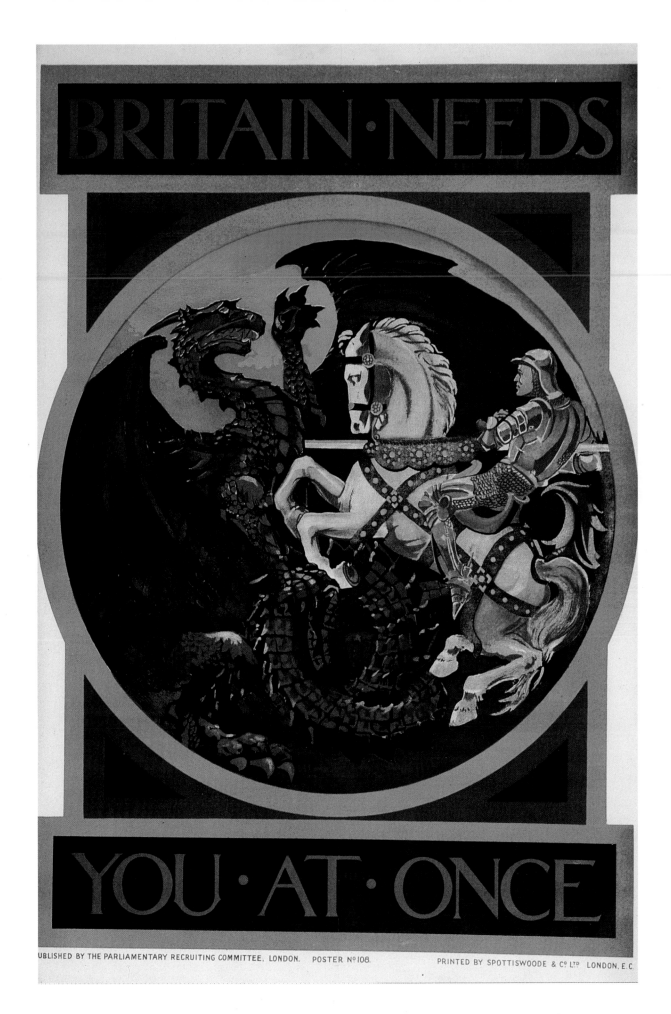

BRITAIN · NEEDS

YOU · AT · ONCE

UBLISHED BY THE PARLIAMENTARY RECRUITING COMMITTEE, LONDON. POSTER Nº108. PRINTED BY SPOTTISWOODE & Cº LTD LONDON, E.C.

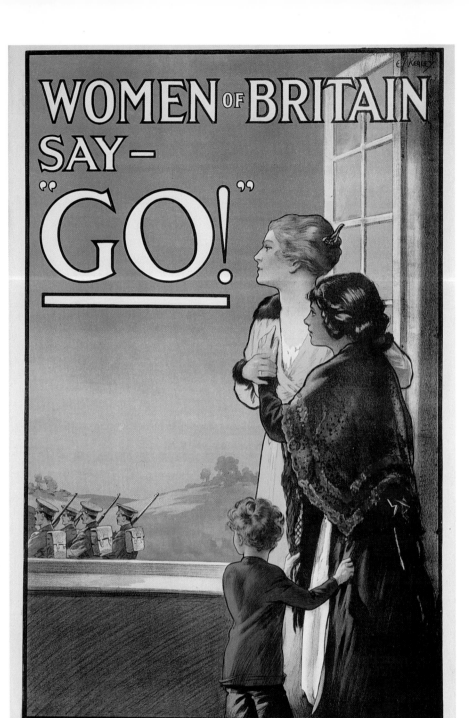

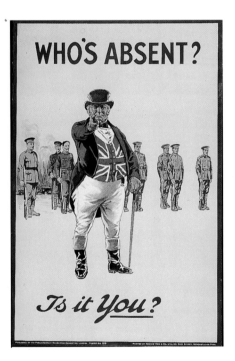

67. Who's absent? Is it you?
Great Britain. 1915.

*Published before conscription was introduced,
John Bull's imperious gesture, like the pointing
finger in the famous Lord Kitchener poster,
played on men's feelings of guilt and shame.
Aesthetically weak, the poster is characteristic
of the many British posters created by printers
not artists. This one trivializes men into stiff toy
soldiers and was unlikely to have inspired a
positive response.*

68. Women of Britain say—"Go!"
Great Britain. 1915. E. Kealey.

*With the simple framing device of the window,
Kealey captured the division of the world into a
private sphere of soft, clinging women and the
public sphere of active, disciplined men delin-
eated with hard sharp lines. The double mes-
sage of the text—directed simultaneously at
women and by women at their men—manipu-
lated the image of mother, wife, and child
within the home into a noble motivation for en-
listing, but also assigned women the responsibil-
ity for ordering men into war.*

69. An appeal to you.
Great Britain. 1915.

This British poster is unusual in its use of so-phisticated techniques drawn from the prewar period. The low angle of vision, the decorative cloud pattern, the jagged silhouettes of marching men contrast oddly with the detailed treatment of the soldier's uniform and produce a disquieting, even sinister, meaning to the beckoning finger that entices rather than commands.

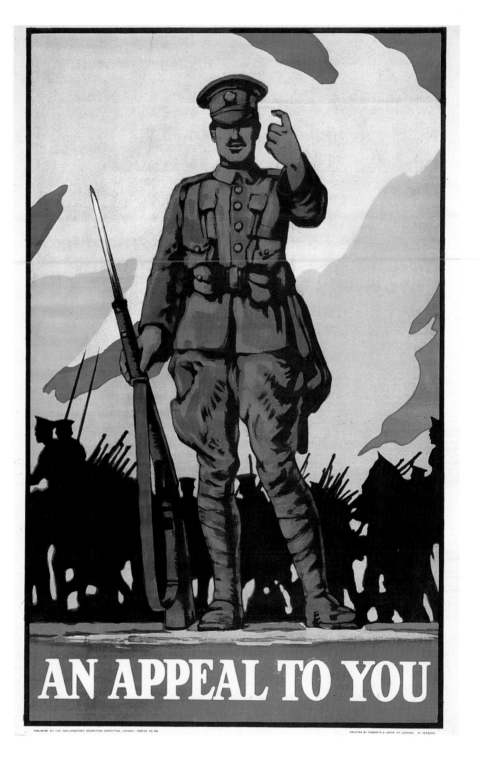

AN APPEAL TO YOU

70. Join the brave throng that goes marching along.
Great Britain. 1915. Gerald Wood.

The appeal to sportsmanship was deeply rooted in Britain where recruiters frequently translated the ideals and traditions of games into a grand battle of football battalions whose team effort would beat the Germans.

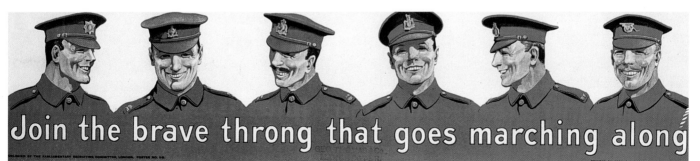

Join the brave throng that goes marching along

71. "The sword is drawn. The Navy upholds it!"
U.S.A. c.1917. Kenyon Cox.

72. It's up to you. Protect the nation's honor.
U.S.A. c.1917. Schneck.

*A stern national goddess, Columbia, calls men to take up the sword of jus-
tice to avenge civilian lives lost on the sea, as the ship steaming on the
horizon reminds the viewer. The high-mindedness of the Navy recruiting
poster's identification of national honor with female honor is subverted in
the other poster by the blatant sexual imagery of war as retribution for the
rape of Columbia—a potent motivation for manly action promoted in the
language of Hollywood.*

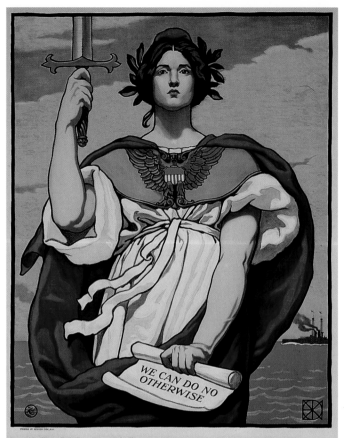

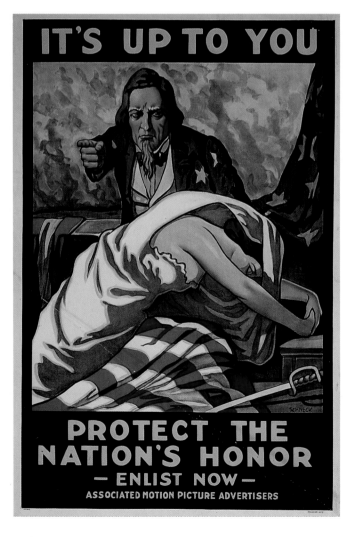

73. It takes a man to fill it.
U.S.A. 1918. Charles Stafford Duncan.

*This strong design continues the concentration
on essentials of the best pre-war posters by
combining a simple image with a brief text into
the definition of military service as a proof of
virility.*

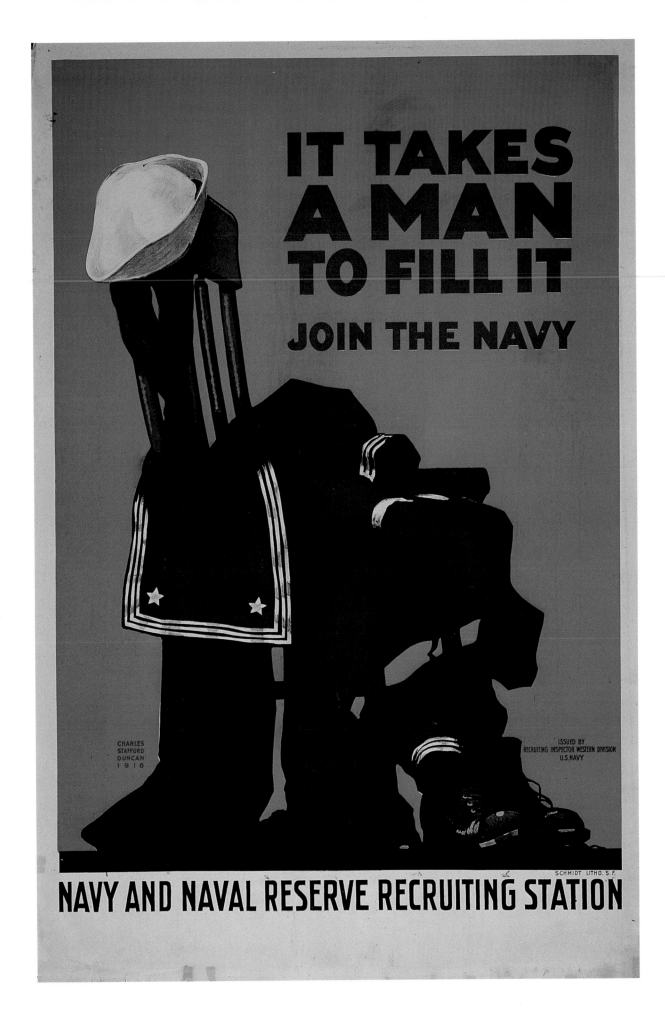

74. I want you for the Navy.
U.S.A. 1917. Howard Chandler Christy.

Sexual provocation was the essence of the "Christy girl" recruiting posters, which were popular even though critics found them silly and lacking in dignity.

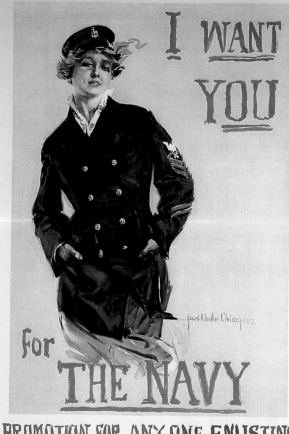

75. Enlist. On which side of the window are you?
U.S.A. 1917. Laura Brey.

Depicting private space as feminine and public space as masculine, this appeal to enlist exploits men's anxiety over their masculinity by suggesting the effeminacy of the man who does not enlist. As in the earlier British design (Poster 68), the window—a poster within the poster—separates the bright male world of waving flags and marching columns from the darkened interior feminine space.

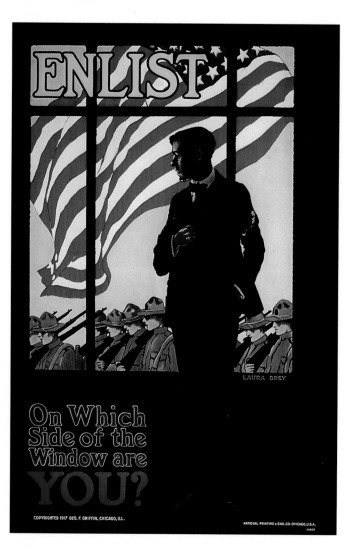

76. Treat 'em rough! Join the tanks.
U.S.A. 1918. August Hutaf.

In this improbable vision of tank warfare, the flaming colors, the Black Tomcat mascot with its vicious claws, and the motto of the U.S. Tank Corps project an image of explosive sexual energy.

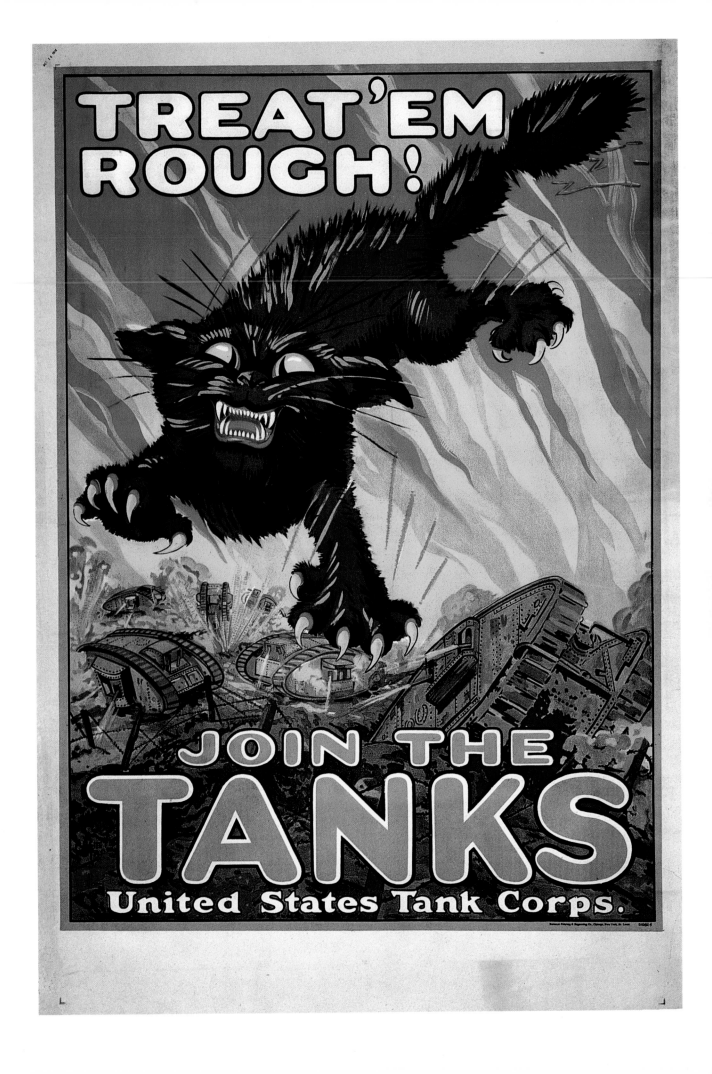

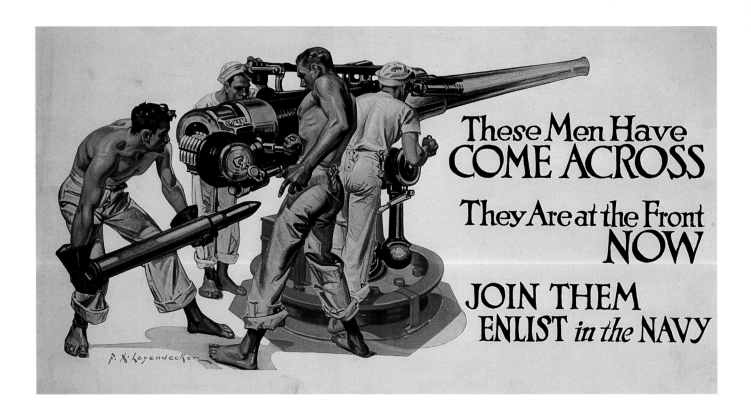

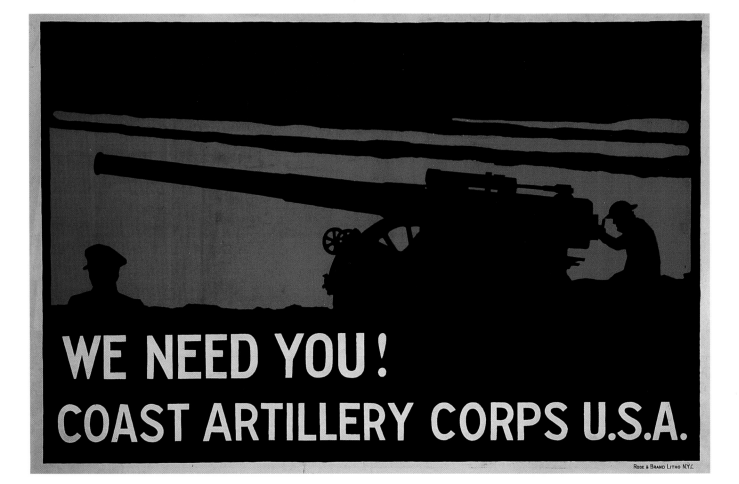

77. These men have come across. They are at the front now.
U.S.A. c.1917. Francis Xavier Leyendecker.

The four muscular sailors exemplify glamorized models of American masculinity that is visually integrated with the phallic imagery of the ammunition and gun.

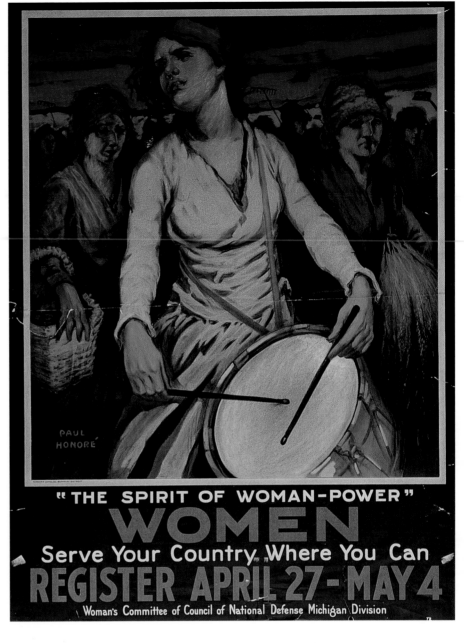

78. We need you!
U.S.A. c.1917.

This pensive image of an artillery piece at sunset, impressive in its simplicity and strength, is disturbing in its aestheticizing of a weapon of destruction. With the lines of the barrel repeating the cloud formation, the canon is transformed into a magnificent natural phenomenon. The process of abstracting death into beauty reached its height in mid-century posters of the nuclear bomb (Poster 304).

79. "The spirit of woman-power." Women, serve your country where you can.
U.S.A. c.1917. Paul Honoré.

The hasty action of women's organizations in April 1917 to promote the U.S. war effort was demonstrated in this early recruiting poster that quickly adapted an anachronistic, if spirited, academic painting of peasant women in the French Revolution to inspire modern American women.

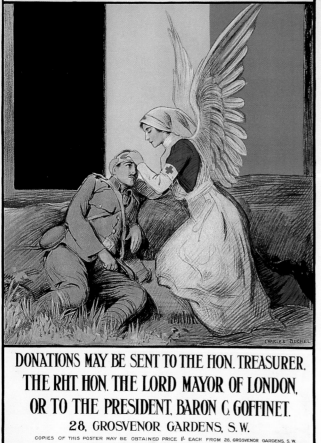

DONATIONS MAY BE SENT TO THE HON. TREASURER,
THE RHT. HON. THE LORD MAYOR OF LONDON,
OR TO THE PRESIDENT, BARON C. GOFFINET.
28, GROSVENOR GARDENS, S.W.

COPIES OF THIS POSTER MAY BE OBTAINED PRICE 1/- EACH FROM 28, GROSVENOR GARDENS, S.W.

80. Belgian Red Cross.
Great Britain. Charles Buchel.

In all countries, women were first mobilized as nurses. Sentimental depictions of an angelic nurse caring for a wounded soldier, used here to appeal for funds, appeared in many variations on posters, postcards, and memorial certificates.

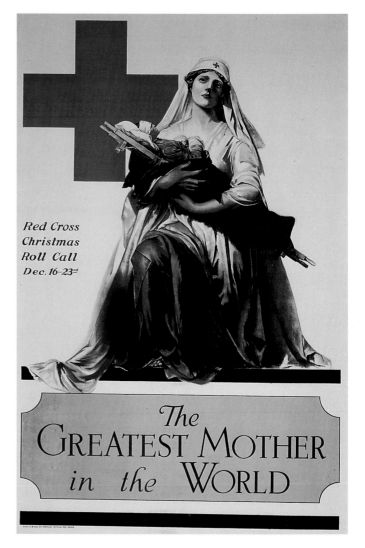

81. The greatest mother in the world.
U.S.A. 1918. Alonzo E. Foringer.

Among the most famous of the war, this poster continued to be used by the Red Cross through the Second World War. The image of the serene giant Piéta cradling a tiny wounded and immobilized soldier conveys an ambiguous and, for some, chilling message of female power and masculine helplessness.

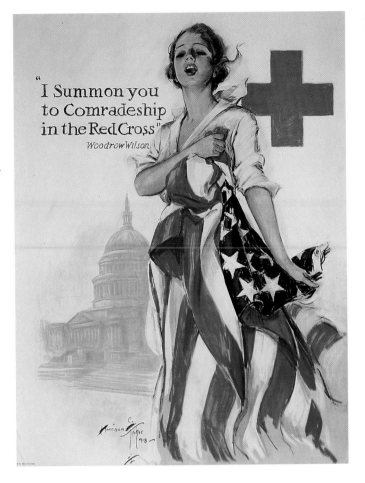

82. "I summon you to comradeship in the Red Cross." Woodrow Wilson.
U.S.A. 1918. Harrison C. Fisher.

83. We need you.
U.S.A. 1918. Albert Sterner.

Using a quotation from Woodrow Wilson, Fisher's frivolous seductress, posed with open mouth, the draped flag hinting at a strip-tease, presents an unseemly summons to service in the Red Cross. In contrast, Sterner's conception is somber and idealized with its stern Red Cross goddess demanding sacrificial service.

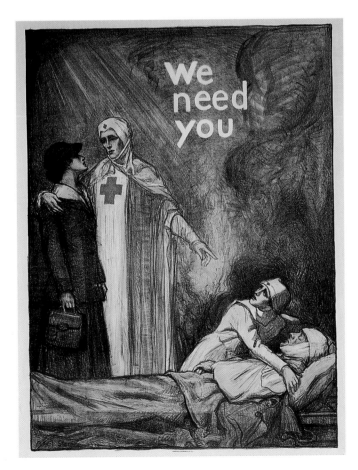

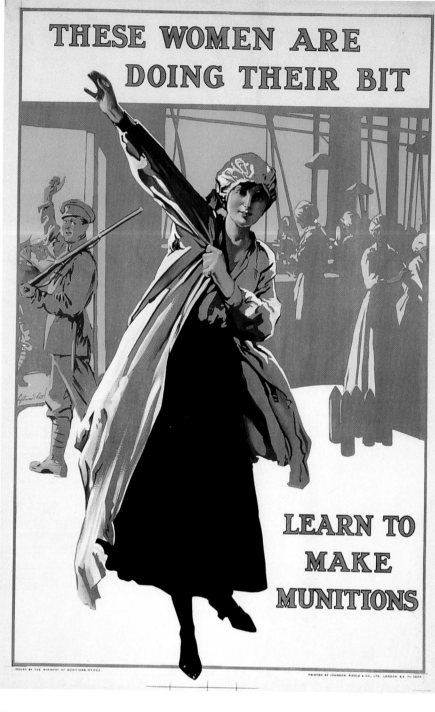

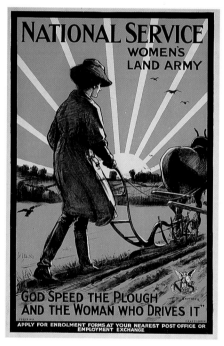

84. National Service. Women's Land Army.
Great Britain. 1917. H. G. Gawthorn.

*In Britain, enormous casualties and the resul-
tant need for replacements led to the employ-
ment of women in industry and the creation of
women's military auxiliaries. Although not a
military service, the Land Army organized
women into uniformed units for essential agri-
cultural work.*

**85. These women are doing their bit. Learn
to make munitions.**
Great Britain. c.1917. Septimus E. Scott.

*Utilizing design elements similar to Kealey's
1915 poster (Poster 68), Scott has transformed
them to emphasize the changing position of
women. Within the frame of the windows, the
feminine interior is light, modishly colored, and
filled with women working at industrial tasks.
The soldier, with a long backward glance,
seems reluctant to move into an indistinct
world, while the woman becomes the center-
piece as the strong active figure preparing for
industrial work.*

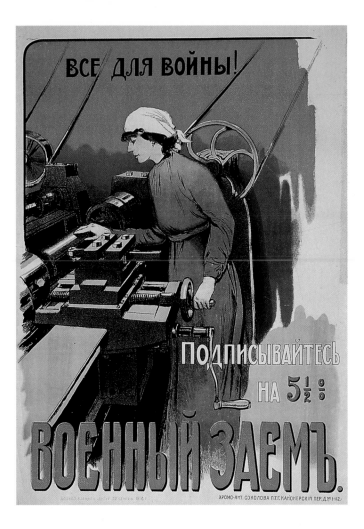

86. Everything for the war.
Russia. 1916.

87. German women, work for victory!
Germany. 1918. Ferdy Horrmeyer.

Germany and Russia were also forced by rising casualties to establish women's labor services. Women in both countries worked in munitions factories, heavy industry, and construction, and provided civilian heavy labor and transport at the front. By January 1918, women munition workers in Germany helped instigate massive strikes. The bleakness of their situation is expressed in this pessimistic poster by a German socialist artist. Much more optimistic, the Russian poster with its realistic details implies that it was natural for women to handle industrial machinery. It does not reveal the disastrous economic and military condition of 1916 in Russia that necessitated female labor.

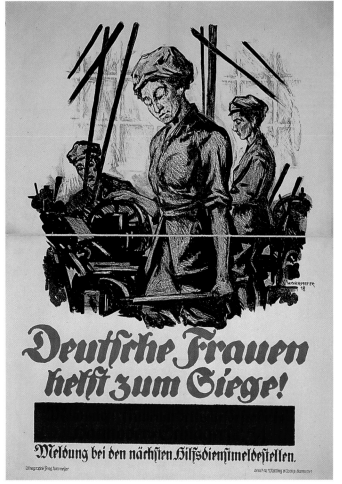

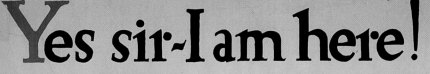

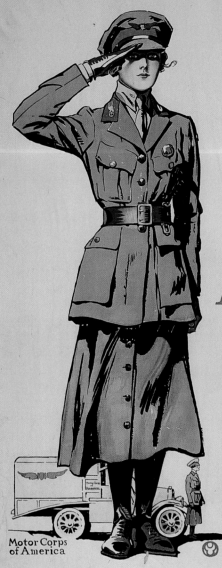

88. Yes sir—I am here!
U.S.A. c.1918. Edward Penfield.

89. If you want to fight!
U.S.A. 1918. Howard Chandler Christy.

For many women, uniforms symbolized their move out of a state of restrictive femininity and into the men's world of work. For others, the assumption of the uniform by women mocked masculinity and suggested the specter of lesbianism. The confusion of genders provided posters with provocative images like this female in a theatrical masculine, military costume whose purpose is seduction of men into service, while the corresponding call by a woman to women is sober, realistic, and uninspiring.

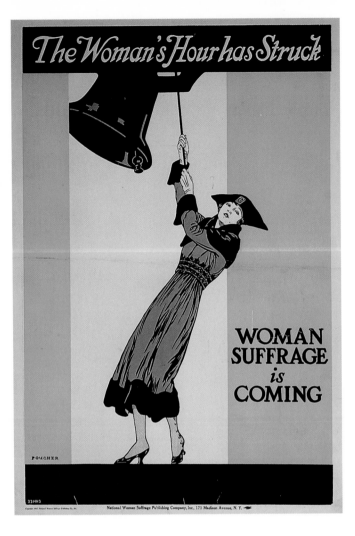

90. The woman's hour has struck. Woman suffrage is coming.
U.S.A. 1917. Poucher.

91. We give our work, our men, our lives if need be. Will you give us the vote?
U.S.A. 1917.

92. Woman suffrage.
U.S.A. Evelyn Rumsey Cary.

Leaders of the women's rights movement, which, on the eve of the war, had seemed close to major success in several countries, supported the war by contributing their organizational skills to national welfare and service bureaucracies. In return, they expected to be rewarded with equal rights. However, even in countries where women were granted the vote, the outcome of the war did not bring about the hoped for equality. The difficult transition from supporting the war to gaining equality was visually demonstrated in these posters. The elegantly feminine patriot—a female Paul Revere—contrasts sharply with women who have adopted male roles and dress in a poster whose visual awkwardness negates the claim to participate in the male world. Although the other poster, with its almost Biblical text, is richly designed, it reverts to a stereotype of woman as goddess of fertility, whose close identification with nature was frequently used as grounds for rejecting her demands for equal treatment.

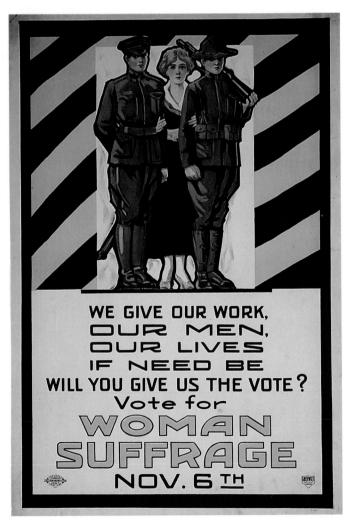

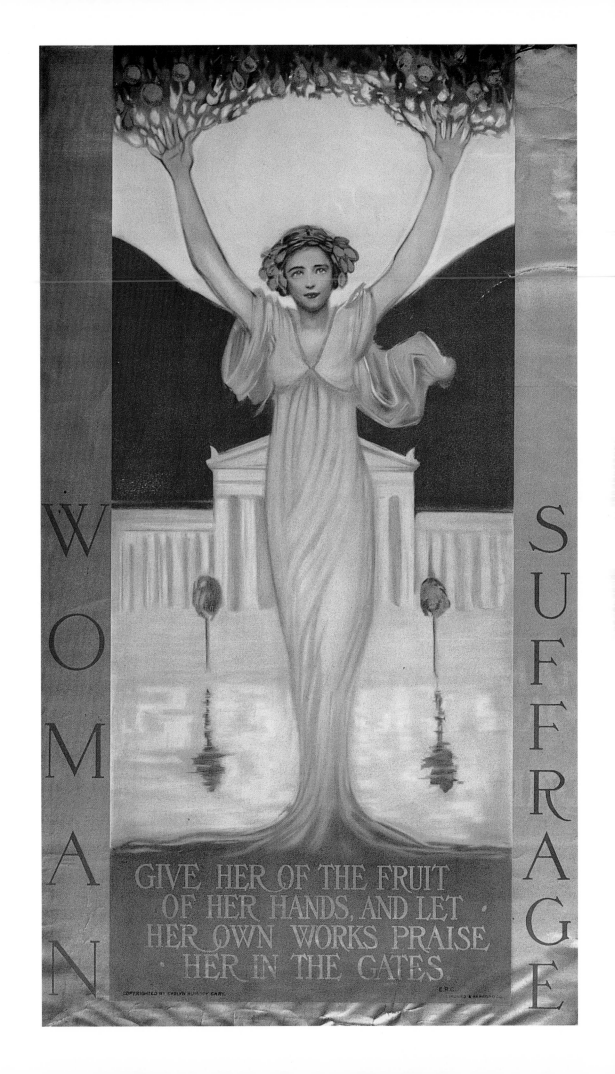

WOMAN

SUFFRAGE

GIVE HER OF THE FRUIT
OF HER HANDS, AND LET
HER OWN WORKS PRAISE
HER IN THE GATES.

COPYRIGHTED BY EVELYN RUMSEY CARY.

6.

War Loans

As it became clear that the war would last longer and need far more resources than had been expected, all belligerents resorted to extraordinary steps to raise money. Together with tax increases, gold and hard currency drives, and government borrowing from banks and industry, every country launched a program of public debt bonds, or war loans. Institutions as well as large and small individual investors were asked to buy government bonds of varying denominations, to be repaid with interest. Large sums were generated through these loans, which continued even after the armistice in the form of victory and reconstruction loans. It has been estimated that war loans covered more than 60 percent of the direct costs of the war in Germany, and somewhat more than one half in Austria-Hungary. In the United States, over sixty-six million separate subscriptions raised nearly twenty-one-and-a-half billion dollars in five Liberty Loans.

Besides raising money, war loans helped governments regulate the economy and limit inflation. By absorbing excess funds from consumers who might otherwise have bought non-essential goods, the war loans made it easier to redirect labor and raw materials toward war industries.

The collapse of Russia in 1917, of Germany and Austria in 1918, and severe inflation in the following years resulted in financial disaster for the investor. The loss of the enormous sums that citizens had lent their governments helped weaken the middle classes and further destabilized central Europe.

War loan posters were almost certainly the largest category of posters produced between 1914 and 1919. They placed less emphasis on the investment value of buying bonds than on the opportunity for civilians to aid the war effort directly. Following the approaches of other propaganda campaigns, such as enlistment and production drives, war loan posters appealed to patriotism and historical identity, raised sexual themes, played on the sense of guilt that might be experienced by those who did not fight, and, in the later stages of the war, argued that the buyer of war bonds

helped speed the end of the war—a response to the increasingly widespread desire of Europeans for an end to the fighting.

A recurring theme specific to war loan posters was the portrayal of money—coins, banknotes, and bonds—as an active force. Designers visually linked money to combat and victory in order to convey the military importance of funds raised by loans. Depicted as bullets and shields, coins are transformed into the actual elements of battle and reconstruction.

93. You buy war bonds. We did our bit.
Great Britain. Bert Thomas.

An elegant appeal by one of Britain's best designers played on civilian guilt. Like Hohlwein, Bert Thomas constructed his images with contrasting planes of tone and color.

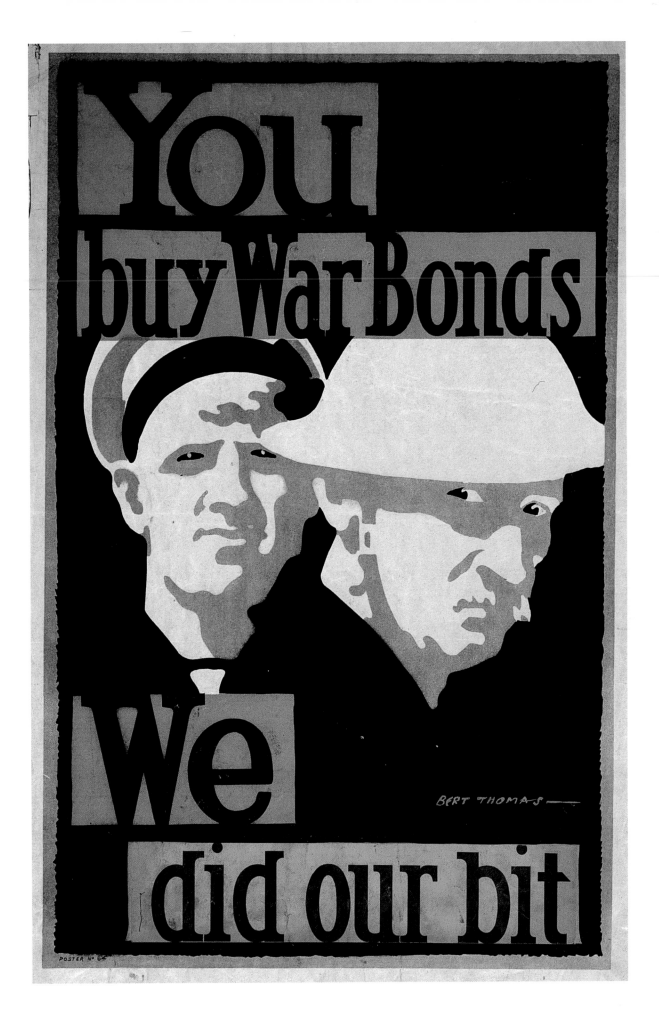

94. Women! Help America's sons win the war.
U.S.A. 1917. R. H. Porteous.

The wreckage and loss of life in the background of this sentimental appeal gives a powerful meaning to the homey maternal figure.

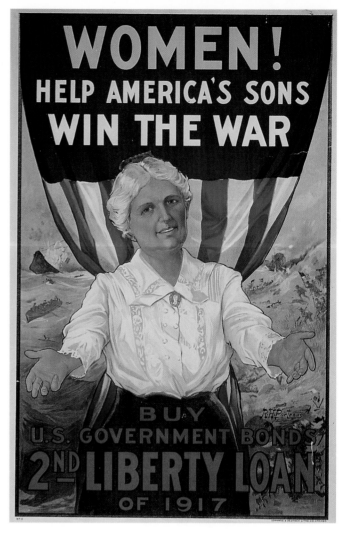

95. I am telling you.
U.S.A. 1918. James Montgomery Flagg.

Flagg designed forty-six posters during the First World War, including the famous "I Want You"—a concept that he borrowed from an earlier British poster. This time Uncle Sam is promoting War Savings Stamps, a smaller-scale complement to the Liberty Loan program. Sixteen twenty-five cent Thrift Stamps purchased a War Savings Stamp that after five years could be cashed in for five dollars. Over one billion dollars were raised in this manner.

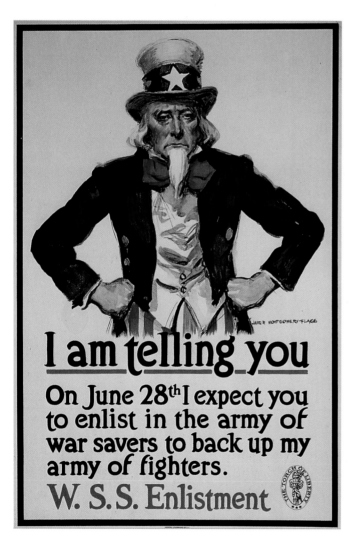

96. Times are hard, but victory is certain.
Germany. 1917. Bruno Paul.

Bruno Paul combines realism with an abstract monumentality to create the visual impression of a new national symbol, Hindenburg, the commander-in-chief of the German armies in the west from 1916 to the end of the war.

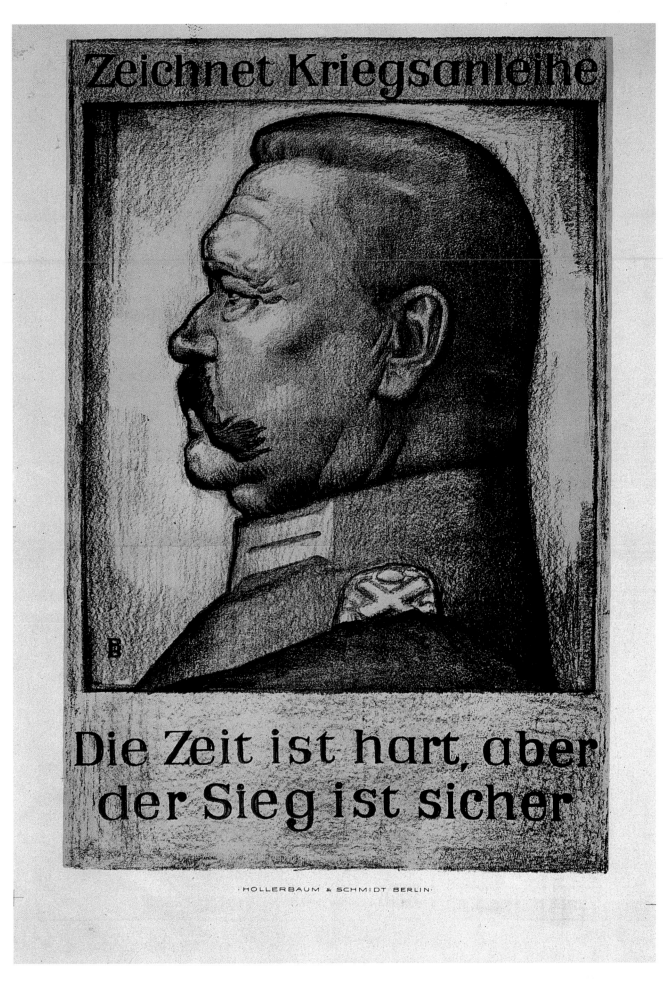

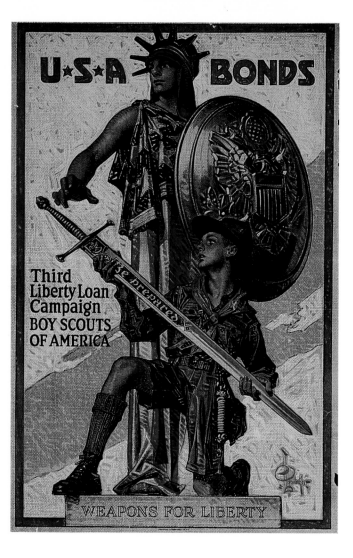

97. USA bonds. Weapons for liberty.
U.S.A. 1918. Joseph C. Leyendecker.

The Boy Scouts of America, one of many civic organizations enlisted by the Treasury to assist in the loan drives, sold over 350 million dollars worth of Liberty and Victory Bonds. Nearly seventy thousand Boy Scouts earned medals for selling bonds to at least ten investors each.

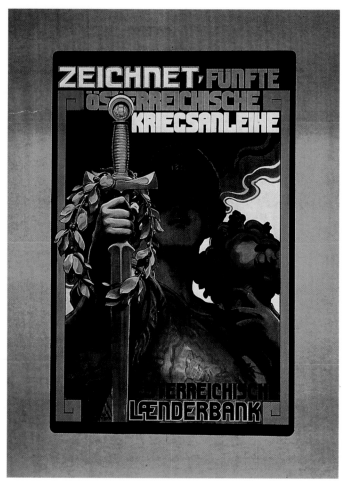

98. Subscribe to the fifth Austrian war loan.
Austria. 1916. A. S.

Even in early stages of the war, the theme of peace often occurred in Austrian posters. Here a heraldic national figure raises in one hand a sword embellished with the laurels of victory, and in her other hand a cornucopia bearing the fruits of peace.

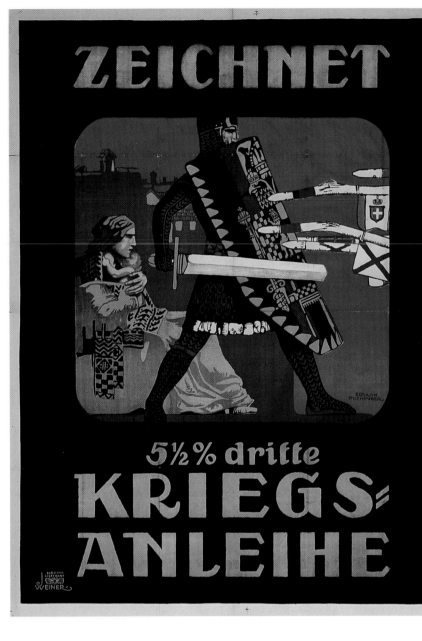

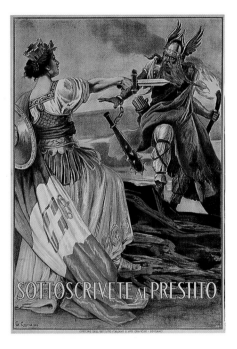

99. Subscribe to the loan.
Italy. c.1917. Giovanni Capranesi.

*Far from being cowed, the female representa-
tion of Italy repels a maurauding Goth, who is
stunned by her defiance. The traditional vocab-
ulary of the theatrical and operatic poster lends
a touch of humor to the patriotic parable.*

**100. Subscribe to the 5 1/2% third war
loan.**
Austria. c.1915. Erwin Puchinger.

*Another example of the defensive theme often
used in German and Austrian posters, this chi-
valric image suggests that the war is being
fought for the protection of women and chil-
dren. The influence of the Vienna Secession can
be seen in the mosaic-like chips of color deco-
rating the knight's belt and shield and the
woman's wrap.*

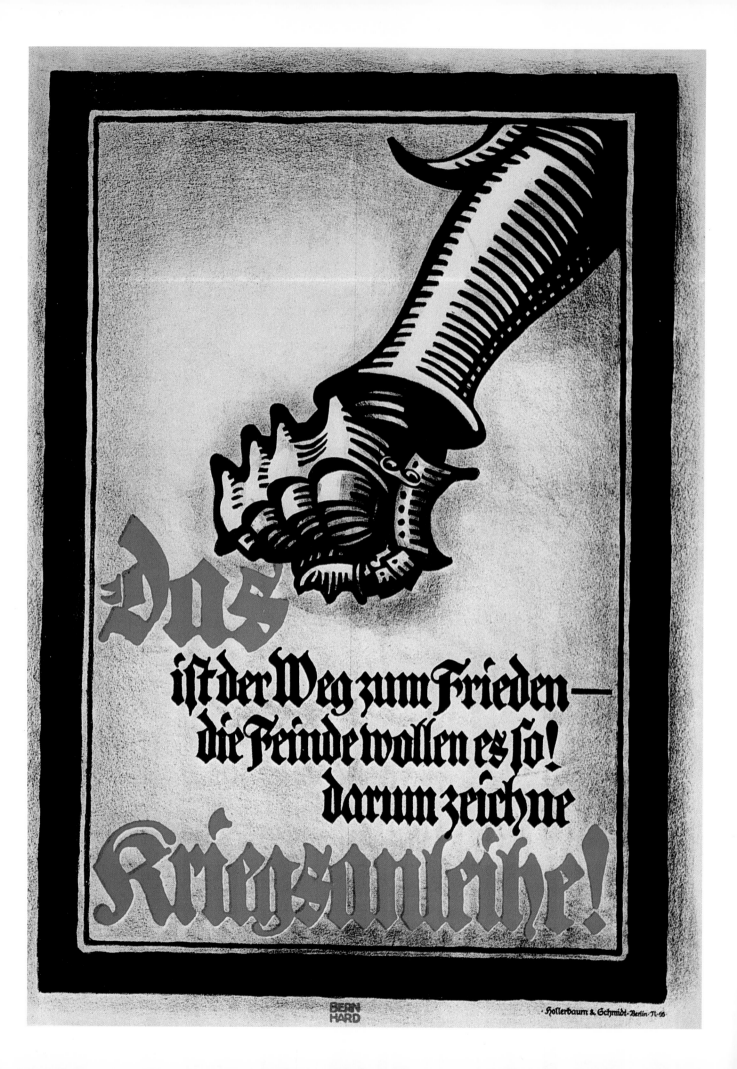

Das ist der Weg zum Frieden — die Feinde wollen es so! darum zeichne Kriegsanleihe!

BERN HARD

Hollerbaum & Schmidt · Berlin · N 65

**101. This is the way to peace—the enemy
wants it so.**
Germany. c.1918. Lucian Bernhard.

*In contrast to the defensive posture of the pre-
vious poster, here the artist throws down the
gauntlet. Both, however, imply an unwanted
war and a wish for peace. Bernhard's mailed
glove resembles the forceful calligraphy of his
slogan.*

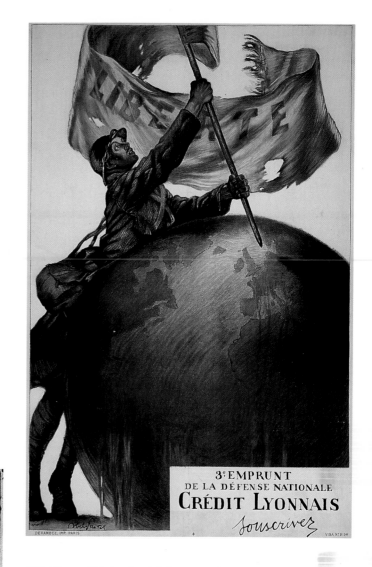

3ᵉ EMPRUNT
DE LA DÉFENSE NATIONALE
CRÉDIT LYONNAIS
Souscrivez

102. Liberty. Third national defense loan. Subscribe.
France. c.1917. Jules Abel Faivre.

*A French poilu plants the battle-torn flag of Liberty into the French earth,
as the blood of Europe runs off the globe. Faivre's style of line drawing rep-
resents an earlier tradition of lithography, one that was being replaced by
the simplicity of the tonal planes used by Hohlwein and Thomas (Posters 23
and 93).*

THAT LIBERTY SHALL NOT PERISH FROM THE EARTH BUY LIBERTY BONDS
FOURTH LIBERTY LOAN

103. That liberty shall not perish from the earth.
U.S.A. 1918. Joseph Pennell.

*Two million copies of this enormously popular horror fantasy were printed.
The poster's unlikely depiction of an air and submarine attack on New York
was designed to bring the war home to a public whose distance from the
fighting seemed to necessitate this most forceful sales effort.*

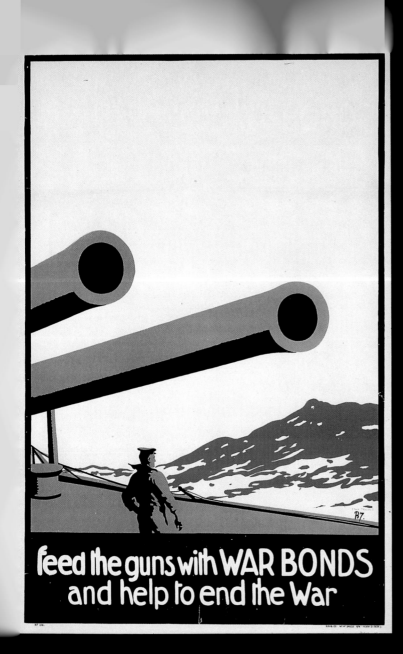

feed the guns with WAR BONDS
and help to end the War

105. Help them. Keep your war savings pledge.
U.S.A. 1918. Caspar Emerson, Jr.

First in a slogan, then demonstrated visually, bonds and coins are equated with munitions.

04. Feed the guns with war bonds and help to end the war.
Great Britain. 1918. Bert Thomas.

11. Subscribe to the loan.
France. 1918–20. René Prejelan.

Coins, with their portraits of rulers and allegorical figures, become the oversized heads for the stick figure bodies of this post-war reconstruction army.

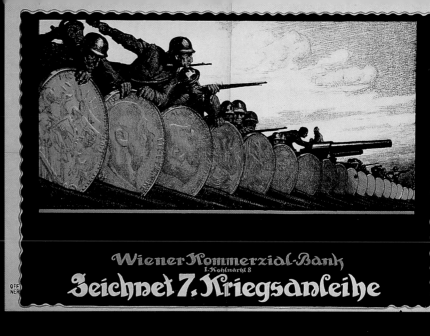

106. Turn your silver into bullets.
Great Britain. c.1915.

107. Subscribe to the seventh war loan.
Austria. 1917. Alfred Offner.

Coins that buy war bonds here serve as defensive shields protecting soldiers and country from the enemy advance. The second poster brings the image of the Austrian knight (Poster 100) into the twentieth century, and, like the goddess holding the cornucopia (Poster 98), calls for peace.

108. Help us in the struggle for peace.
Austria. 1918. Moldovany.

110. Lend your five shillings to your country and crush the Germans.
Great Britain. 1915. D. D. Fry?

109. For France, pour out your gold. Gold fights for victory.
France. 1915. Jules Abel Faivre.

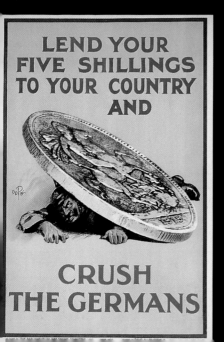

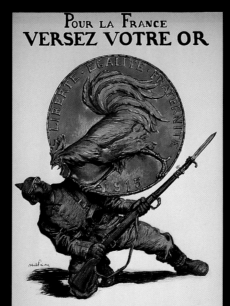

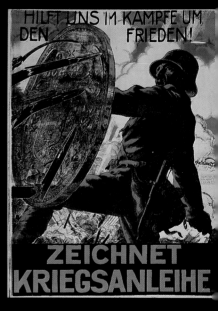

In these two posters, the inanimate takes on life. Faivre's famous design shows the French cock breaking through the edge of the coin to torment the bewildered enemy. In the British poster, the five shilling piece flattens the German soldier, leaving St. George triumphant.

7.

Food and Industry

The war was as much an economic and industrial conflict as an armed struggle, and the links between the two were very close. Both Germany and Great Britain, each the industrial backbone of its alliance, were vulnerable to the loss of essential raw material from overseas. The British blockade led to unlimited German submarine warfare, which eventually brought the United States, with its enormous productive capability, into the war. In the final analysis, it was not the sacrifice of millions of lives that achieved victory, but rather war production that was the decisive factor.

Since none of the countries was economically prepared for the massive drain on resources, all had to create new agencies and policies to produce the needed food and supplies. Posters by these agencies were augmented by posters sponsored by local groups, institutions, municipalities, and industries, admonishing the public to produce and save. Competitions for poster designs heightened citizen involvement in the home front campaigns.

As a major voice speaking for war production everywhere, posters document both common problems and differences in attitude among the belligerents. Everywhere poster designers exploited economic hardships to create a bond between civilian society and the forces in the field. Rationing often lent itself to light-hearted treatment. Overall, the appeals to produce and to save were more somber in tone in Great Britain and on the Continent, while American posters, drawing on the country's seemingly unlimited natural resources, expressed a lush exuberance and sense of abundance.

112. Through work to victory! Through victory to peace!

German. 1917. Alexander M. Cay.

The symbolic handshake uniting the steel-helmeted front fighter and the munitions worker is reenforced by the text that proclaims the sequence from work to peace. The message is addressed to workers whose dissatisfaction with the war led to strikes in early 1917. Cay, who produced right-wing posters after the war, here made effective use of dark muted colors to emphasize the sobriety of the struggle.

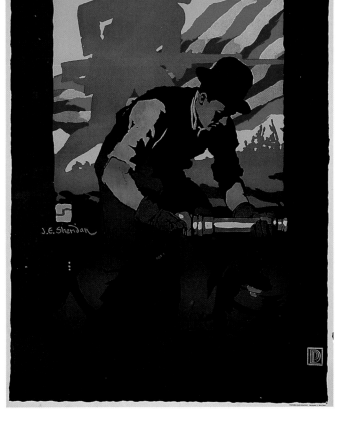

113. Rivets are bayonets. Drive them home!

U.S.A. c.1918. John E. Sheridan.

The American vision of cooperation between soldier and machinist is more dynamic with a bright scene of flag-waving combat that equates production with defeat of the enemy. Sheridan often employed the device of superimposing a familiar homefront scene on a stylized battlefield (Poster 123). Here, the two scenes are linked by the parallel postures of worker and soldier, the repetition emphasizing the message of interdependence.

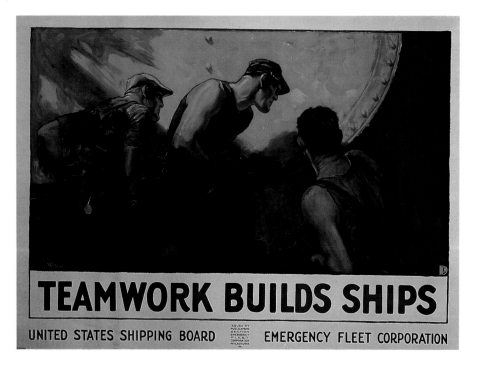

TEAMWORK BUILDS SHIPS

UNITED STATES SHIPPING BOARD — EMERGENCY FLEET CORPORATION

114. Teamwork builds ships.
U.S.A. c.1918. William Dodge Stevens,

115. On the job for victory.
U.S.A. c.1918. Jonas Lie.

116. The ships are coming.
U.S.A. c.1918. James H. Daugherty.

Responsible for building the huge fleet needed to transport men and materiel across the Atlantic, the U.S. Shipping Board also sponsored some of the most impressive production posters of the war. Marked by their vigorous use of color, these three posters employed different design concepts to demonstrate industrial power. The most subtly designed is the close-up view of concentrated human energy. The didactic image of the shipyard emphasizes the pragmatic organization underlying American's boundless strength. Finally, the brilliant eagle accompanying the armada of ships surging to rescue Europe is a superb use of national symbolism.

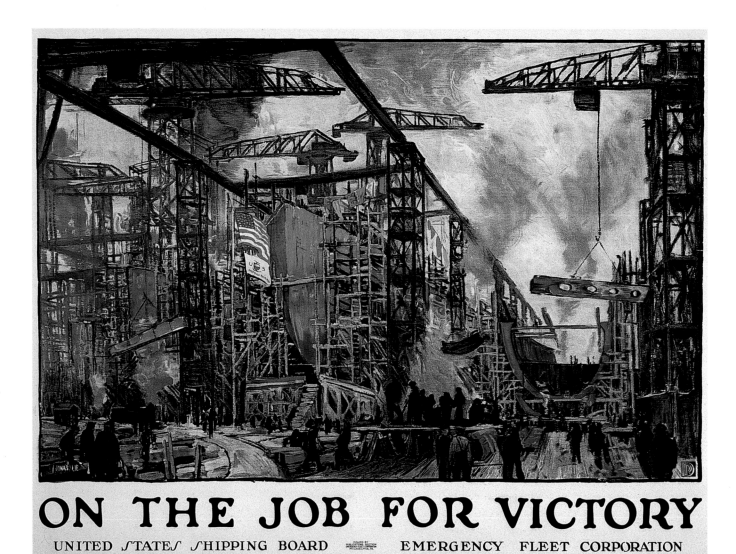

ON THE JOB FOR VICTORY

UNITED STATES SHIPPING BOARD — EMERGENCY FLEET CORPORATION

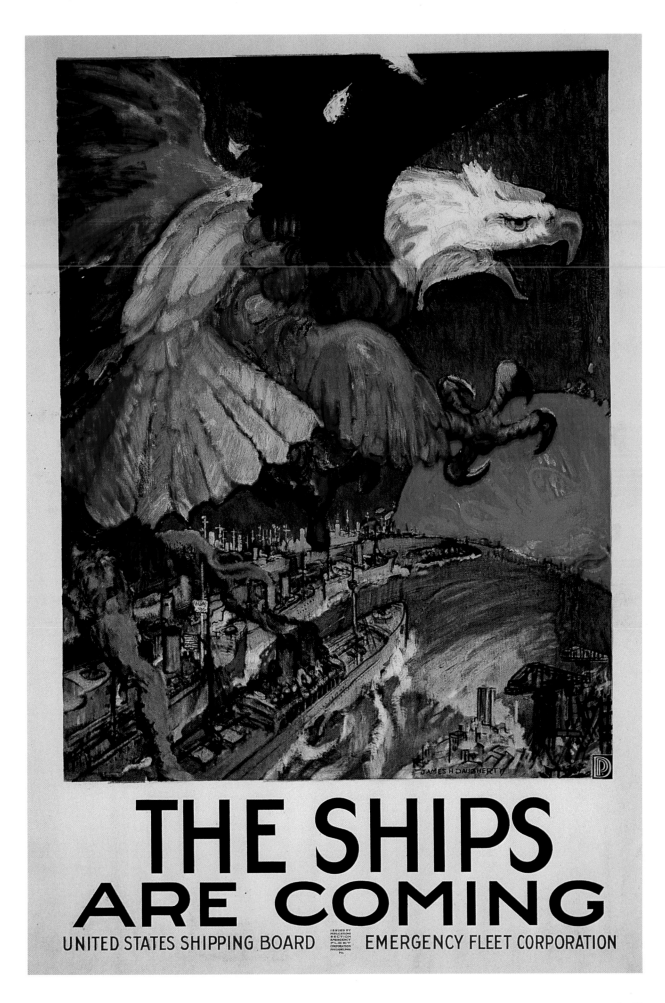

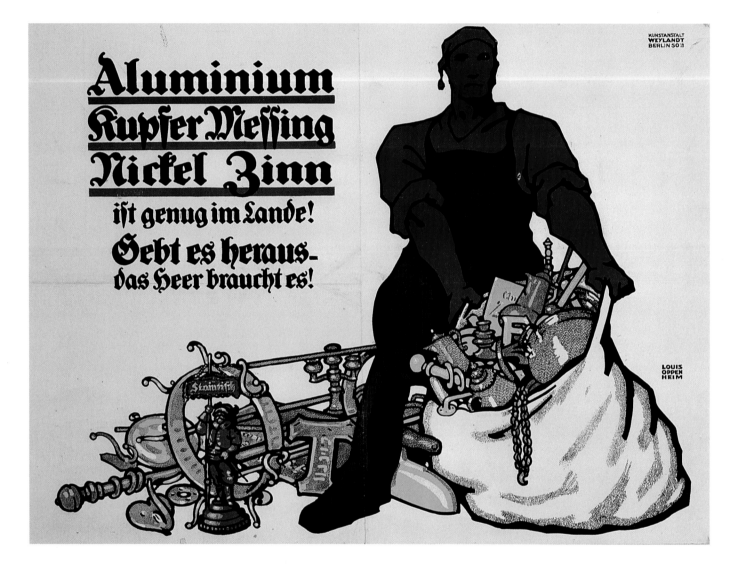

117. There is enough aluminum, copper, brass, nickel, zinc in the country. Turn it in—the army needs it.
Germany. 1917. Louis Oppenheim.

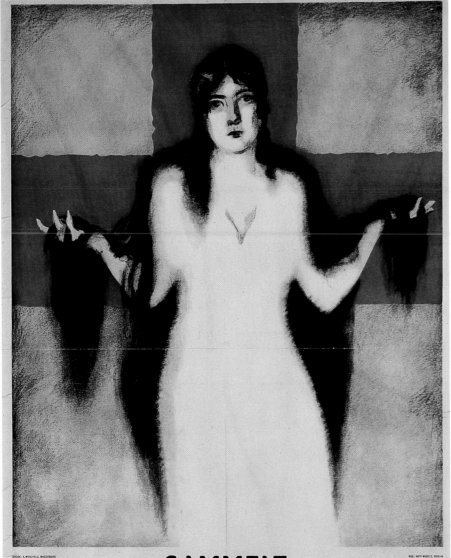

118. Collect combed-out women's hair.
Germany. 1918. Jupp Wiertz.

119. Collect fruit kernels for oil.
Germany. 1915–16. Julius Gipkens.

Shortages caused by the British blockade forced Germany to create substi-
tute materials and collect household objects to be recycled into war sup-
plies. The fruit kernel drive, with a series of humorous posters by Gipkens,
an innovative pre-war commercial artist, enlisted the efforts of children and
schools in the war effort. The most curious collection was of women's long
hair to take the place of leather and hemp in drive belts and insulation. The
crucifix-like image on the poster for the campaign, organized by the Red
Cross, acknowledged the traumatic sacrifice required of women in a culture
in which cutting one's hair was for many still synonymous with a loss of
femininity.

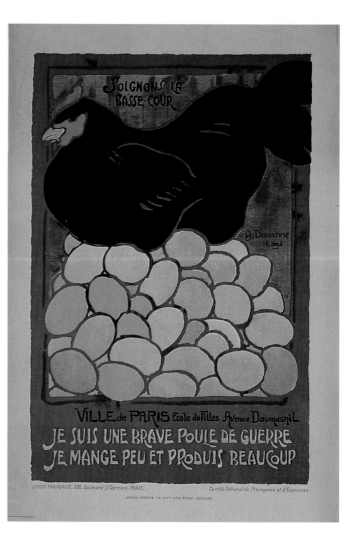

120. National egg day.
Great Britain. Wippell.

121. Look after the poultry yard. I am an honest hen of war. I eat little and produce much.
France. G. Douanne.

122. Frenchmen, save gas.
France. Jeanne Fapournoux.

Conserving food and fuel was a constant preoccupation for civilian and military authorities. In France, the National Committee for Foresight and Thrift sponsored a competition among school children for conservation posters; these two are remarkably modern and sophisticated in their use of clear simple images, especially when compared to the fussy British hen.

FRANCAIS. ÉCONOMISEZ. LE. GAZ

UNION FRANÇAISE, 286, Boulevard St Germain, PARIS. Cette Affiche ne doit pas être vendue Comité de Prévoyance et d'Économies

AFFICHE
Composée
par les
Enfants de France
pour la PRÉVOYANCE et les Economies
≈ APPEL ≈
du Comité National de prévoyance et d'économies
UNION FRANÇAISE
Association Nationale
pour l'expansion morale et matérielle de la France.

286, Boulevard Saint-Germain, Paris.

Food *is*
Ammunition-
Don't waste it.

UNITED STATES FOOD ADMINISTRATION

HEYWOOD STRASSER & VOIGT LITHO. CO., N.Y.

123. Food is ammunition—don't waste it.
U.S.A. c.1918. John E. Sheridan.

124. War gardens over the top.
U.S.A. 1919. Maginel Wright Enright.

Agricultural bounty which is almost tactile in its rich detail is incongruously superimposed on the remote silhouettes of mounted troops—a romantic image drawn from the Wild West, not from trench warfare. In a caricatural style characteristic of many conservation posters, vegetable-soldiers fight for peace by storming out of their trenches into victory gardens.

WAR GARDENS
OVER THE TOP

The Seeds of Victory
Insure *the* Fruits of Peace

FOR FREE BOOKS WRITE TO NATIONAL WAR GARDEN COMMISSION
WASHINGTON, D.C.
Charles Lathrop Pack, President Percival S. Ridsdale, Secretary

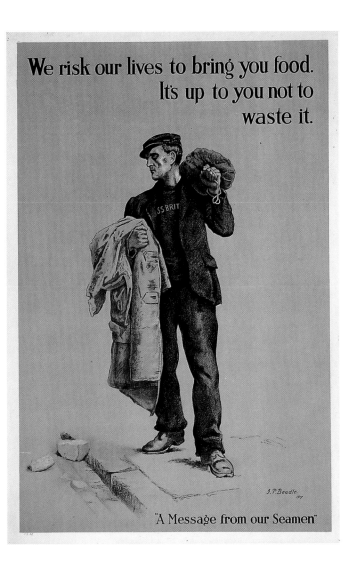

We risk our lives to bring you food.
It's up to you not to
waste it.

"A Message from our Seamen"

125. We risk our lives to bring you food. It's up to you not to waste it.
Great Britain. 1917. J. P. Beadle.

This grave, muted poster was a reminder of the high toll taken by German submarines on British merchant ships.

8.

The End of the War

Posters that appeared as the war drew to a close and in the first months after the armistice continued earlier appeals for money to help one's prisoners in enemy hands and to care for the wounded and the sick. In France and Belgium a new theme was introduced: the entreaty for money to help finance the reconstruction of formerly occupied territories and areas devastated by the fighting. War loan drives quickly turned into fund-raising campaigns to help win the peace. Other posters were issued to express a general sentiment and win or maintain the public's support of its government negotiating the transition from war to peace. Posters celebrate victory, welcome the returning troops, and call for days of prayer and remembrance.

In the countries that suffered military defeat, followed by political upheaval, the poster assumed a new role. It became a weapon of revolution and of political combat. Even in countries that retained relative social and political stability, the poster, which during the war had claimed to speak for society as a whole, now turned into an expression of political and ideological diversity.

126. Liberation loan.
France. 1918. Jules Abel Faivre.

In a poster initially designed for a war loan drive in 1915, the Kaiser sinks to his knees under the weight of Allied flags. It was used again with the addition of the Stars and Stripes for the fourth war loan in 1918.

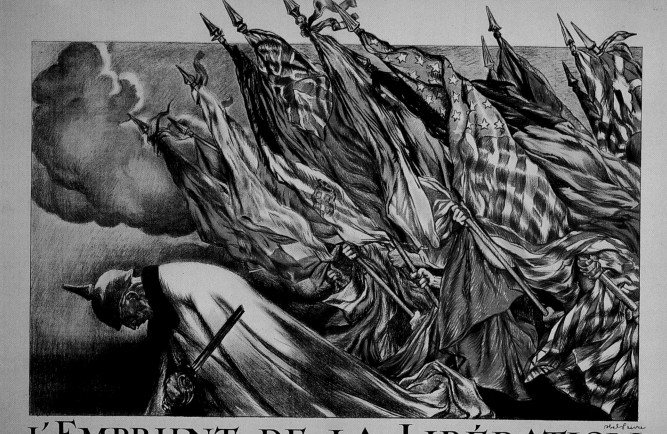

L'EMPRUNT DE LA LIBÉRATION

MAQUET, Gr. PARIS.

127. An appeal to invest in national reconstruction.
France. c.1919. L. Jonoy?

On the roof of a Gothic church, high above an Alsatian town that once again belonged to France, three workers, one still wearing army-issued pants and another his fatigue cap, nail a flagpole with a tricolor on an ancient finial.

128. Day of the liberated areas. After victory, to work!
France. c.1919. Auguste Leroux.

A demobilized soldier with the Gallic cock on his shoulder sets to work on the tasks of reconstruction.

129. Heroes back from the front! Your country greets you!
Germany. 1918–19. Walter Ditz.

A small child, the symbol of Munich, welcomes the city's returning soldiers. The poster's warm, affectionate text and design give no hint of the legend of the undefeated army—stabbed in the back—that was beginning to circulate through German society.

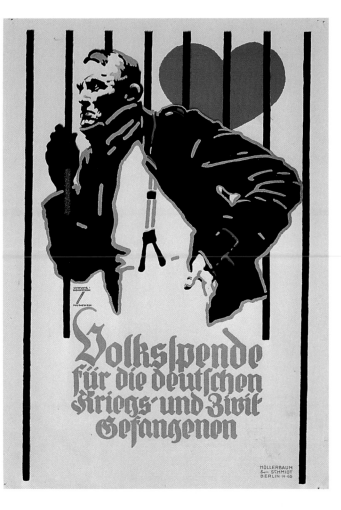

130. The German people are asked to help its prisoners of war.
Germany. 1918–19. Ludwig Hohlwein.

131. Help the prisoners!
Germany. W. Dittrich.

German posters represented German prisoners as counterheroes—brave but now powerless. After the armistice prisoners portrayed further meanings: They became symbols of a nation whose armies had fought deep in enemy country but had nevertheless lost the war; as survivors they held out the promise of a better future. Hohlwein's poster, first published in 1916, was used again at the end of the war. The stoic, masculine figure of the prisoner, the great heart of Germany hovering over his shoulder, is very different from Dittrich's wounded, older man, sitting by a barbed wire fence. Intentionally or not, Dittrich drew a dejected, defeated counterpart to the mythic hero in field gray, whom Erler's famous image (Poster 58) had defined for the nation when the war still seemed in balance.

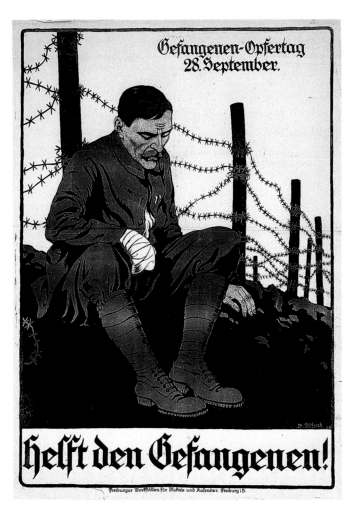

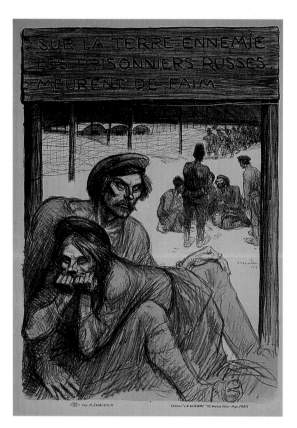

132. In enemy country, Russian prisoners die of hunger.
France. 1917. Théophile-Alexandre Steinlen.

In its sketch-like quality, subdued colors, and empathy with the victim, this is a characteristic example of the thirteen posters Steinlen produced during the war and the immediate post-war period.

133. Ludendorff fund for disabled veterans.
Germany. 1918. Ludwig Hohlwein.

By association with the general who guided German strategy on the western front from 1916 on, this humanitarian cause also served to build patriotism and morale.

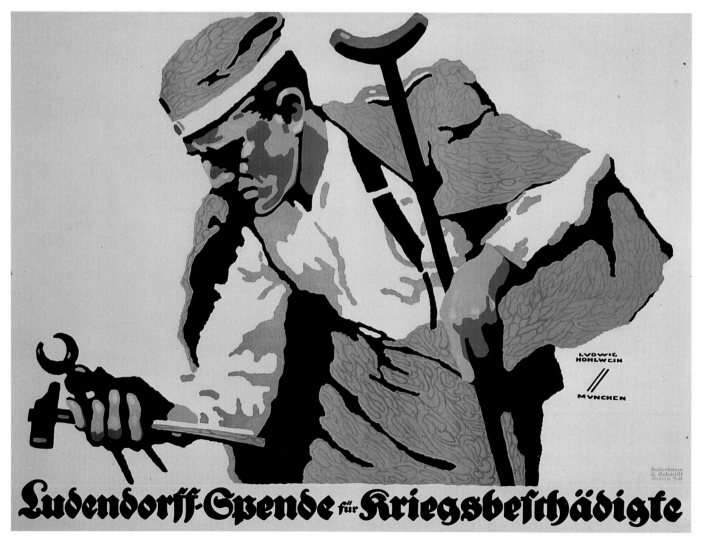

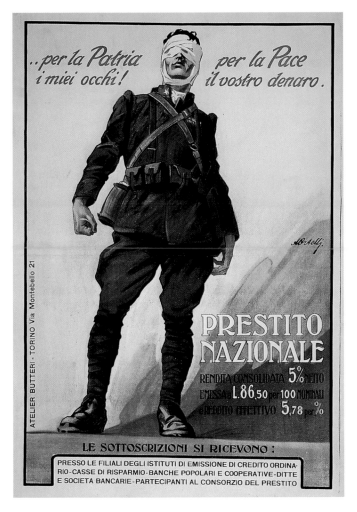

134. For the fatherland my eyes! For the peace your money.
Italy. 1918. A. Ortelli.

Here is patriotic rhetoric pushed to an extreme of mawkishness. The artist, favoring a realistic style, shows a wounded soldier, blood seeping through the bandage over his eyes and obviously out of the war for good, still fully uniformed with his right hand clenched into a defiant fist. Was the public impressed, disgusted, or did people simply ignore the poster?

135. Permanent blind relief war fund.
U.S.A. 1918–19. Albert Sterner.

The symbolic treatment in this appeal to help the blind is more convincing than realism in the service of bathos in the preceeding poster.

136. The Association of Disabled Veterans.
France. 1917. Georges Dorival.

Two highly decorated veterans—an officer who has lost an arm and is standing before a town with factory chimneys and a poilu who has lost a leg and has returned to farming—are shaking hands. The pair symbolizes the absence of social distinctions in the associations's work, but the poster nevertheless conveys the image of a hierarchic society: the officer is associated with the modern urban world; the common soldier is a peasant.

JOURNÉE NATION

ANCIENS MILITAIRES

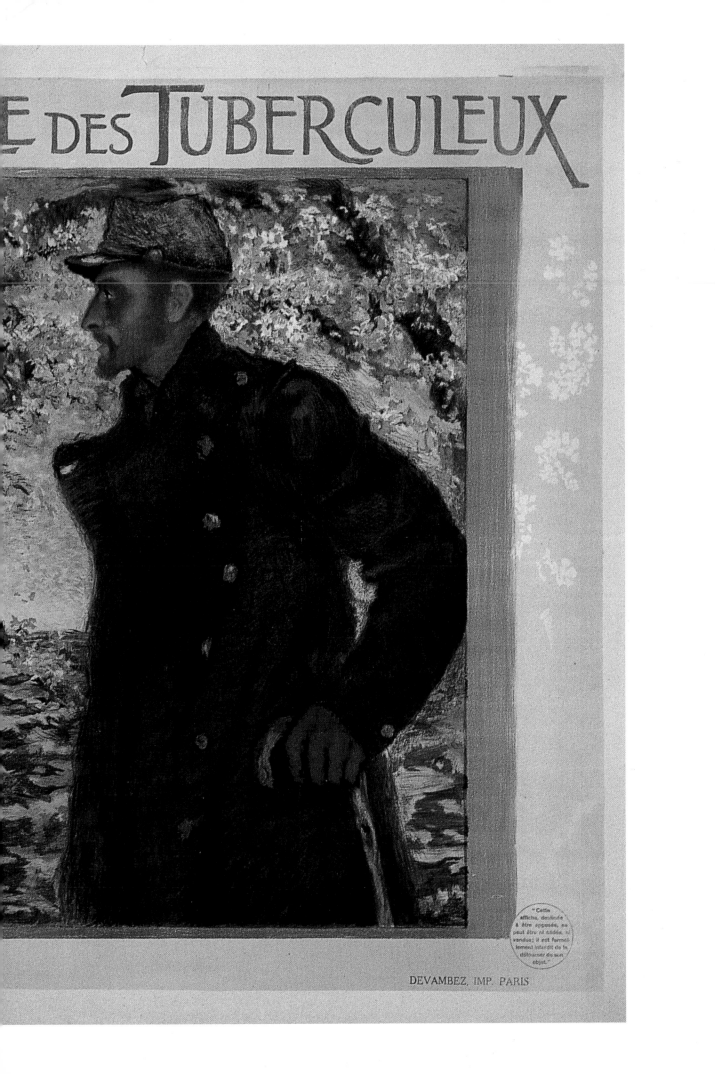

DEVAMBEZ, IMP. PARIS

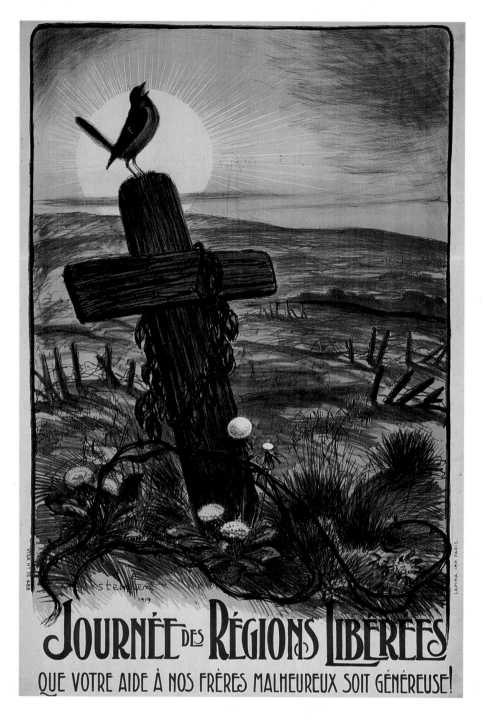

138. Day of the liberated areas.
France. 1919. Théophile-Alexandre Steinlen.

Over a grave in what was once a battlefield hangs a withered laurel wreath atop a cross, a bird greets the rising sun, and at the base of the cross dandelions again grow between twisted barbed wire.

139. Day of sacrifice. Put money in the bowl of sacrifice! Add your signature to the book of sacrifice!
Germany. 1918. Walter Ditz.

The poster was also printed with a different verse, which further clarified its message: "Burn, sacred flame, burn! Never cease to burn for the Fatherland!" The adjuration to offer further sacrifices on the altar of Germany, a massive block marked by an emblem that is both sword and crucifix (and within its circular enclosure suggests a swastika), is couched in the mystic, tragic tones that exerted a powerful attraction on some Germans during and after the war. There is a striking difference between this brooding and threatening image and Steinlen's idyll of life returning (Poster 138). The two posters may be seen as defining radically opposed political attitudes in post-war Europe: reconstruction and the cult of violence. But Germany also produced posters that called for efforts to repair and rebuild, and for the time being the death-centered mystique of endless war attracted only small groups of adherents in the defeated country.

(preceding pages)
137. National day for tubercular veterans.
France. c.1919. Lucien Levy-Dhurmer.

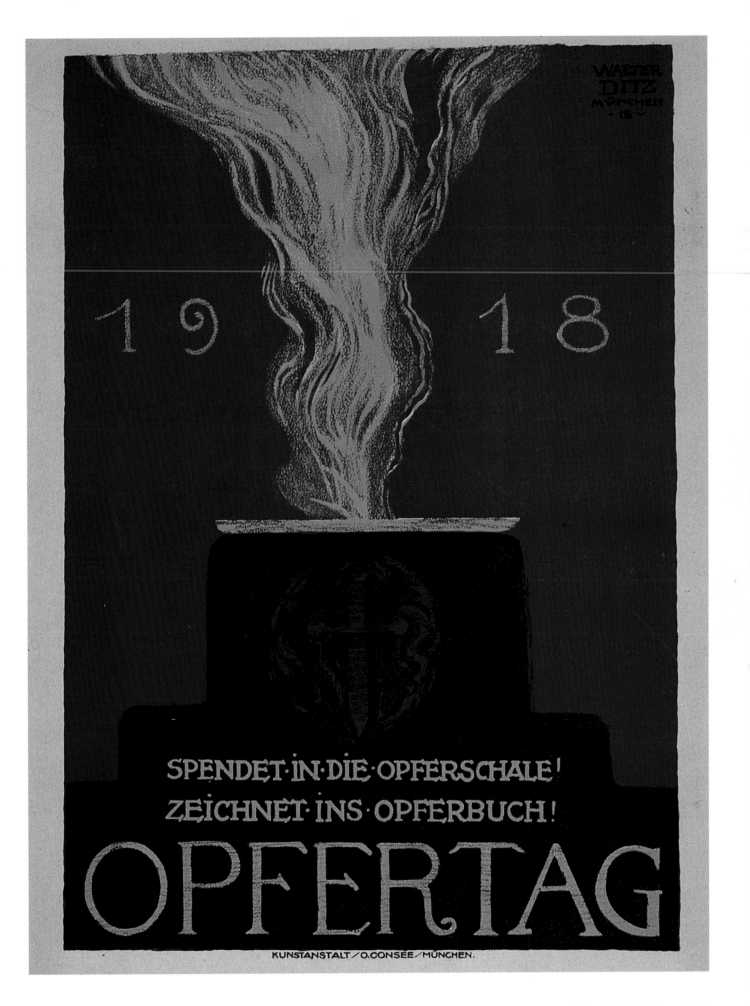

Part II

The Interwar Years

9.

Revolutions

In the empires of central and eastern Europe, military defeat was accompanied by the abdication of monarchs and the collapse of the old order. In the midst of popular demonstrations, calls for revolution, economic dislocation, and demobilization of millions of soldiers, posters took on a new stridency and urgency. Apart from official bulletins, political posters had been virtually nonexistent before the war, either being illegal or irrelevant within the old political systems. Commandeered during the war by governments for their own purposes, posters became an essential part of the political process after the war. In volatile revolutionary situations, the idealization of one's cause and the denigration of the enemy, developed during the war, were transferred from the international level to internal politics.

Just as the pre-war commercial posters helped develop an expanding market, posters mobilizing whole populations in support of the war effort implicitly created the expectation of mass involvement in the political process. With the fall of the old regimes, revolutionary energy took concrete form in the formation of workers' and soldiers' councils and committees for citizen action in Russia, Germany, and Hungary. Similarly, artists' councils and collectives were rapidly formed to produce political posters to promote—or oppose—the new governments. Thus, for a brief period, avant-garde artists in all three countries joined poster artists in populist ventures to reach and influence the new mass political audience.

The initial popular demonstrations in support of revolutionary change soon encountered both political and military resistance. Demobilized officers and soldiers, monarchists, conservatives, and large segments of the middle class and of peasants organized to counter what they perceived to be anarchic forces emanating from the Bolsheviks. In the ensuing civil wars that racked the new German Republic, the Soviet Union, and Hungary, political posters conveyed equally vicious images of the bolshevik specter menacing Europe and the capitalist, imperialist monster strangling reform. Two powerful poster types faced each other: the worker-soldier building a revolutionary society and the front soldier guarding the established order.

140. Freedom loan.
Russia. 1917. B. M. Kustodiev.

The image of the Russian soldier towering over demonstrating workers and soldiers was used to legitimize the provisional government formed in the February revolution and to demonstrate the continuation of the war against the Central Powers.

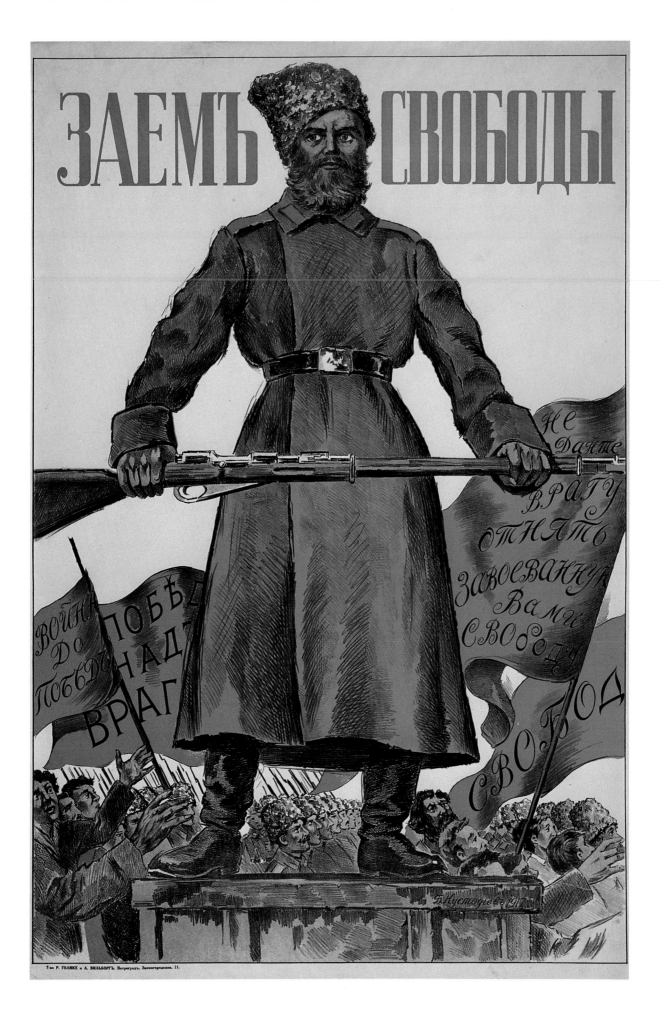

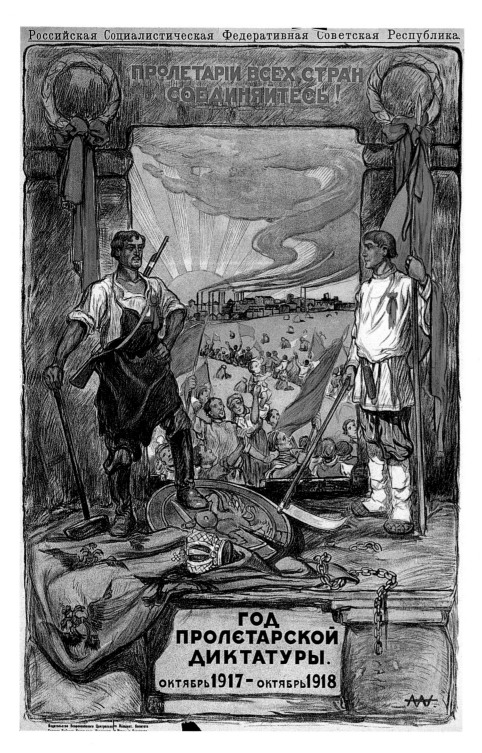

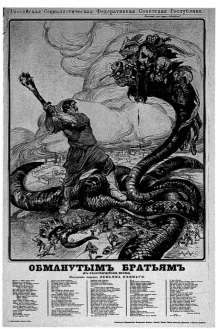

141. A year of the proletarian dictatorship, October 1917–October 1918.

U.S.S.R. 1918. Alexander Apsit.

Under Lenin's direction, the All Russian Central Executive Committee of So-viets planned to educate the largely illiterate population through "monu-mental propaganda" which relied heavily on posters. In Moscow, Apsit pro-duced the first new Soviet posters which, like previous Russian posters, featured much detail, narrative style, and frequent folk motifs. In this poster, worker and peasant herald the dawn of the future productive com-munist nation seen through the window frame. Under their feet in the inner room, representing the past, are the luxurious and oppressive symbols of the vanquished tsars.

142. To the deceived brothers.

U.S.S.R. 1918. Alexander Apsit.

The Red Army's struggle against Allied interven-tion and White Guard armies is personified by Apsit in the peasant's Herculean combat against the hydra-headed monster of imperial-ism—one of whose crowned heads is Nicholas II. Directed at White supporters, the poster is based on a revolutionary poem by Dem'yan Bednyi, but the image is drawn directly from the tsarist poster of the Russian boyar (Poster 14).

143. Long live the revolutionary Red Army!
U.S.S.R. 1919.

Early Soviet posters often appealed to the population by linking folk culture with current politics. In the style of a woodcut, this poster portrays Red Army Cossacks on winged horses proclaiming victory over White generals while the Red Army surrounding the medieval Kremlin drives away Woodrow Wilson, John Bull, and William II, who even after his abdication remained a useful symbol of German militarism.

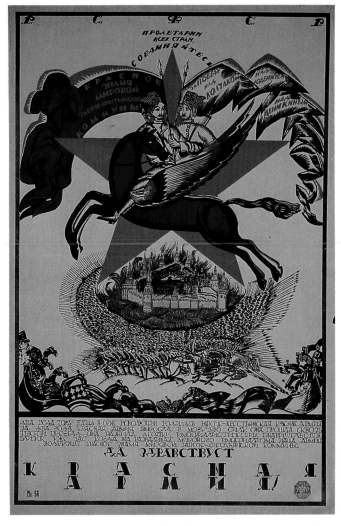

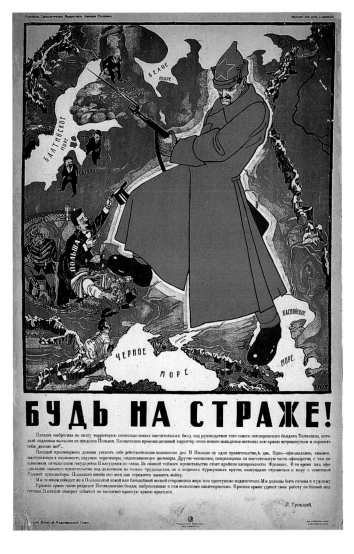

144. Be vigilant.
U.S.S.R. 1920. Dimitri S. Moor.

Moor produced over fifty political posters for the Revolutionary Military Council under Trotsky during the years 1919–1920 in which he combined large stereotyped images with fussy didactic details. This one, showing a Red Army hero defending the Russian border, appeared after the Russo-Polish war and warned that enemy armies—depicted as black capitalists incited by a French officer and a Ukrainian hetman—may again invade.

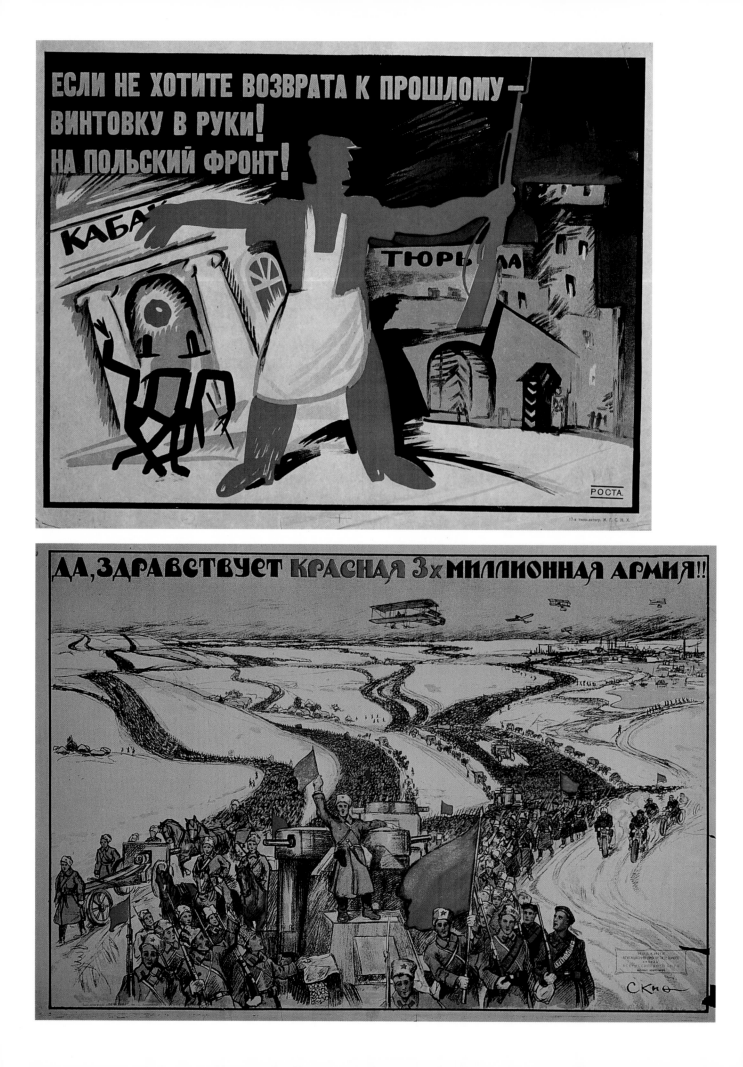

145. If you don't want to return to the past, take your bayonet and hand to the Polish front!
U.S.S.R. 1920.

Avant-garde artists, including Mayakovsky and Rodchenko, worked from 1919 to 1922 to create hand-stenciled posters, continuing the moralistic folk-tradition of woodcuts in a simplified modernist style. These hastily executed sheets communicated news bulletins from the Russian Telegraph Agency, ROSTA, for display in shop windows in Moscow. Here, the red worker calls on comrades to fight against counter-revolutionary forces, represented by dissolute capitalists staggering before a bar and a prison.

147. Three words: uninterrupted demobilization—building the republic—peace.
German, 1918–1919. Heinrich Richter-Berlin.

In the first winter after the war, expressionist artists in Berlin produced posters for the socialist government calling for discipline, order, and the end of strikes. The foray into national politics by avant-garde artists met with little success since the agitated expressionist style translated poorly into the mass language of political posters. This image of a worker upholding the government slogans against a backdrop of revolutionary flags is the top half of a large poster that was also used in this truncated fashion.

146. Long live the three-million man Red Army!
U.S.S.R. 1919. Skif (A. Apsit).

Apsit's panoramic vision of a victorious Red Army streaming across the great plains of Russia was produced in late 1919, before he fled from a Moscow threatened by the White Army. Apsit lived to see his early Soviet posters denounced as stylistically bourgeois in their idealism and lack of socialist realism.

148. Who protects us against collapse? The armed proletariat!
German. c.1919–1920.

The infrequent early posters of the German Communist Party reflected the ambiguous, provocative position of the party in the first years of the republic. By trying to radicalize the revolution, the party precipitated sporadic civil war that shattered the left and strengthened reactionary coalitions. In this drab poster, the defiant armed stance and slogan of the worker is belied by his stolid appearance and the prosperous landscape below.

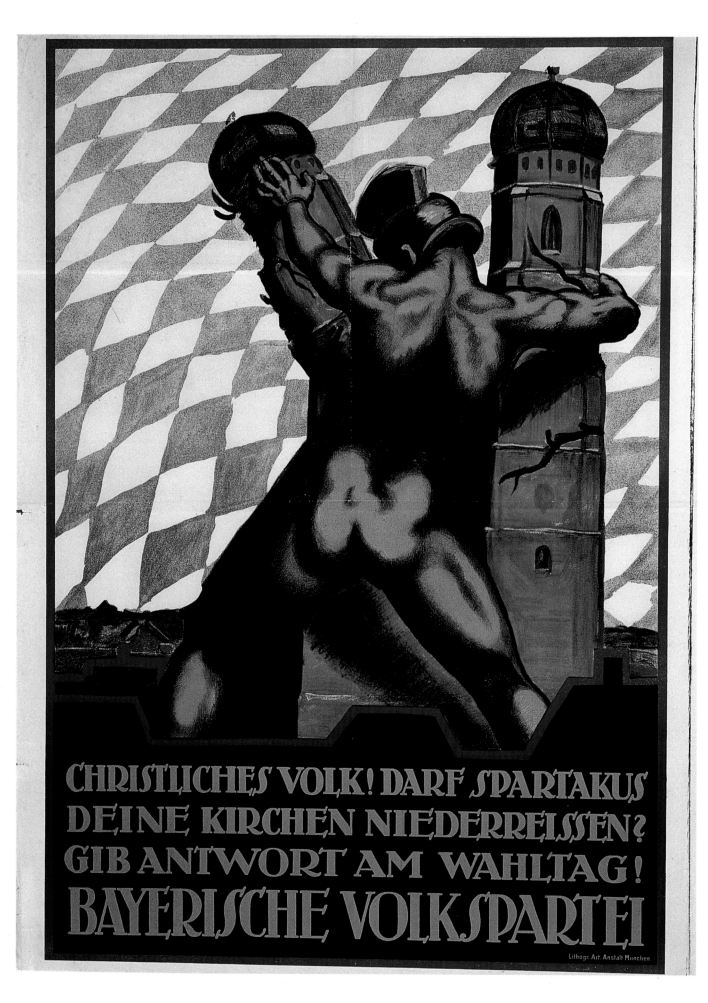

CHRISTLICHES VOLK! DARF SPARTAKUS
DEINE KIRCHEN NIEDERREISSEN?
GIB ANTWORT AM WAHLTAG!
BAYERISCHE VOLKSPARTEI

Lithogr. Art. Anstalt München

149. Christians! Shall Spartacus tear down your churches?
German. 1919. Hermann Keimel.

The Bavarian People's Party symbolized its opposition to the revolutionary government that had ousted the Bavarian monarcy in 1918 with this image of a huge communist (Spartacist) toppling Munich's central landmark—the Church of Our Lady. The academic modeling of the body constituted a conservative aesthetic challenge to the angular posters of the expressionists favored by the revolutionaries (Poster 147).

151. East Prussian Volunteer Corps.
Germany. 1919. FVZ.

A stylistically modern poster accenting camouflage techniques developed by artists during the war.

150. Join the Eastern Frontier Guards! Protect your country against bolshevism!
German. 1919. Lucian Bernhard.

Shortly after the war, recruiting began among demobilized soldiers for mercenary corps to fight bolshevism in the east and at home. Conservative groups paid for heavy anti-bolshevik advertising, including this bizarre poster by Bernhard, evoking a bestial threat to the German homeland defined both by the medieval village and by the Germanic typeface that was a specialty of Bernhard (Poster 25).

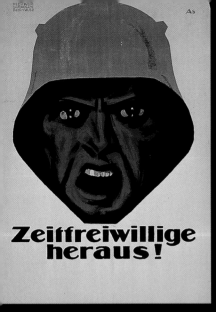

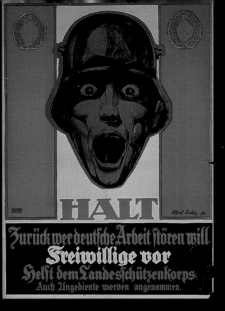

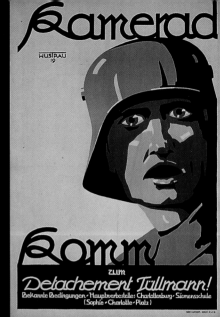

52. Temporary volunteers, let's go!
German. 1919. AS.

153. Stop those who want to disrupt German work.
German. 1919. Albert Birkle.

154. Comrade, come to the Tüllmann detachment!
German. 1919. Wustrau.

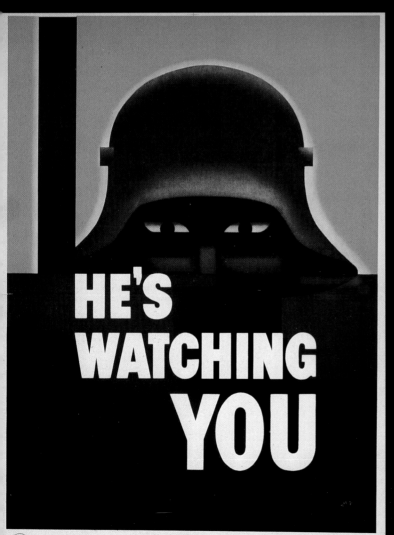

Since the volunteer corps were drawn from front soldiers molded by trench warfare, crystallized in Fritz Erler's 1917 poster (Poster 58), it is not surprising that their steel helmet, adopted in 1916, became the symbol of military—and masculine—strength. Extolled by the conservative author Ernst Jünger in his war memoirs as princes of steel with piercing eyes and granite chins, these men in helmets became the right-wing anti-bolshevik counterpart to the Red Army soldier with his soft-peaked cap.

The strength of the image led to its use in recruiting posters for the Reichswehr, the new republican army, which on a visual level revealed the close ties between the army and the mercenary corps. By the late 1920s, the Steel Helmet was both name and symbol of the rightist organization of front soldiers and was used in election posters. Under National Socialism, the helmet became an icon of military prowess and national pride, while for the Allies it encapsulated Hitler's sinister and menacing regime.

159. He's watching you.
US. 1942. Glen Grohe.

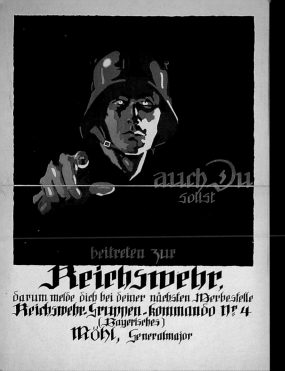

155. You too should join the Reichswehr.
German. 1919. Julius Ussy Engelhard.

In this surprisingly abstract poster for the new republican army, Engelhard, one of the Munich artists who produced anti-bolshevik posters (Poster 178), combined the steel helmet motif with the pointing gesture of recruiting posters of the war.

156. And you?
German. 1932. Ludwig Hohlwein.

Hohlwein's stunning poster, used with different texts by both the Steel Helmet and the German National People's Party in the elections of 1932 and 1933, transforms man and helmet into an inhuman sculptural mass imposed on a schematic imperial German flag.

157. Wheels must roll for victory.
German. c.1942. von Axster-Heudtlass.

158. The front calls to the homeland.
German. c.1941. Mjölnir (Hans Schweitzer).

In these Nazi posters, which juxtapose production with military success, the helmet promises protection for life behind the front (Poster 272).

160. Red Parliament! Vote Social Democratic.
Hungary. 1919. Biró.

161. They wash themselves!
Hungary. 1919.

In the events of March 1919 in Hungary leading to the Soviet Republic under the Communist leadership of Belá Kun, these posters played off each other, using revolutionary red to convey opposing views. For the Social Democrats, cooperation with the Communists promised the renewal of parliament; for the right-wing, communism meant a bloody massacre of the state perpetrated by the ape-like Bolshevik.

162.
Hungary. 1919. Manno Miltiades.

The idealized or demonized giant red worker is aghast at his devastation of his own country. The image, borrowed from fussy Soviet Russian posters and grotesque German anti-bolshevik posters, is aesthetically simplified into a counter-revolutionary message.

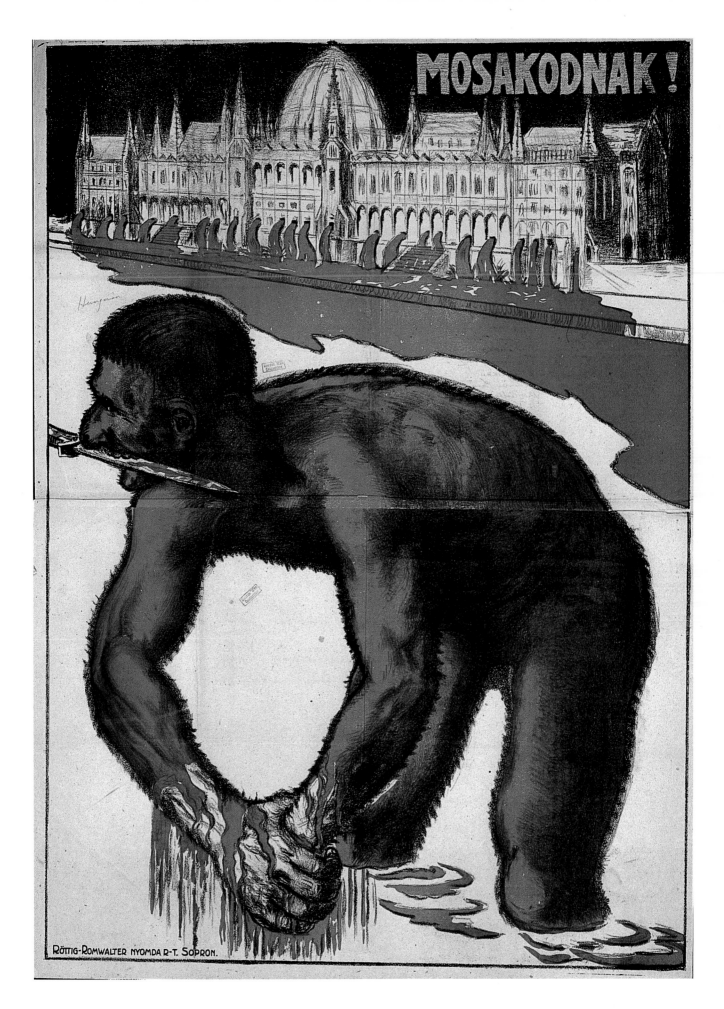

10.

The Soviet Union

163. Long live the Third Communist International.
U.S.S.R. 1920. Sergei Ivanov.

Issued to publicize the Second Congress of the Comintern, which met in Moscow in July, this poster optimistically portrays British Communists joining Russians in holding high the revolutionary flag.

After civil war and foreign intervention ended in 1921, the Soviet government threw its energies into building a new Communist state. But the rhetoric of the government's posters notwithstanding, it proved impossible to sustain the fervor of the revolutionary years. The need to bring order out of wartime chaos and to turn a backward society into a model state was transposed into increasingly didactic posters that formulated social imperatives. Posters became vehicles for literacy and hygiene campaigns, economic development, political indoctrination, and social change. The hope of Commissar of Enlightenment, Anatoly Lunacharsky, to enlist the avant garde to create new proletarian art forms was disappointed as control and instruction took precedence over experimentation and imagination.

By the 1930s, with the Five-Year Plans making industrialization and collectivization the top priorities, poster artists were regimented into a social realism that slavishly followed Communist party directives and af-

firmed the new Soviet order under Stalin. Most of the posters of this decade were reduced to presenting heroic cardboard peasants and workers against a background of progressive industrial and agricultural scenes. Despite this, the strong caricatural tradition and the constructivist ROSTA style managed to emerge on some posters, particularly in the late 1930s when the rise of facism in Europe again provided an external enemy to vilify.

The persuasive function of posters means that they often convey, particularly in a political context, not only equivocal but deceitful messages. While all political posters are ideologically motivated, the posters of Stalin's Soviet Union and Hitler's Germany were cynically mendacious in their optimistic representations of new social orders that camouflaged their disregard for human lives. The posters of both regimes document the continuation of the tactics of wartime propaganda into an assault against one's own people as part of the process of ideological indoctrination.

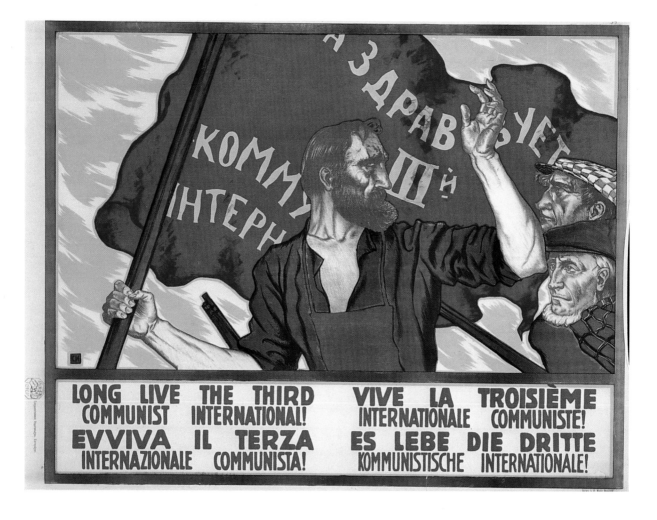

LONG LIVE THE THIRD COMMUNIST INTERNATIONAL!
EVVIVA IL TERZA INTERNAZIONALE COMMUNISTA!
VIVE LA TROISIÈME INTERNATIONALE COMMUNISTE!
ES LEBE DIE DRITTE KOMMUNISTISCHE INTERNATIONALE!

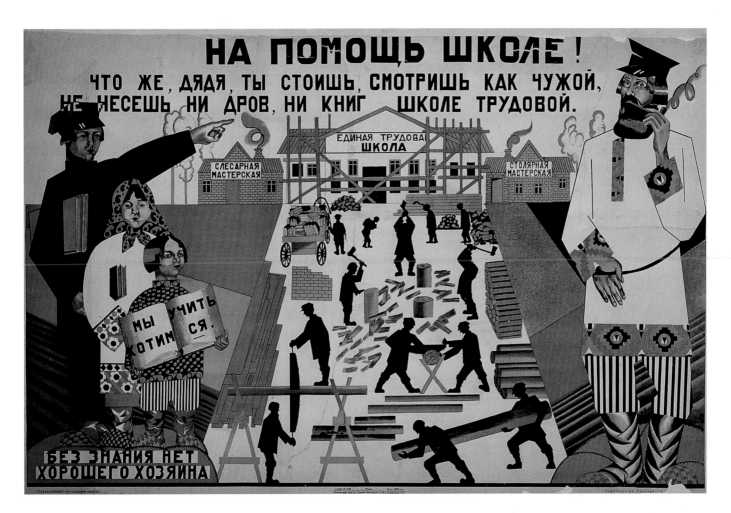

164. Help the school.
U.S.S.R. 1923.

This charming poster is a surprising amalgamation of modern two-dimensional poster techniques with folk images. It celebrated the building of a new school that combined literacy and labor by locating a metal shop and wood shop on either side of the classroom. The doll-like Russian children admonish their elders for failing to join in the enterprise.

165. The illiterate man is a blind man. Failure and disaster await him.
U.S.S.R. 1920. Aleksei A. Radakov.

The poster, whose image suggests a peasant proverb, is actually a state advertisement insisting upon the necessity of literacy and promoting books on progressive methods of farming and husbandry.

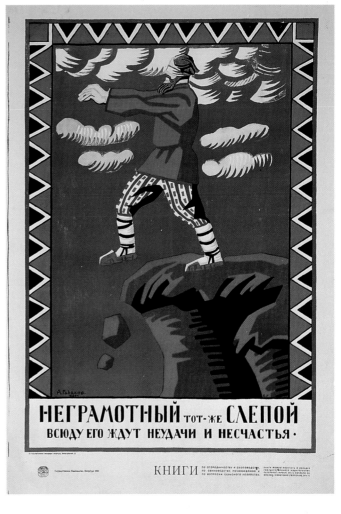

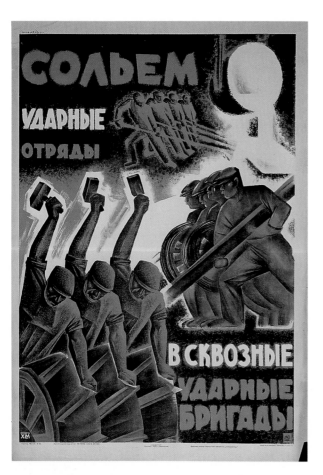

166. Merge shock detachments into combined shock brigades.
U.S.S.R. 1931. Leningrad Artists Collective.

167. We smite the lazy workers.
U.S.S.R. 1931.

Two posters mobilize workers into industrial shock brigades for the Five-Year Plan: men are absorbed into a machine-like system that is embodied in rhythmic, futuristic styles. The disciplined motion of the red robotic workers cannot tolerate the irregularity of the slacker, here presented in a style adopted from the anti-capitalist caricatures of the German artist George Grosz.

168. Remember the starving.
U.S.S.R. 1921.

During the disastrous famine of 1921–23, the American Relief Administration, led by Herbert Hoover, collected and distributed over $60 million worth of food and medical supplies from Europe and the United States. At the same time campaigns within the Soviet Union were directed at the people to encourage frugality. This stark poster skillfully arranged the pointing hand and simple meal against the sketchy intimation of desperate, emaciated multitudes to produce its harsh admonition.

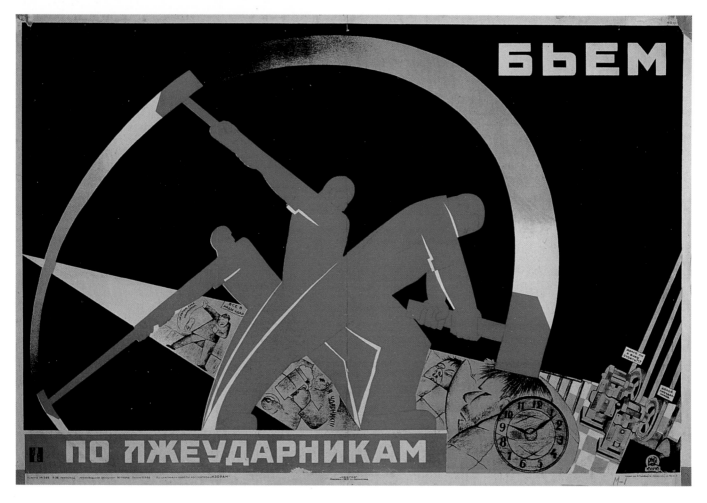

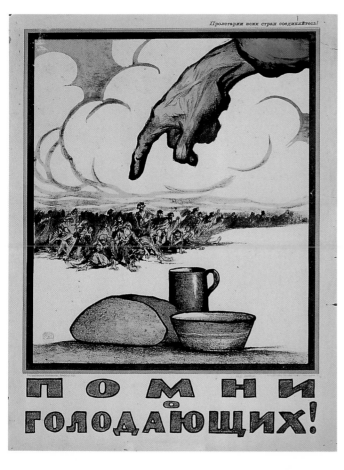

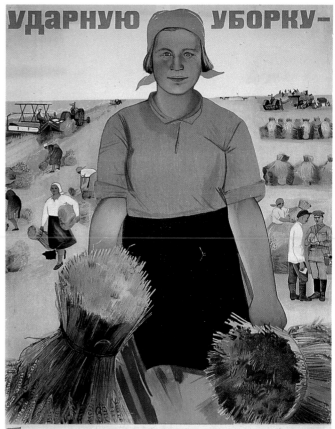

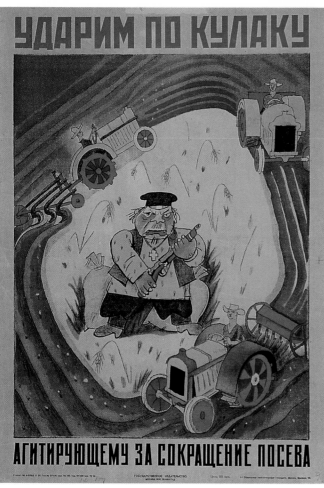

169. For shock-brigade reaping and for a bolshevik harvest.
U.S.S.R. 1934. Maria Voron.

A typical example of socialist realism promoting mechanization of agriculture on the large collective farms that were formed from peasant holdings. Supervised by local soviets, the peasants—male and female—were urged to work in brigades, as in industry, to increase productivity. The poster visualizes an ideal of disciplined workers in ordered fertile fields. The robust figures give no hint of the actual crop failures and famine in 1931–32 that resulted from forced collectivization.

170. We will smite the kulak who agitates for reducing the cultivated area.
U.S.S.R. 1930.

The massive program of expropriating the land of the kulaks and eliminating them as a class through forced deportations is given expression by this unpleasant image of a wealthy land-owning peasant who does not want to lose his land to collectivization. The designer drew the encircling pattern of the cultivation of the land by tractors to represent the new agricultural policy against which the caricatured peasant vainly defends his miserly, antisocial ways.

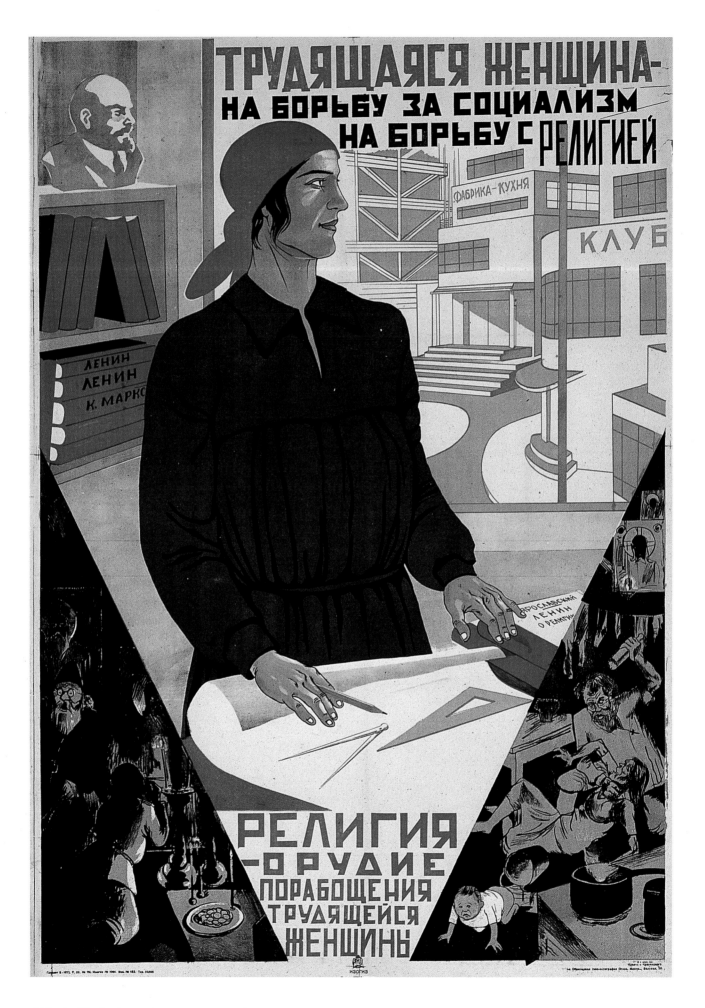

171. Religion is poison. Safeguard the children.
U.S.S.R. 1930. N. B. Terpsikhorov.

(opposite page)
172. Working woman in the struggle for socialism and the struggle against religion.
U.S.S.R. 1931. B. Klinch and Koslinskii.

These posters proclaim the same message: the new Marxist-Leninist state will free women from their bondage to reactionary priests and teach them to become productive citizens in a utopian socialist society, symbolized in both by strong new modern buildings. In a vigorous design, the old woman struggles against the child's desire to turn away from the crumbling edifice of the church towards a future in which the cross is replaced by an airplane. The design on the left divides the past from the future through a realm of light emerging out of the darkness of religious superstition where drunken men brutalized women. Women, freed from religion by Lenin's writings, become productive workers—here as an architect designing the shining international-style city of the new society.

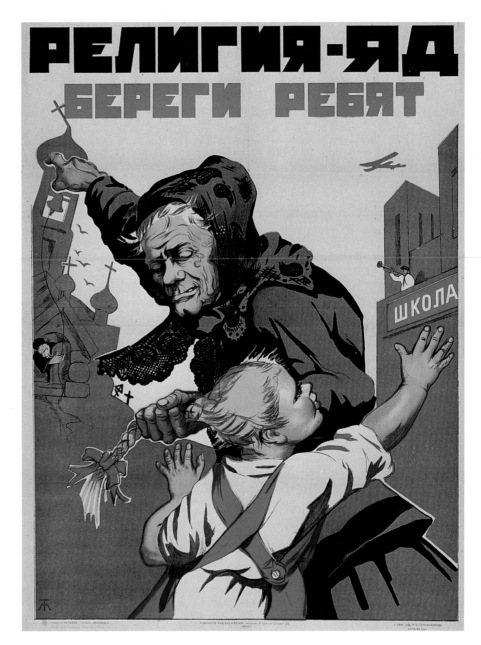

(following pages)
173. **Raise higher the banner of Leninism, the banner of the international proletarian revolution.**
U.S.S.R. 1932. N. Kochergin.

Designed to celebrate the completion of the First Five-Year Plan, carried out during the years of the Great Depression, the poster again uses light and dark to distinguish scenes of Soviet progress from those of capitalist collapse. On the top, in red, can be seen the upward progression of orderly ranks of proud workers who are united, under Lenin's guidance, in building new industry and boosting production. Below, the capitalist world of stock exchanges, banks, and factories crumbles into chaotic civil war, while yellow figures—signifying Social Democrats—mediate battles between workers and police, protest exploitation and executions of workers, and attempt to stop the Nazi onslaught—all without success because they do not follow true revolutionary principles.

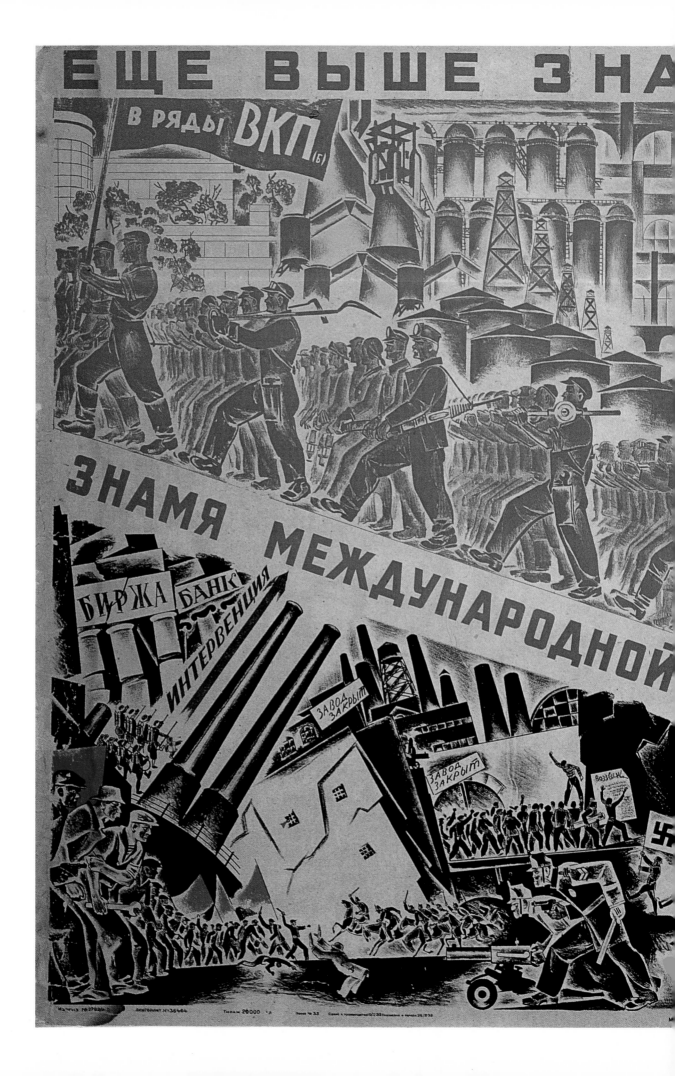

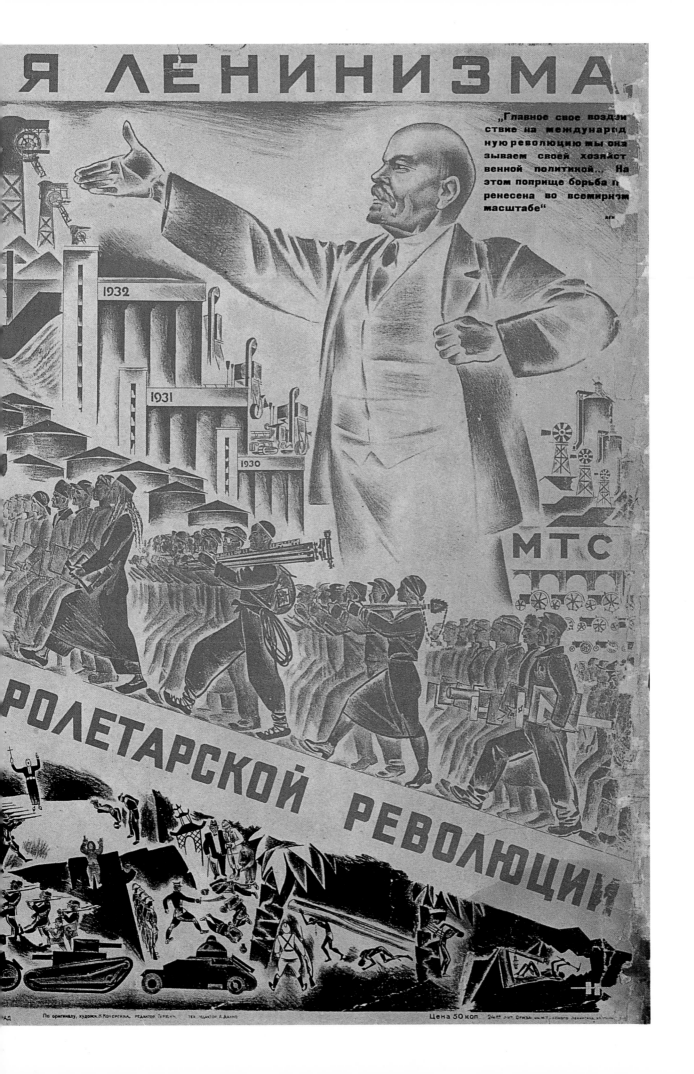

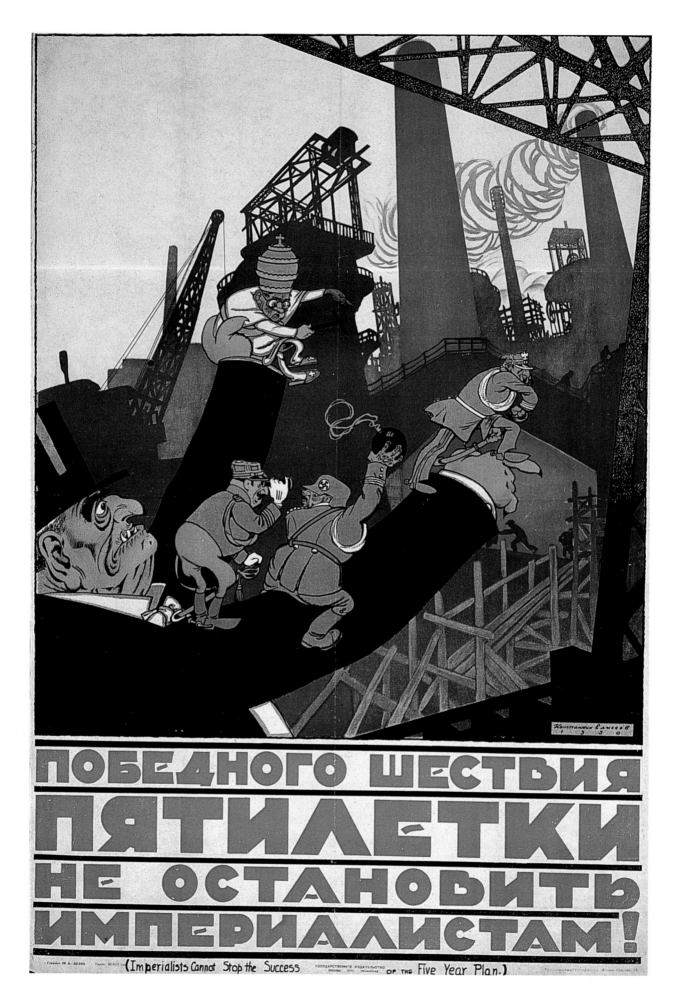

ПОБЕДНОГО ШЕСТВИЯ ПЯТИЛЕТКИ НЕ ОСТАНОВИТЬ ИМПЕРИАЛИСТАМ!

(Imperialists Cannot Stop the Success of the Five Year Plan.)

174. Imperialists can not stop the triumphal march of the Five-Year Plan.
U.S.S.R. 1930. Konstantin Eliseev.

The aging, top-hatted capitalist vainly goads his puppets—German, French and Polish officers and the pope—to attack the rising Soviet industrial power. Even before Hitler's accession to power, Russian propaganda linked German militarism with National Socialism.

175. United Front for the storming of capitalism.
U.S.S.R. 1935. A. Keil (Ék Sándor).

A Hungarian communist, Ék Sándor, was active in setting up artist organizations after 1928 in both Germany and Russia that enforced Communist party guidelines among artists. This Soviet poster—very similar to German posters of the 1930s—confirms the new United Front policy calling for co-operation of all the parties of the left against capitalism.

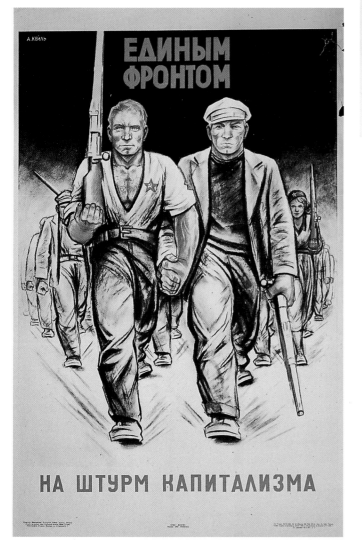

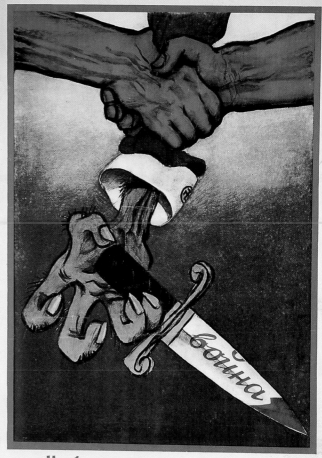

176. Increase the forces of the antifascist front to make the knife fall from the paw.
U.S.S.R. 1938. Mikhail M. Cheremnykh.

Produced in August during the Czechoslovakian crisis, but before Chamberlain's capitulation to Hitler, this poster invokes its message through hands: strong clasped hands of the united antifascist front forcing the bestial Nazi hand to drop its plans for war. Once again, light and darkness define the realms of good and evil.

11.

Germany
and National
Socialism

The National Assembly elected in January 1919 voted to establish a constitutional parliamentary republic of federated states in Germany. In the following fourteen years, twelve national elections were held—three presidential and nine, in which, because of proportional representation, over twenty parties vied for National Assembly and then Reichstag seats. When state and municipal elections are added, it is clear that the republic provided a bonanza for the designers of political posters. Many posters were mediocre to poor, but the ideological and social diversity represented by the parties ensured that they expressed important interpretations of social and political issues. Throughout the country, posters constituted raucous visual debates, rather than the monologue of assertions that issued from one-party governments.

During the twenties, the parties of the far left and right attacked their enemies and expressed their convictions in aggressive posters, which by the end of the decade openly opposed the republic. Posters of the liberal and Catholic parties, often produced by commercial artists, tended to be less effectual and often seemed to lack conviction. A National Socialist analysis of political posters argued that persuasive posters contained three ingredients—the enemy, the defender, and what needs to be defended—and singled out the anti-bolshevik posters of 1919 as compelling models. Nazi posters refined this formula, intensifying the fear of the Bolshevik-Jew, glorifying the front soldier of the war posters, and romanticizing the family. Orchestrated by Goebbels, Nazi propagandists, appealing to the young and to the socially and economically insecure, helped bring about the massive electoral shift in the Reichstag elections of September 1930, which in effect marked the end of the parliamentary government.

After Hitler became chancellor in 1933, though still the leader of a minority party, the contentious party election posters were replaced with posters whose purpose was uniform indoctrination, as parties that opposed Hitler were eliminated. A division for posters under Hans Schweitzer (Mjöl-nir) was created in the Reichs Chamber for the Visual Arts in Goebbels' Ministry of Propaganda. Posters to win support at home and abroad presented a unified vision of an orderly nation peopled by wholesome workers and families whom National Socialism protected from domestic and, soon, from foreign enemies.

177. The danger of bolshevism.
Germany. 1919. Rudi Feld.

(page 124)
178. Bolshevism brings war, unemployment, and famine.
Germany. 1918. Julius Ussy Engelhard.

Political life in the republic was haunted by the fear of communism that posters of the anti-bolshevik leagues and volunteer corps had helped propagate. European caricatures had depicted socialism as a skeleton since the nineteenth century, but Feld's image was adopted from a horror novel. The most influential source for these bolshevik monsters was, ironically, Allied images of the bestial German Hun. Engelhard's Bolshevik is a cross between Triedler's and Hopp's sub-human destroyers of civilization (Posters 31 & 32). Under the Nazis, the bolshevik menace took on the added form of the Jew (Posters 190 & 191).

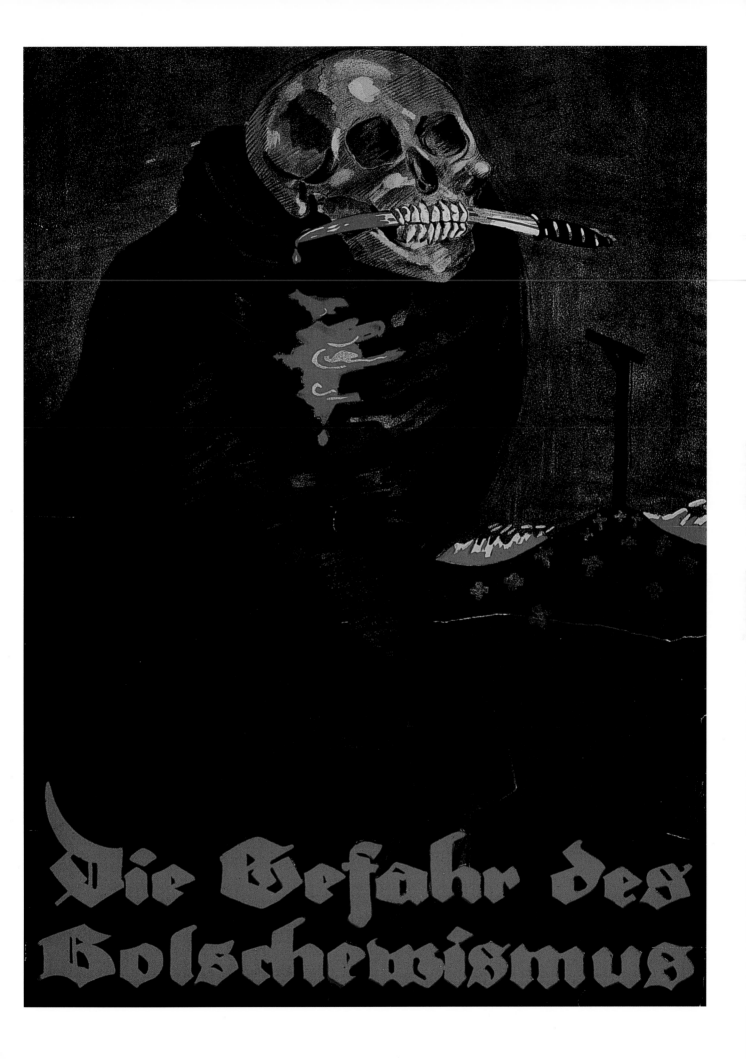

Die Gefahr des Bolschewismus

179. Women! Provide for peace and bread! Promote and vote for the election!
Germany. 1919. Lucian Bernhard.

A non-partisan poster, created by Bernhard for the Committee of Women's Associations in Germany, urged women to vote in the first election held under the provisional government that in November 1918 had proclaimed women's right to vote. Various political parties ingeniously usurped the poster by pasting their own message over the orange square.

180. Women and men, ensure the happiness of your family and children by voting for the Christian People's party (Center party).
Germany. 1920. Julius Gipkens.

Since the women's vote was potentially very large, all of the parties, even the rightist ones that had opposed women's suffrage, undertook serious campaigns to win their vote. Each party's posters reflected its attitude toward the role of women within society. The Socialists and Communists treated them as emancipated working women; the conservative parties, especially the Catholic Center, focused on the importance of women's votes for preserving traditional family values, here epitomized by a nineteenth-century silhouette of a happy family.

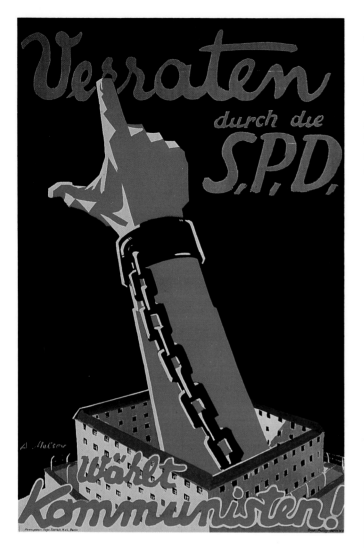

181. Betrayed by the Socialists. Vote Communist!
Germany. 1930. A. Malsov (Victor Slama).

182. Clear the way for List 1. Social Democrats.
Germany. 1930.

The Communist party poster for the crucial September 1930 election, with its shackled hand emerging out of a prison, repeated the charges that the Socialists had betrayed the cause of the worker during the course of the republic, while the Socialist party represented itself as the only true working class party opposing both Communists and Nazis.

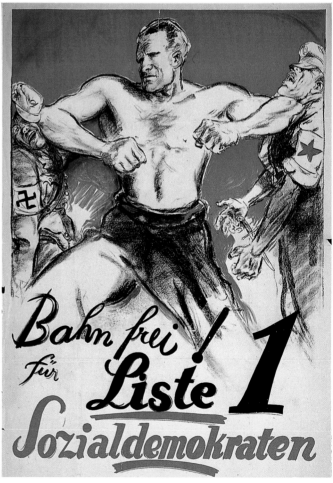

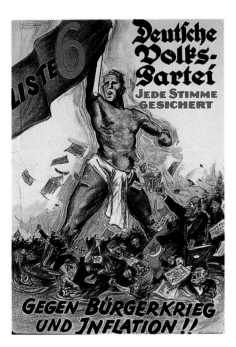

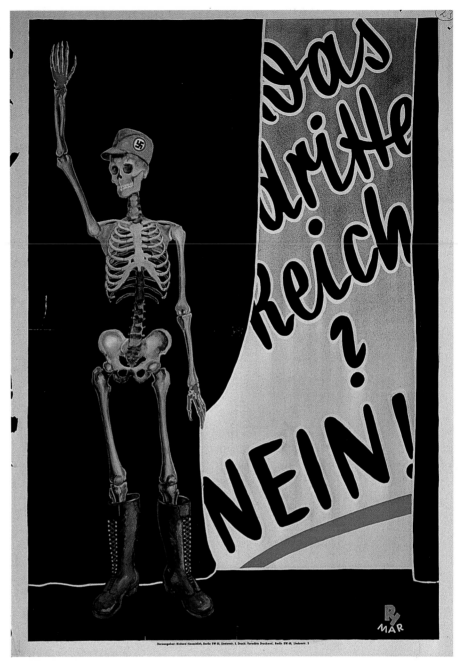

183. Every vote counts against civil war and inflation!!
Germany. 1932.

In successive Reichstag elections in 1932, the conservative People's party presented itself as the muscular savior who would clean up the chaos into which Germany was falling. The design, with its bloody street fighting incited by capitalist corruption, plays on the fears of the 1921–23 inflation, although by now Germany was in the midst of the Great Depression.

184. The Third Reich? No!
Germany. 1932. Rimar.

According to one Nazi account, this Social Democratic party attack on the National Socialists was blunted when, forewarned about the poster, the Nazis pasted a socialist hat and logo onto the skeleton and changed the "No" to a "Yes."

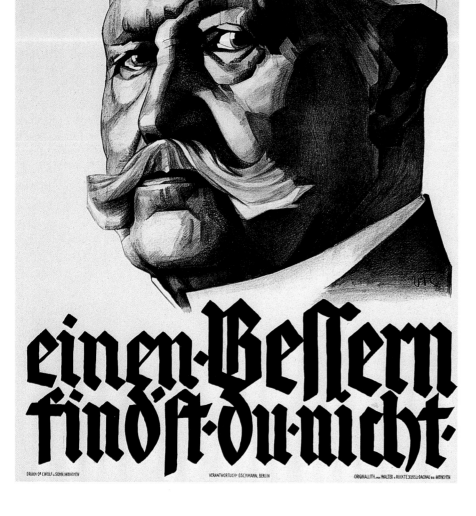

185. A better man you won't find.
Germany. 1932. Walter von Ruckteschell.

186. Our last hope: Hitler.
Germany. 1932. Mjölnir (Hans Schweitzer).

Hitler unsuccessfully challenged the incumbent Hindenburg in two presidential elections in the spring of 1932, but, within a year, Hindenburg named Hitler chancellor of the republic as head of a Nazi-Nationalist alliance that would resolve the parliamentary deadlock. The rock-like poster of Hindenburg evoked the First World War hero (Poster 96) both in the image and in the title taken from a traditional soldier's song known by every school child. Mjölnir's poster of grim-faced Germans, whose only hope lay in Hitler, was one of his major successes (see page xvi).

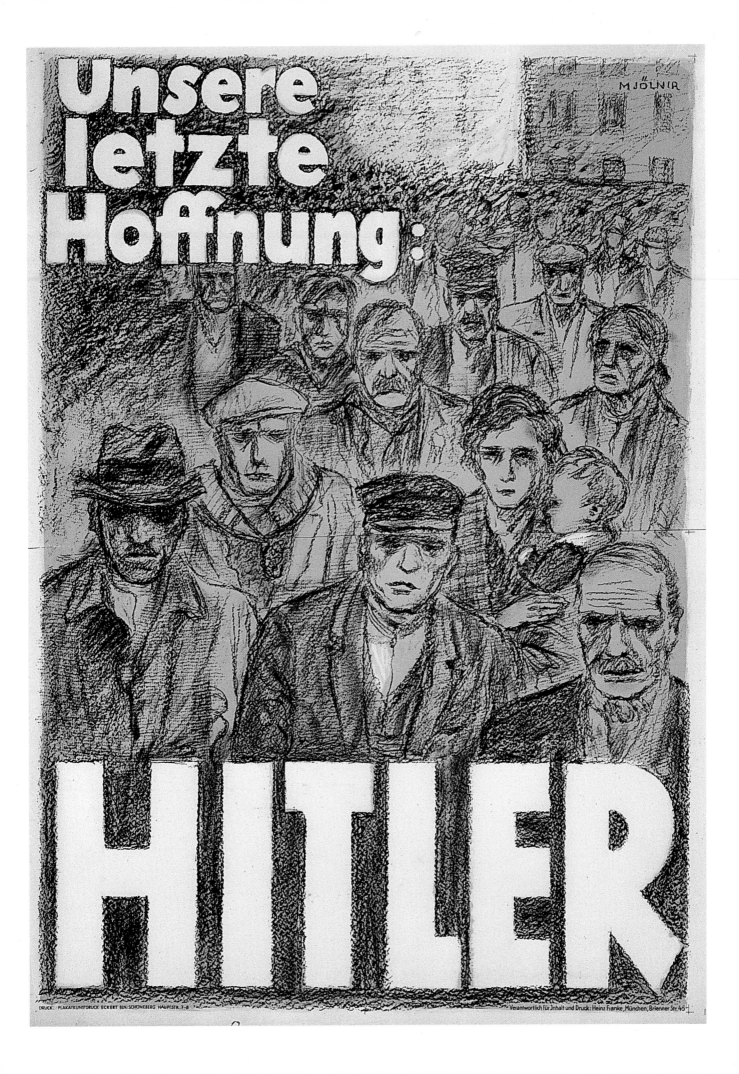

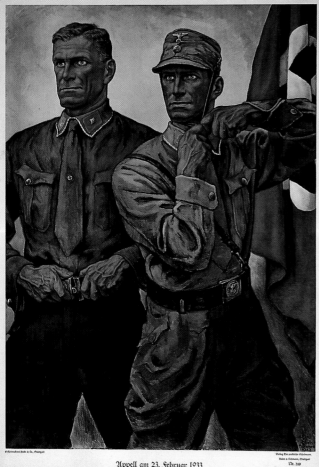

Appell am 23. Februar 1933

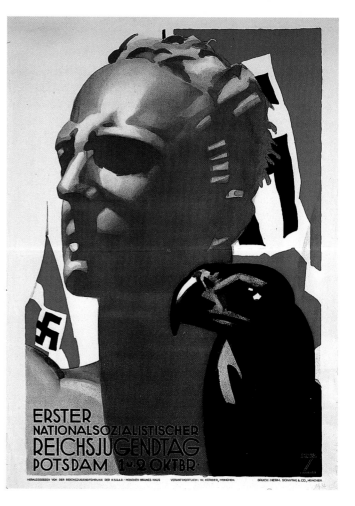

ERSTER
NATIONALSOZIALISTISCHER
REICHSJUGENDTAG
POTSDAM 1 u 2 OKTBR

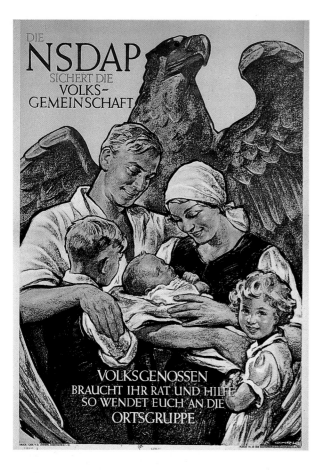

DIE
NSDAP
SICHERT DIE
VOLKS-
GEMEINSCHAFT

VOLKSGENOSSEN
BRAUCHT IHR RAT UND HILFE
SO WENDET EUCH AN DIE
ORTSGRUPPE

187. Roll call on 23 February 1933.
Germany. 1939. Elk Eber.

188. The first National Socialist national youth day.
Germany. 1932. Ludwig Hohlwein.

189. The National Socialist party ensures the people's community.
Germany. Ahrle.

*The design in each of these posters uniquely characterizes the basic images
of the new racial community: storm troopers girding themselves for action,
Hitler youth following the Führer, and mothers surrounded by their family.
Eber's academic painting style with carefully delineated hands and faces as-
serts the tough reality of these veterans of street brawls; Hohlwein's sculp-
tural masses arranged against flags affirms the abstract idealism of un-
tested youth; and Ahrle's romantic, saccharin style suited the extravagant
exaltation of the family common to Nazi rhetoric.*

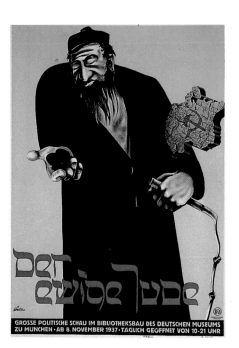

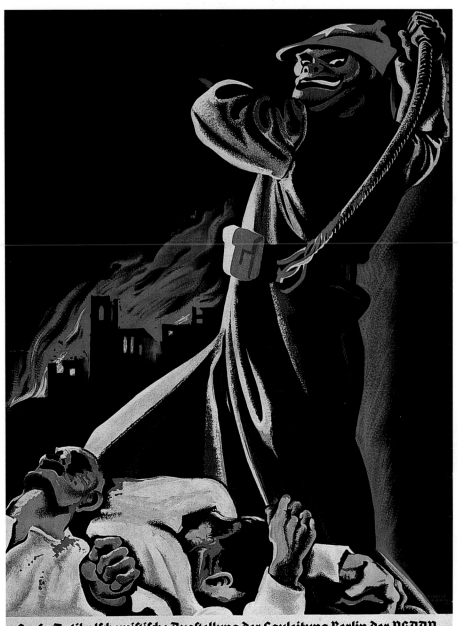

190. The eternal Jew.
Germany. 1937. Hans Stalüter.

191. Bolshevism unmasked.
Germany. 1937. Herbert Agricola.

*These stereotypes of the Jew as a money
lender enslaving Germany to the Bolsheviks,
and of the Bolshevik as the destroyer of civilza-
tion, announced major exhibitions in Munich
and Berlin designed to enable Germans to rec-
ognize the marks of the enemy spawned by the
East and to provide ideological instruction for
the new national order. Not coincidentally, both
posters borrowed modernist techniques of fore-
shortening, shocking colors, and flat simplified
masses to stress the degenerate nature of the
enemy.*

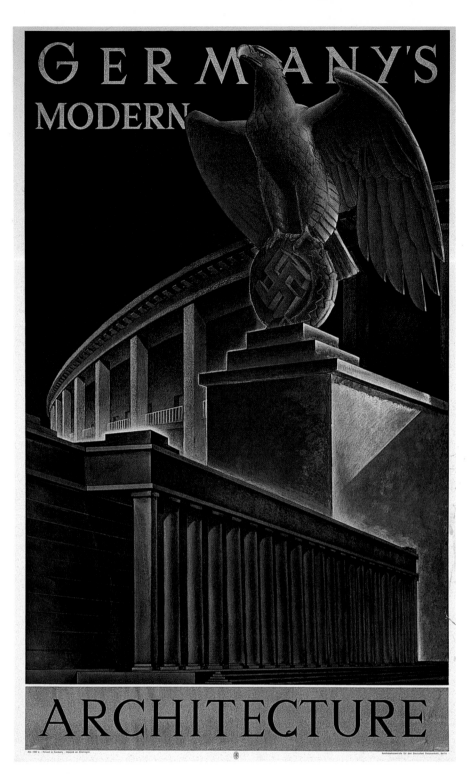

192. Germany's modern architecture.
Germany. c.1936–37.

193. Speed along German Reich autobahn.
Germany. c.1936–37. Robert Zinner.

Two posters in the sophisticated painterly academic style favored by the Nazis present the positive face of National Socialism to the world: tourists are invited to drive along the spectacular new highway, with its discrete Nazi pylon, cutting through scenic ancient lands, and to admire the neoclassical architecture of the New Germany that has replaced the Bauhaus style of the corrupt republic.

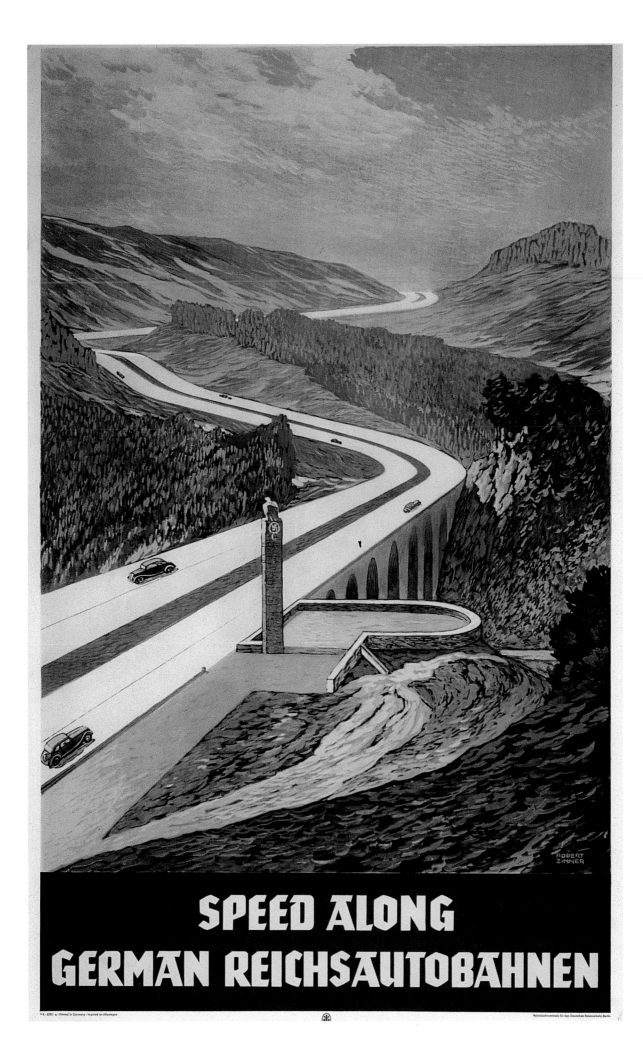

SPEED ALONG
GERMAN REICHSAUTOBAHNEN

12.

The Spanish Civil War

Posters of the Spanish Civil War express the ideological and political issues of the 1920s and '30s in a context of overt violence. The conflicts between republican and authoritarian systems of government, between capitalism and communism, and between bolshevism and the noncommunist left that had shaken Europe since 1918 all appear in the Spanish posters, but now shifted from the framework of politics to that of war.

In July 1936 a military coup against the newly elected Popular Front government in Spain started a three-year civil war, which pitted nationalists, monarchists, and fascists against republicans and the parties of the moderate and revolutionary left. Spain's strategic importance and the ideological polarization of the antagonists, which reflected the divisions throughout the western world, made it impossible for the rebellion to remain contained. The civil war soon became an international conflict.

Within a few weeks of the initial uprising, Hitler and Mussolini began sending military aid to the nationalists, while France and Great Britain adopted a policy of non-intervention. Only the Soviet Union supported the republic with arms shipments, but, in the process, its attempts to undermine moderates and anarchists in the defense coalition destroyed any hope for a truly united front.

With the influx of foreign military aid, the Spanish Civil War soon became a testing ground not only for ideologies but for modern weapons and military doctrine. Air raids on towns and cities broke down any distinctions that might still have been drawn between civilian areas and the front.

The decision of Great Britain and France not to assist the republic—motivated by distrust of the left, widespread pacifism caused by the horrors of the First World War, and their own military unpreparedness—proved to be a major miscalculation. The western powers failed to understand the seriousness of the threat posed by Hitler and, in his wake, by Mussolini. In the end, the Spanish Civil War, together with Germany's dismemberment of Czechoslovakia, shattered all realistic expectations that war could be avoided by passivity, appeasement, or diplomatic measures of any kind.

Posters from both sides of the Civil War are among the best political posters of the 1930s. Responding to the abstract and cubist styles in whose development Spanish artists were playing a major role, many of the posters make a distinct break from both Russian social realism and National Socialist romantic realism. Their greater use of abstraction and stylization is evident if one compares, for example, a Spanish anti-bolshevik poster (Poster 200) with German and American posters of the same subject (Posters 31 and 178).

194. Forward fighters for Liberty!

Spain. c.1936.

The anarchist and anarcho-syndicalist trade unions, identified in the acronyms at the top of the poster, organized the initial military response to the rebellion with which the Civil War began. The republican government's initial reluctance to arm the unions in its defense prevented a quick defeat of the uprising. This poster combines elements of social realism, not often used during the Spanish Civil War, with abstraction and a sculptured monumentality. The pathos of the profiles and the woman's oversized hands are meant to express power and extreme determination.

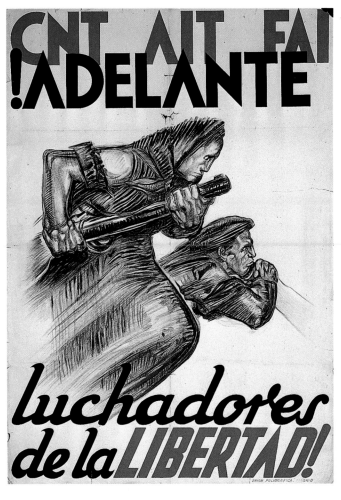

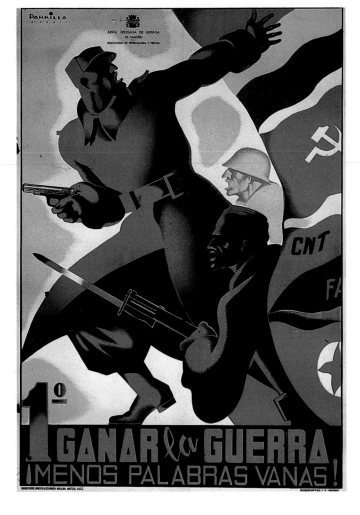

195. First win the war. Fewer idle words!

Spain. 1937. Parilla.

Fearing an imminent nationalist capture of Madrid, the republican cabinet fled to Valencia in November 1936 and left the city in control of an emergency Council for the Defense of Madrid. The flags behind the militia men represent the component groups of the council: the Spanish Republic, the Spanish Communist Party, the anarcho-syndicalist trade union (CNT/FAI), and the flag of the Soviet army, which sent equipment and advisers to the republican forces.

The Spanish Civil War / 135

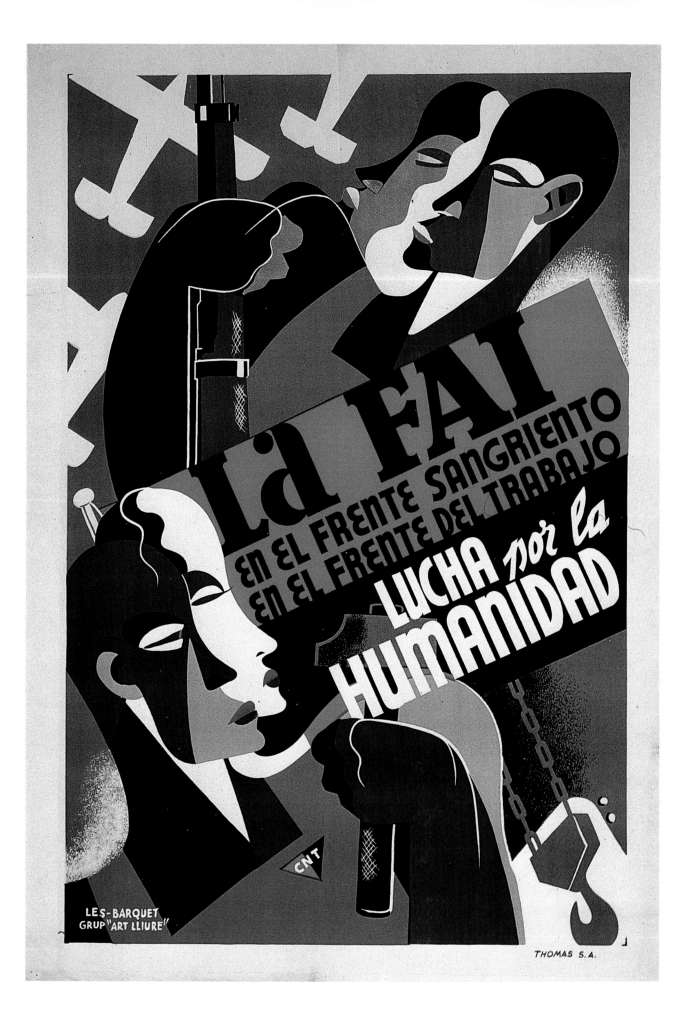

196. The FAI. On the bloody front; on the workers' front. Fight for humanity.
Spain. c.1937.

This highly stylized cubist poster, issued by the Federation of Iberian Anarchists, is a play on parallels. The two soldiers in the upper half of the image defy the aerial threat; below, their counterparts, two workers with hammer and crane hook, produce the weapons that will bring victory. The two-tiered slogan, repeating the dualities of the image, refers to the FAI's effort to turn its local trade syndicates into militia units.

197. The Generalissimo.
Spain. c.1937. Pedrero.

Produced by the artists' syndicate of the socialist trade union (UGT), this poster caricatures General Franco who had assumed leadership of the nationalist forces. Franco, his malevolence signaled by his death's head and the swastika on his chest, is a stiff, two-dimensional, cardboard puppet that serves as a front for the figures representing the military, capitalism, and clergy who gleefully carry his coat tails.

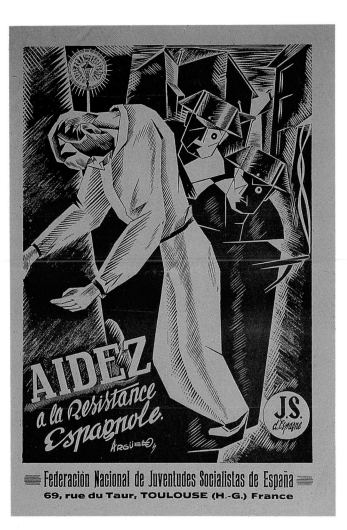

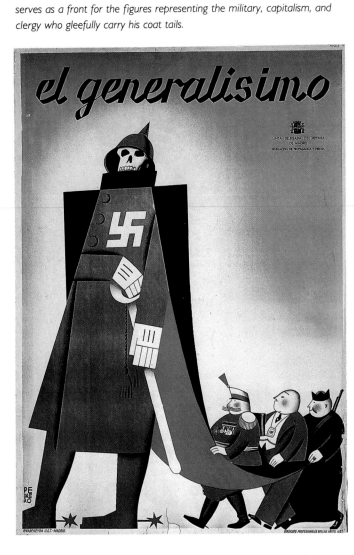

198. Aid the Spanish resistance.
Spain. c.1937. Arguello.

This cubist image shows a supporter of the republic who has just been shot by pro-Franco members of the Civil Guard, one of whom holds a smoking gun. Because of the Civil Guard's role in the often brutal suppression of peasant and worker uprisings over the previous decade, their distinctive hats had become common symbols of repression and social injustice. Under the halo of the street lamp, the falling Spaniard becomes a secular martyr.

199. Assassins!
Spain. c.1938. Lleo.

Issued as an appeal to the French public by the socialist trade union (UGT), the poster refers to the bombing raids on the population of Barcelona carried out by units of the Italian air force.

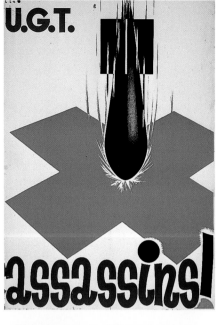

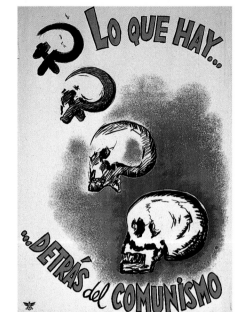

200. Communism destroys the family.
Spain. c.1937.

201. This is what lies behind communism.
Spain. c.1937.

Franco and his supporters presented all forms of disagreement and unrest as the work of bolshevism. One poster shows the hammer and sickle to be, in reality, a symbol of death; the other employs the trite but evidently effective motif of depicting the enemy as rapists and murderers.

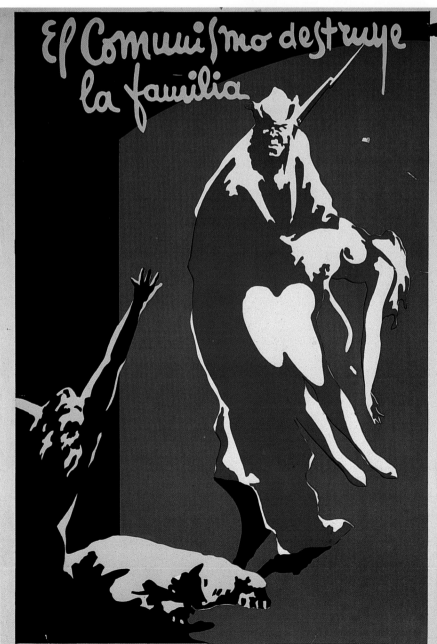

202. Discipline.
Spain. c.1937. Martinez Ortiz.

The sophisticated design of this nationalist poster belies its straightforward message of power. Spanish workers, peasants, teachers, and officials—symbolized by the factory, the plow, and the pen—must subordinate themselves to the same discipline as the steel-helmeted soldier who is shown as the unifying element of the new Spain he is fighting to create. The soldier's neck and shoulders meet in architectonic right angles, making him one with the factory buildings; his unseen right arm wraps around the image, with its hand, holding a gun, reappearing in the lower left corner. The series of repeated, stylized forms shared by the soldier and the symbols of the new society—the curved plow-blade and the helmet, the wavy drifts of smoke and the front rim of the helmet, the smoke stacks and the gun barrel, even the pen nib and the outline of the soldier's nose—all indicate union and integration under military force. The entire design is slanted across the poster to give the message a pronounced dynamic.

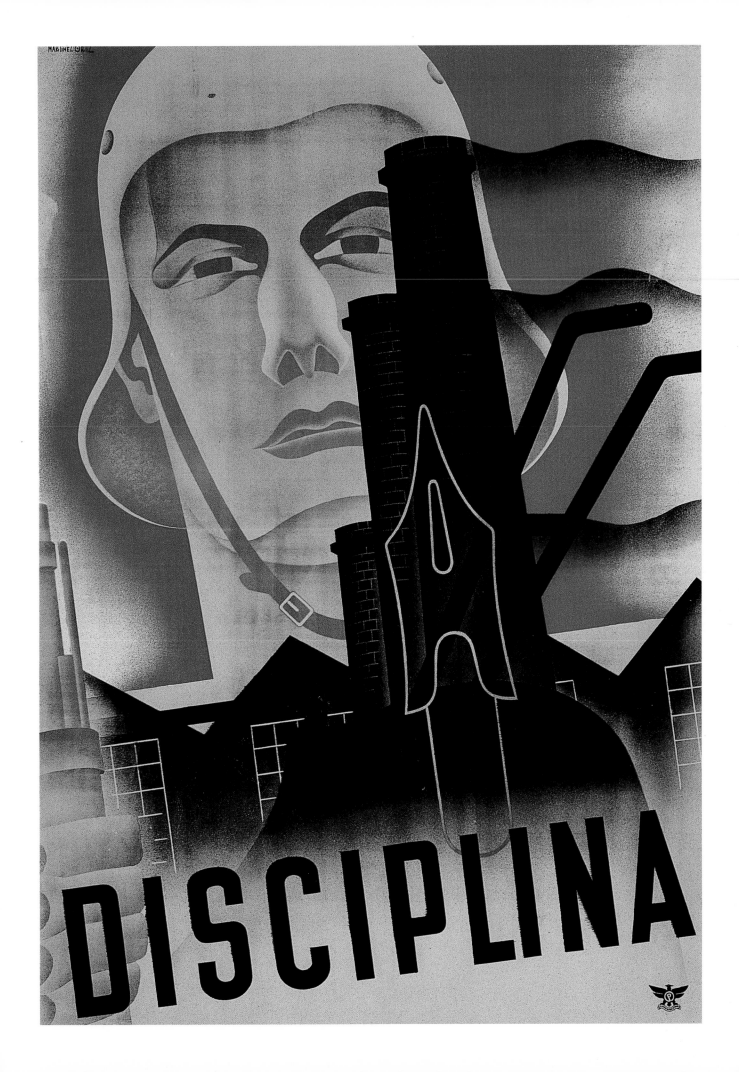

DISCIPLINA

Part III

The Second World War

13.
Early Stages

During the First World War, posters and their forerunners—proclamations and other official announcements—together with newspapers, pamphlets, books, and motion pictures made up the means of mass communication. By 1939, the print media no longer dominated the field, but shared it equally with radio, films, and newsreels. With this larger arsenal of propaganda weapons available to them, most governments relied on posters less than they once had. Nevertheless, the intense politicization of the poster during the interwar years inevitably made it a forceful presence in a conflict that was far more ideological then the First World War had been.

In every country, efforts were made to bring propaganda under central control, but as in the earlier war, true centralization remained elusive. The perspectives and interests of the services and those of foreign and domestic policy did not always coincide, and many departments and agencies retained their own publication and publicity programs. In Great Britain, the new Ministry of Information never completely controlled the output of news and propaganda, a situation that was paralleled in Germany, all attempts by Goebbels to concentrate authority in his hands notwithstanding. Several times Goebbels demanded the withdrawal or overpasting of posters from other agencies; for instance, when a poster was issued by the High Command of the Wehrmacht in 1940 with the ambiguous slogan, "To fight is to act, to talk is treason," which could be read as being directed against Goebbels' own Ministry of Propaganda. But even in the last year of the war, the army and other agencies still printed posters that were not part of a coordinated policy under his control (Poster 295). In all warring countries, posters continued to express a range of opinions and points of view, even if the range was narrow.

Posters in Great Britain and the United States, which had tarred the Kaiser and his soldiers with the brush of barbarism, rarely stressed atrocities in the Second World War, although they would have had infinitely greater justification for doing so. If only because the public had grown more skeptical, it was no longer considered an effective theme. Germany, Italy, and Russia, on the other hand, used atrocity propaganda extensively. It is improbable that accusing the enemy of inhuman actions increased the determination of Russian or German soldiers and civilians, who in any case had little choice but to follow orders, but accusing the enemy of crimes may well have helped justify one's own atrocities.

In the aggregate, posters of the Second World War may include a somewhat greater proportion of fairly realistic depictions of life in the services, combat, and conditions in the rear areas than had been the case earlier. This was less so in the Soviet Union than elsewhere—the falsifications inherent in social realism, further intensified by a repressive political system, threw up barriers to truthfulness that were too high to overcome. But showing the reality of combat was difficult for poster artists everywhere, and, in any case, was not generally regarded as helpful to the war effort. As a practical matter, the Germans and their opponents continued to believe that the primary task of the poster was not so much to inform as to exhort.

203. The messenger.
Germany. 1942. Elk Eber.

In this painting by an artist who had been a follower of Hitler since the early 1920s, National Socialism is presented as the force that is continuing the struggle of 1914–1918 and rectifying its outcome. A soldier from the earlier conflict is carrying a message through shell craters to a forward position. His features and gleaming eyes are in the tradition of Erler's field-gray savior of 1917 (Poster 58), who now has evolved from a general type to a particular individual, Hitler. The German military term Meldegänger *(runner or messenger) is here given the additional mystical connotation of the one who brings the message of salvation to his people and the world. The text is a quotation from Hitler's* Mein Kampf, *in praise of the heroism of the German soldiers of the First World War, "The iron front of the gray steel helmet."*

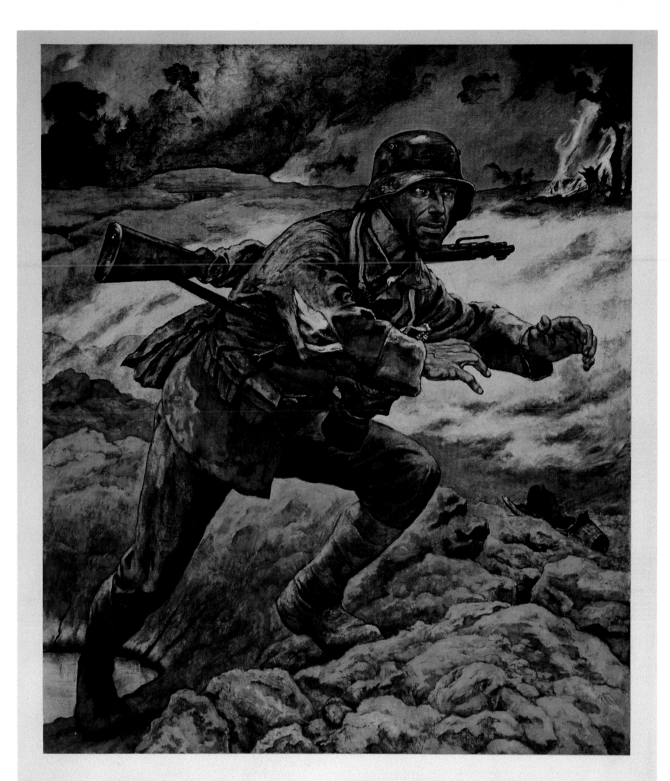

Mögen Jahrtausende vergehen, so wird man nie von Heldentum reden und sagen dürfen, ohne des deutschen Heeres des Weltkrieges zu gedenken. Dann wird aus dem Schleier der Vergangenheit heraus die eiserne Front des grauen Stahlhelms sichtbar werden, nicht wankend und nicht weichend, ein Mahnmal der Unsterblichkeit. Solange aber Deutsche leben, werden sie bedenken, daß dies einst Söhne ihres Volkes waren.

Adolf Hitler, Mein Kampf (Seite 182)

Der Meldegänger
Nach einem Original von Professor Elk Eber †

Verlag Der praktische Schulmann,
Keller & Nehmann, Stuttgart
Nr. 293

Offsetdruckerei Fricke & Co., Stuttgart

Text dazu im „Schulmann" Heft 1/1942

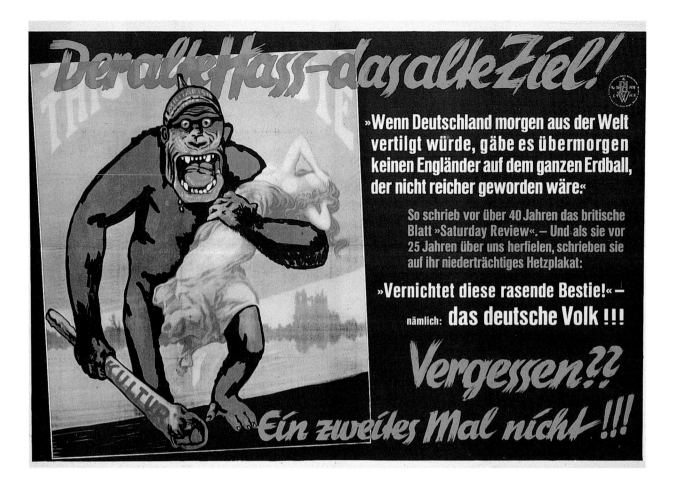

Der alte Hass – das alte Ziel!

»Wenn Deutschland morgen aus der Welt
vertilgt würde, gäbe es übermorgen
keinen Engländer auf dem ganzen Erdball,
der nicht reicher geworden wäre.«

So schrieb vor über 40 Jahren das britische
Blatt »Saturday Review«. – Und als sie vor
25 Jahren über uns herfielen, schrieben sie
auf ihr niederträchtiges Hetzplakat:

»Vernichtet diese rasende Bestie!« –
nämlich: das deutsche Volk !!!

Vergessen??
Ein zweites Mal nicht !!!

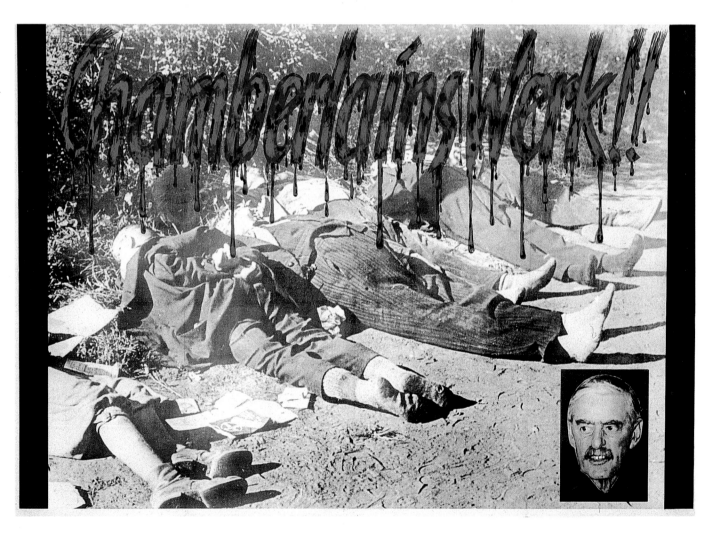

Chamberlains Werk !!

204. The old hatred—the old goal!
Germany. 1939.

In the spring of 1939, Goebbels launched a series of weekly posters or "Party Wall Newspapers," with the title "Motto" or "Message of the Week." The 36th in the series was issued on September 5, four days after the invasion of Poland and two days after the British and French declaration of war. The poster borrows the image of Germany as a wild beast from an American poster of the First World War (Poster 32) with an accompanying text that reads in part: "When they assaulted us 25 years ago, they wrote on their rotten slanderous poster: 'Destroy this mad beast'—they meant the German people!!!"

205. Chamberlain's work!
Germany. 1939.

Two weeks after the preceding poster, the 38th number in the series appeared. The blood-dripping slogan superimposed on a photograph of bodies in civilian clothes accuses the British of having master-minded an attack by Poles on German civilians, an event that served as the immediate pretext for the invasion of Poland. In reality Germans had staged the attack.

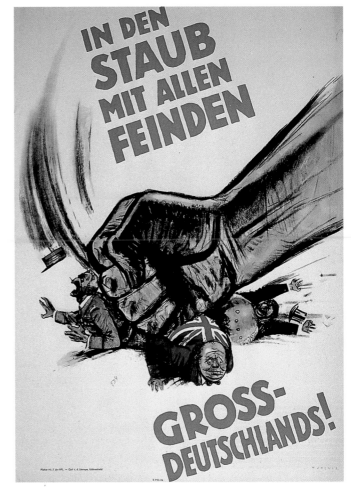

206. Into the dust with all enemies of Greater Germany!
Germany. 1940. Mjölnir (Hans Schweitzer).

France, Great Britain, and World Jewry are smashed by the German fist. The words are a play on the final line of one of the great dramas of German classicism: Heinrich von Kleist's Der Prinz von Homburg.

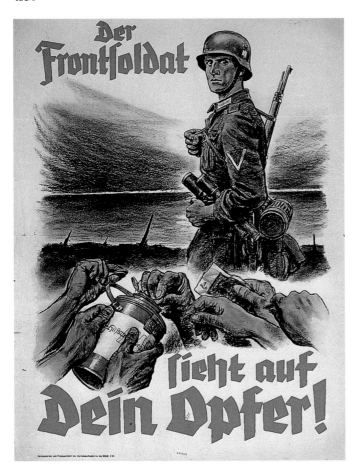

207. The soldier at the front expects your sacrifice!
Germany. 1940. M. Rothgaengel.

Whatever the realities in the field, posters showed Germany fighting a defensive war. Here, civilian hands fill the collection can while the army and anti-aircraft guns keep the enemy at bay.

11.12 NOVEMBRE 1939

★ JOURNÉE FRANCO-BRITANNIQUE ★

AU BÉNÉFICE DE CEUX QUI COMBATTENT ET DE LEURS FAMILLES

208. Anglo-French day for the benefit of the combatants and of their families.
France. 1939. Jean Carlu?

A similar appeal as that in the preceding poster is presented from the Allied side.

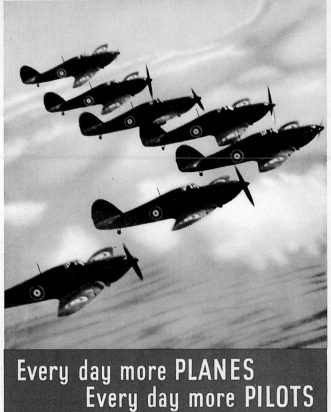

MIGHTIER YET!

Every day more PLANES
Every day more PILOTS

209. Mightier yet!
Great Britain.

British posters in the Second World War often made use of photographs. This characteristic example is designed to maintain morale on the home front.

210. "We shall not flag."
Great Britain. 1940.

On June 4, 1940, the evacuation from Dunkirk was completed, with 338,000 men saved. In the first phase of the campaign in Belgium, The Netherlands, and France, however, the Germans took 1,200,000 prisoners, and an invasion of Great Britain seemed possible. In such a crisis, words are more effective than images, and the wholly typographical poster reappeared.

WE shall not flag. We shall not fail. We shall fight in France, and on the seas and oceans. We shall fight with growing strength in the air. If invaded, we shall fight on beaches, landing grounds, in fields, in streets and on the hills. We shall never surrender. Even if a large part of Great Britain be subjugated and starving, then the Empire beyond the Seas will carry on the battle. Winston Churchill, June 4, 1940

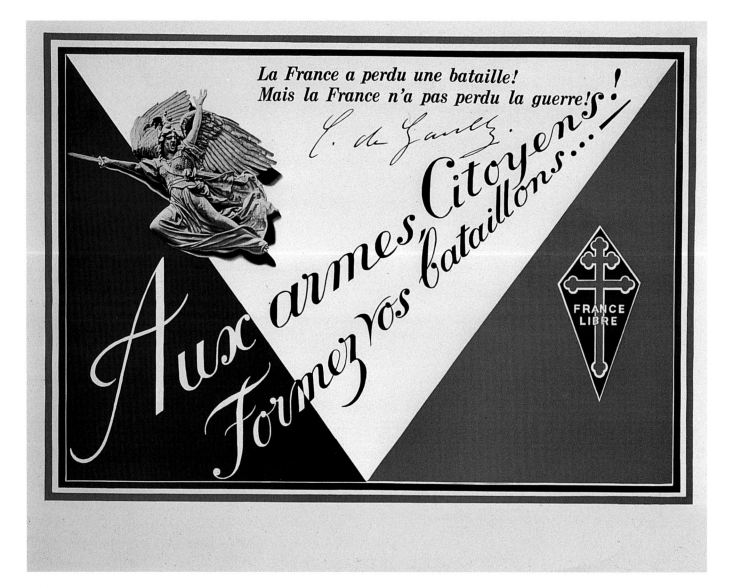

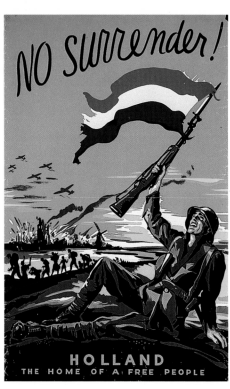

211. France has lost a battle, but France has not lost the war!
Great Britain. 1940.

*De Gaulle's proclamation is reinforced by two lines from the Marseillaise
and by an old and a new symbol: the avenging Gallic goddess from the Arc
de Triomphe and the new Free French emblem, the cross of Lorraine.*

212. No surrender! Holland—the home of a free people.
Great Britain? 1940? Winfield.

*Probably produced in Great Britain, the poster was intended to arouse sym-
pathy in the United States and the British Commonwealth for the Allied
cause.*

213. The life-line is firm.
Great Britain. Charles Wood.

*Great Britain's dependence on supplies from
overseas was a major strategic factor in the
war. This poster, one in a series of Britain at
war, paid recognition to the Merchant Navy
and reassured the home front.*

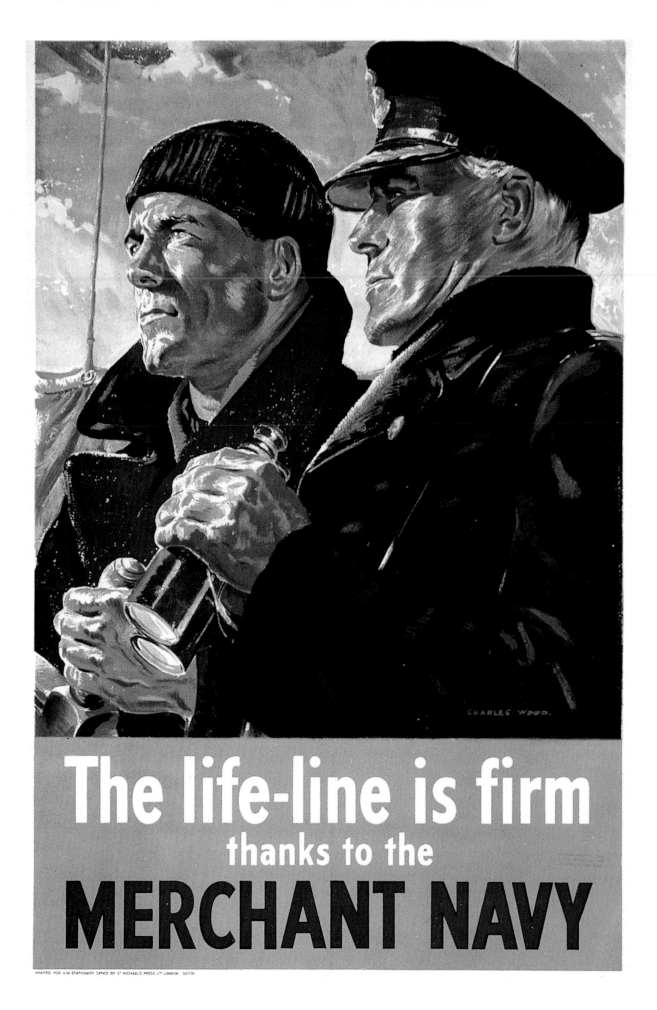

The life-line is firm
thanks to the
MERCHANT NAVY

PRINTED FOR H.M STATIONERY OFFICE BY ST MICHAEL'S PRESS LTD LONDON. 51/1131.

14.
The Air War

Posters of the air war differed in an important respect from most other posters between 1939 and 1945. They often dealt with acts of violence that affected their public directly rather than indirectly. They did not ask civilians, far from the front, to subscribe to war bonds, work harder, or save scarce resources; instead, they addressed men and women whom modern technology had made the immediate object of military action.

During the Second World War, bombing raids broke down many of the distinctions between civilian life and life at the front. First used on a large scale in the Spanish Civil War, the aerial bombardment of open cities and civilian populations became accepted in both the Axis and Allied air forces. Because of the airplane's vulnerability in daylight attacks and the difficulty of precision bombing at night, Germany, Great Britain, and the United States adopted policies of massive, largely indiscriminate raids on population centers in the hope of disrupting the enemy economy and destroying civilian morale. Some thought of these attacks as effective precursors for eventual land invasions, while others insisted that air strikes alone, if conducted severely enough over a long period of time, could win the war.

From the summer of 1940 on, German planes repeatedly bombed London and other cities in southern England. Between July and December, over 55,000 civilians were killed or wounded in the raids. The Allies, in turn, launched hundreds of raids on German cities and towns and escalated destruction to new extremes. In one week of July 1943, raids on Hamburg killed some 30,000 civilians and destroyed 250,000 houses. Even in the last months of the war, when the outcome could no longer be seriously in doubt, heavy air-strikes continued against now largely defenseless targets. Overall, about 500,000 civilians died from Allied bombing.

The resilience of civilian society under these attacks surprised the Axis and the Allies alike. The raids did not destroy morale; at times they even seemed to create a mood of defiance. Industry, too, proved more resistant to bombing than had been expected; despite heavy raids, German war production remained at fairly high levels until the last months of the war.

Posters of the air war are divided between those with offensive and defensive themes: the strength of one's own air power on the one hand, and the danger posed by enemy bombing on the other. Boasts of air superiority and the results of raids are common. Other posters, issued for civilians at risk, relied less on rhetoric and concentrate rather on providing information and instruction. The chivalric heroism and romance of flight in posters with themes of air-to-air combat or the bombing of industrial targets stand in stark contrast to the morbid, sometimes surreal, allusions to death that appear in posters dealing with bombing of civilian targets.

214. Day and night the bombers of the R.A.F. attack the Nazi oil depots and industrial centers.
Great Britain, c.1945. W. Krogman.

Made for liberated France and Belgium, this British poster's lurid colors, detailing, and comic-book depiction of blasts and explosions assert the Allies' superiority in technological warfare.

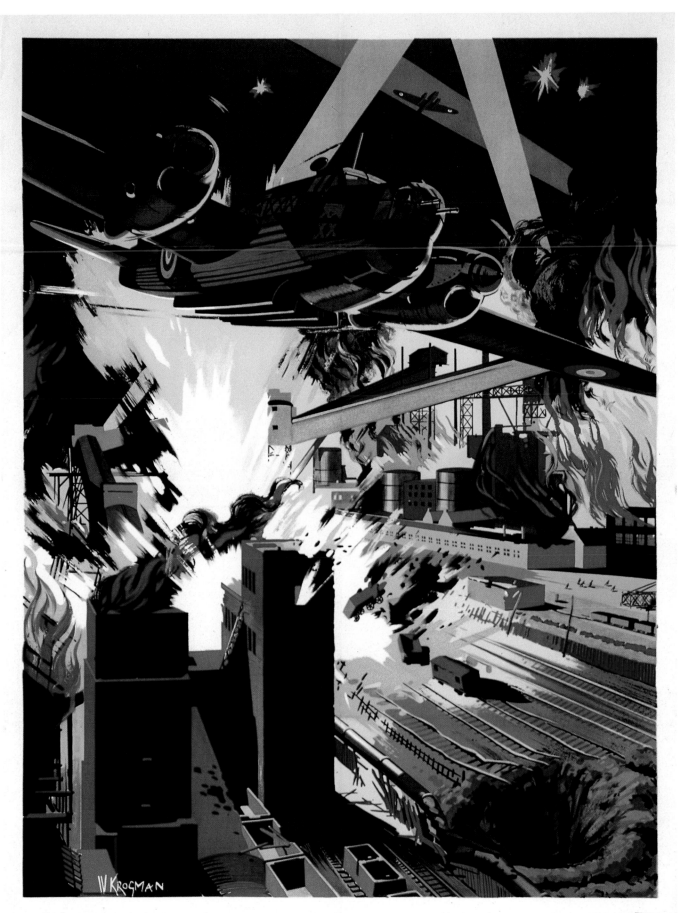

De jour et de nuit, les bombardiers de la R.A.F. attaquent les dépôts d'essence et les centres industriels des Nazis.

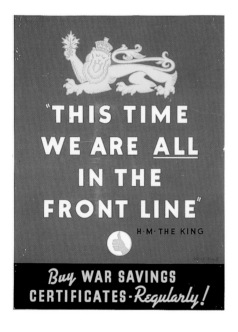

215. "This time we are all in the front line."
Great Britain. 1940.

The significance of the message is ill-served by bland images and poor interaction between image and typography.

216. Forward to victory.
Great Britain. Marc Stone.

This poster is one in a series of posters meant to build civilian confidence and raise service morale.

217. "Never was so much owed by so many to so few."
Great Britain. c.1940.

The famous quotation from Churchill's tribute to the victors of the Battle of Britain is given visual form in this photomontage. The movie-like image shows undecorated sergeant-pilots, rather than commissioned officers, to suggest that the country was saved not by social elites, but by representatives of the entire population.

218. All goes very well . . . Madame la Marquise.
Belgium. c.1940.

Distributed in occupied Belgium, this poster combines a line from a pre-war song, made famous by Maurice Chevalier, with a caricature of Churchill. His pants ripped and the hole in his hat repeating the wound on his forehead, Churchill is making himself ridiculous by insisting that the bombing of England is nothing to worry about.

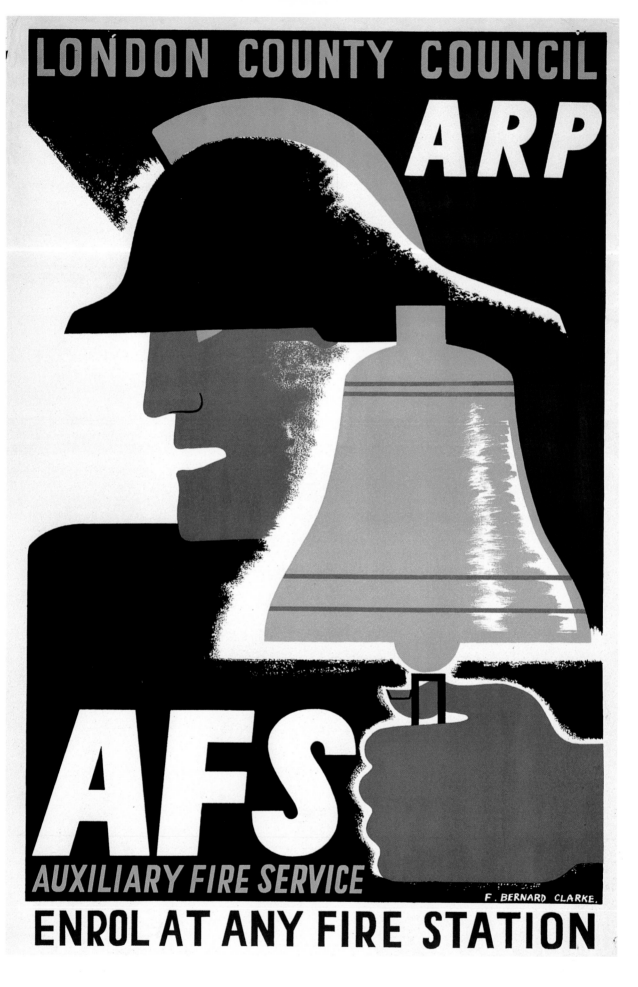

LONDON COUNTY COUNCIL

ARP

AFS

AUXILIARY FIRE SERVICE

F. BERNARD CLARKE.

ENROL AT ANY FIRE STATION

219. London County Council ARP. AFS, Auxiliary Fire Service.
Great Britain. c.1941. F. Bernard Clark.

The civilian firefighter is shown as a modern-day hero, his tin-hat and bell suggesting the crested helmet of a classical warrior. Fires resulting from incendiary bombs became one of the greatest dangers of the raids. Bombing raids on the night of December 29, 1940 reportedly started 1500 fires in and around London.

220. The new incendiary bomb is heavier . . .
Great Britain. c.1941.

The schematic style of the poster underscores its instructional rather than emotive function.

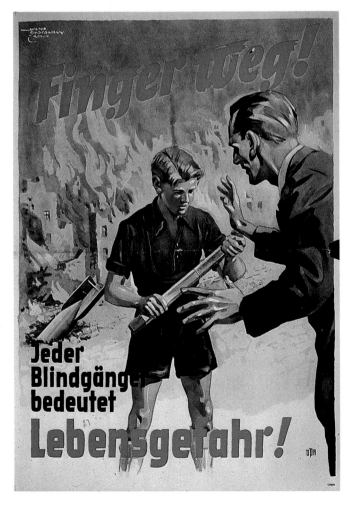

221. Don't touch! Every dud can kill!
Germany. 1944. Walter Biederman.

The boy is holding an unignited magnesium "stick" incendiary bomb, over two million of which were dropped on Berlin alone in the latter part of the war. An overt sense of hopelessness and defeat surrounds this German public-safety poster with its apocalyptic scene of a destroyed city.

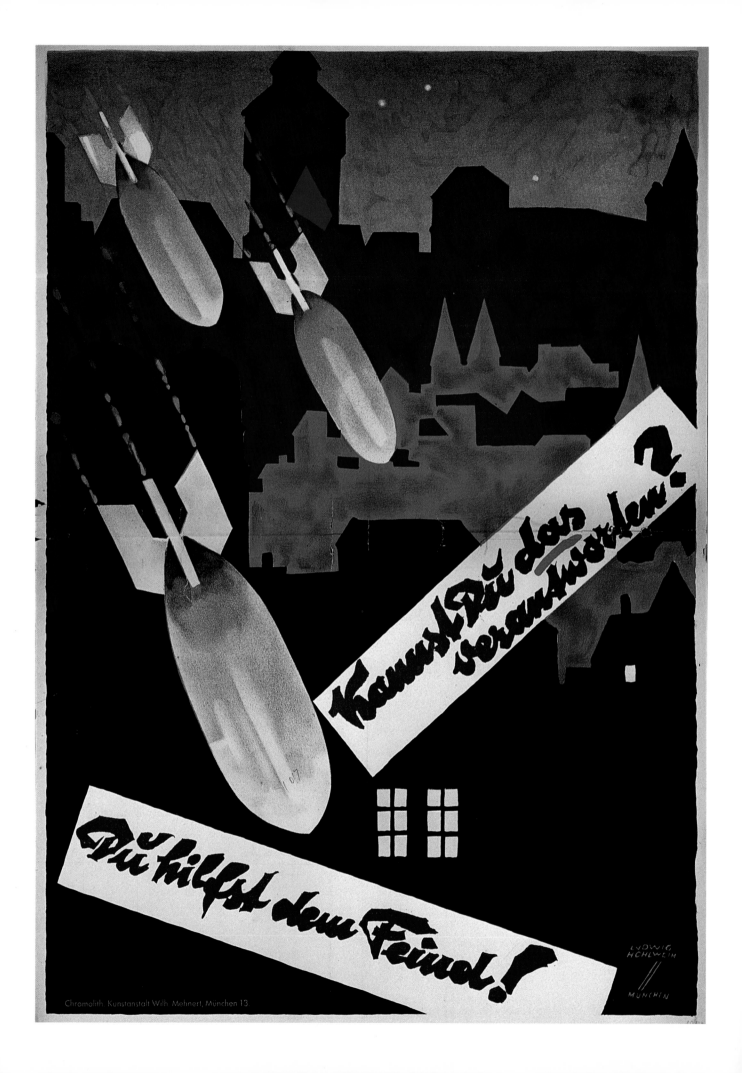

Kannst Du das verantworten?

Du hilfst dem Feind!

Chromolith. Kunstanstalt Wilh. Mehnert, München 13

LUDWIG
HOHLWEIN
MÜNCHEN

222. Can you be responsible for <u>this</u>? You are helping the enemy!
Germany. 1942. Ludwig Hohlwein.

223. Light means your death!
Germany. c.1944. Schmitt.

More than just public-safety instructions, these two posters, demanding strict observance of blackout regulations, relied on threats and on people's fear and sense of guilt to carry their messages. Even in the extremity of total war, Hohlwein constructed an elegant image out of superimposed, flat, and precisely outlined areas of color. Near the left edge, the shadowy twin towers of the Munich Church of Our Lady can be made out. The poster accuses those whose lighted windows guide the enemy bomber of treason. The second poster is derivative of Hohlwein, but also blames the blackout violator for bringing the scourge of death to Germany. The shared color of the window and the skull reinforces the message that, for Germany at this time, light is death.

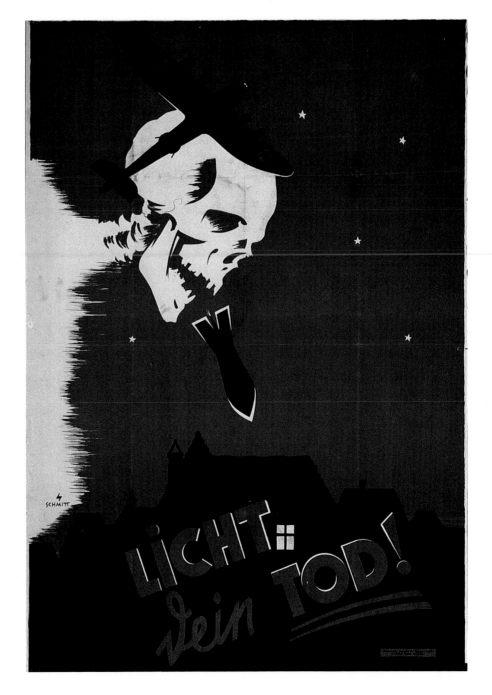

R.A.F. HAMMER BLOWS ON NAZI KEY INDUSTRIES

COLOGNE 119 RAIDS

ESSEN 57 RAIDS

HAMBURG 105 RAIDS

KIEL 74 RAIDS

HANOVER 45 RAIDS

BERLIN 67 RAIDS

OSNABRÜCK 44 RAIDS

HAMM 86 RAIDS

BREMEN 103 RAIDS

FRANKFURT ON MAIN 36 RAIDS

EMDEN 82 RAIDS

GELSENKIRCHEN 44 RAIDS

WILHELMSHAVEN 79 RAIDS

MANNHEIM 57 RAIDS

DUISBURG 61 RAIDS

DORTMUND 41 RAIDS

DÜSSELDORF 53 RAIDS

SOEST 35 RAIDS

These German industrial centres have been bombed OVER 30 TIMES up to August 1943. Up to the same date 20 other towns have been bombed between 11 and 30 times. Between 1 and 10 raids have been made on each of a further 256 towns.

THE R.A.F. HITS GERMANY WHERE IT HURTS HER MOST

224. RAF hammer blows on Nazi key industries.
Great Britain. 1943.

These attacks were not, in fact, directed at key industries, but, as the earlier German raids, against military and civilian targets alike. Despite the rhetorical claims of the British Bomber Command, by 1943 strategic bombing had done little either in the way of preparing for an invasion, or as an independent means of victory.

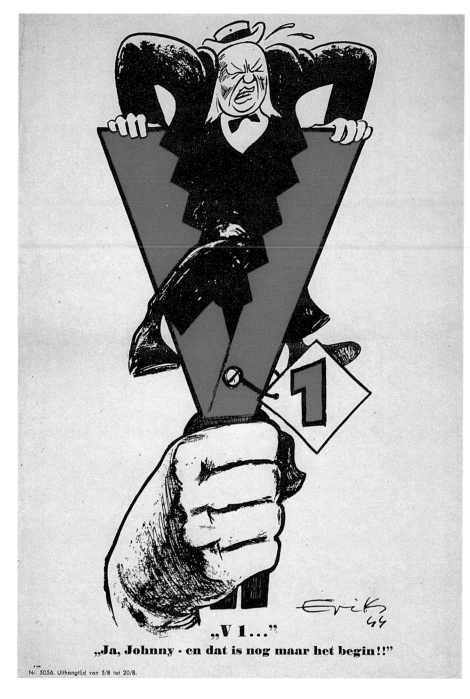

225. "V-1 . . . Yes, Johnny—and that is only the beginning."
Germany. 1944. Erik.

From 1943 on, a major theme in Nazi propaganda was the promise of retaliation for the Allied bombings. In this poster for occupied Holland, John Bull is being crushed in a vise representing the new V-1 rockets. The German "V" for "Vergeltung," meaning retaliation, responds to the Allied "V for Victory."

15.

The Invasion of Russia

The war with Russia was the fulfillment of fantasies basic to Hitler's conception of the historical mission of National Socialist Germany. It was also the result of strategic frustration. After Great Britain refused to come to an accommodation with Hitler in the summer of 1940 and after the Luftwaffe lost the battle for air superiority over the Channel and southern England, which rendered a landing in England out of the question, the balance of strength would gradually shift against Germany unless she expanded her continental base to the east or south. Under the best of circumstances the invasion of Russia was a desperate gamble, the success of which depended not only on military victories on the grandest scale, but also on the ability to govern the conquered territories. In actuality, ideological preconceptions prevented the efficient economic and political exploitation of the deep penetration and wide encirclements of the opening campaign, and turned the administration of occupied Russian territory into something akin to a vast concentration and slave labor camp.

From the first weeks of the war, a major theme of Soviet posters concerned the conditions in this camp—the murder and enslavement of millions of Russians. Linked to this was a second theme—that of civilian resistance to the Germans. Posters that showed acts of sabotage or of partisan warfare served as a bridge between the occupied territories and areas that continued under Soviet control. They sought to arouse sympathy and anger, and proclaimed that everyone must fight and sacrifice until the invader was driven out of the country.

German soldiers and their leaders were depicted not only as brutal criminals out to ravage Russia and destroy communism, but they were ridiculed as well. Beneath their threatening surface they were revealed as arrogant yet cowardly little men, wearing silly uniforms, who would not escape the fate appropriate to cartoon figures of being skewered, sliced, or beheaded.

Above all, Russian posters during these years celebrate the Russian army and people—soldiers and civilians who, except when shown grieving over victims of atrocities, unfailingly bear expressions of determination or patriotic joy. Posters of all countries at this time eschewed conscious ambiguities in their images, but as represented on Russian posters during the war Soviet faces are unusually empty of any sign of the complexities of the human condition. The Russian people deserved far better posters than their government produced.

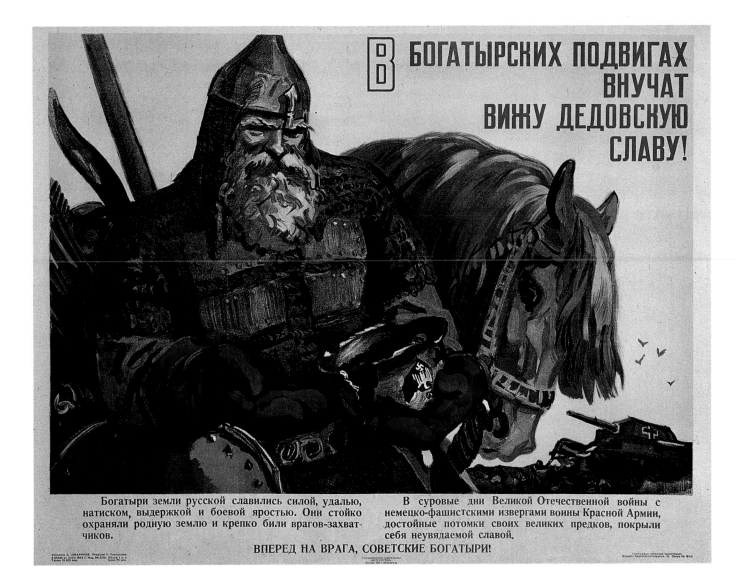

Богатыри земли русской славились силой, удалью, натиском, выдержкой и боевой яростью. Они стойко охраняли родную землю и крепко били врагов-захватчиков.

В суровые дни Великой Отечественной войны с немецко-фашистскими извергами воины Красной Армии, достойные потомки своих великих предков, покрыли себя неувядаемой славой.

ВПЕРЕД НА ВРАГА, СОВЕТСКИЕ БОГАТЫРИ!

226. In the heroic deeds of the grandsons I see the glory of the grandfathers.
U.S.S.R. 1943. D. Shmarinov.

A Russian knight in chain mail, armed with a bow and arrows, lance, and sword, holds a German steel helmet torn by bullets and shrapnel. Behind his horse are German corpses and a destroyed tank. The overt message here is that patriotism and the link between the Russian past and present will defeat the Germans.

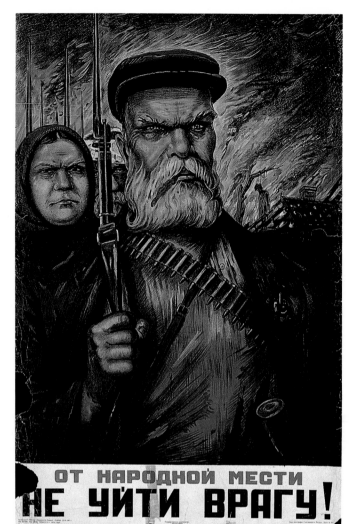

227. The enemy shall not escape the people's revenge.
U.S.S.R. 1941. I. Rabichev.

Ten days after the invasion began, Stalin called for armed resistance by the population behind the advancing German lines. This poster, issued in September at a time of devastating Russian defeats, turned the partisans into a symbol of the entire people.

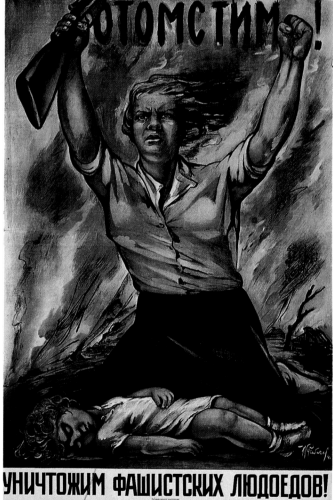

228. We shall have our revenge!
U.S.S.R. 1941. I. Rabichev.

A few months later the same artist returned to the identical theme in a similar way: an armed civilian, surrounded by death and devastation, swears revenge. The pathos of social realism cannot hide the feebleness of the drawing; the woman's right fist, which grasps the rifle, lacks any muscular strength and tension, and the rest of the drawing is equally flaccid. Russian posters repeatedly used the motif of a mother sorrowing over her dead child.

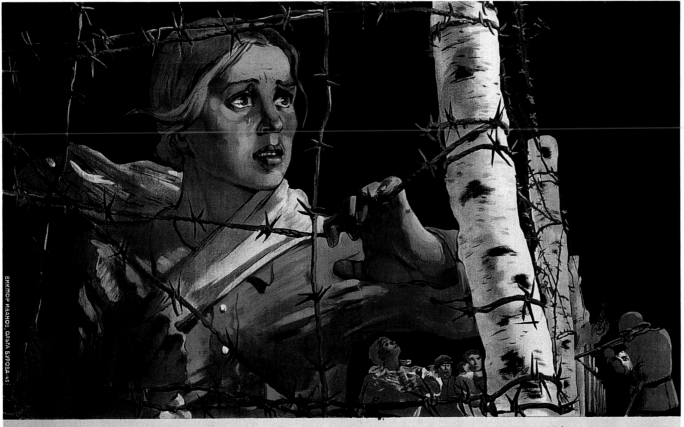

229. Our hope is in you, Red Warrior!
U.S.S.R. 1943. Viktor Ivanov and Olga Burova.

A young woman in a barbed-wire compound represents the tens of millions
of Russians behind German lines. In the background, other prisoners are be-
ing shot.

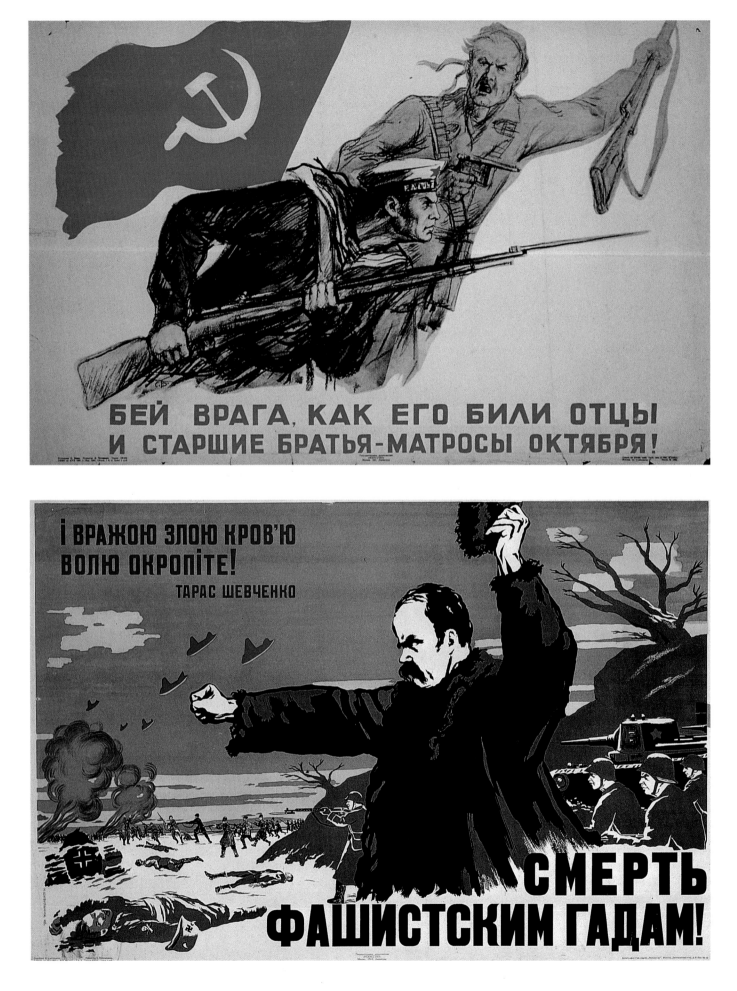

230. Beat the enemy as he was beaten by your fathers and older brothers—the sailors of October.
U.S.S.R. 1941. S. Boim.

This poster issued in the first month of the war refers to the sailors in Petrograd during the Bolshevik Revolution of October/November 1917.

231. "Let us baptize your freedom with enemy blood!" Death to the fascist vipers!
U.S.S.R. 1942. I. Tsybul'nyk.

The Red Army is urged on by the 19th-century Ukrainian nationalist poet Taras Shevchenko who in 1990 would become a symbol for Ukrainian separatism.

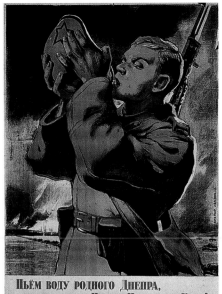

ПЬЁМ ВОДУ РОДНОГО ДНЕПРА,
БУДЕМ ПИТЬ ИЗ ПРУТА, НЕМАНА И БУГА!
ОЧИСТИМ СОВЕТСКУЮ ЗЕМЛЮ
ОТ ФАШИСТСКОЙ НЕЧИСТИ!

233. We drink the waters of our Mother Dnieper.
U.S.S.R. 1943. Viktor Ivanov.

234. Glory to the liberators of the Ukraine!
U.S.S.R. 1943. D. Shmarinov.

These two posters celebrate the reconquest of the Ukraine. The equestrian statue in the background of the second poster represents Kiev, which was retaken on November 6, thirteen days before the poster was published.

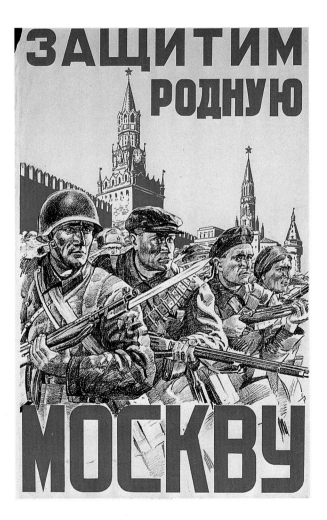

ЗАЩИТИМ РОДНУЮ МОСКВУ

232. We will defend our mother Moscow.
U.S.S.R. 1941. B. A. Mukhin.

The poster, showing soldiers and armed civilians before the Kremlin, was printed at a time when German forces were within striking distance of the capital and the Russian government had moved to the Volga. A month later the Russian counteroffensive began and Hitler's plan for the rapid conquest of European Russia had failed.

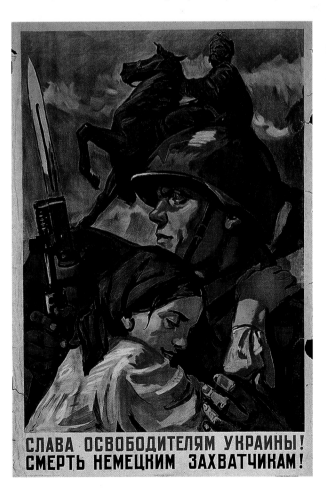

СЛАВА ОСВОБОДИТЕЛЯМ УКРАИНЫ!
СМЕРТЬ НЕМЕЦКИМ ЗАХВАТЧИКАМ!

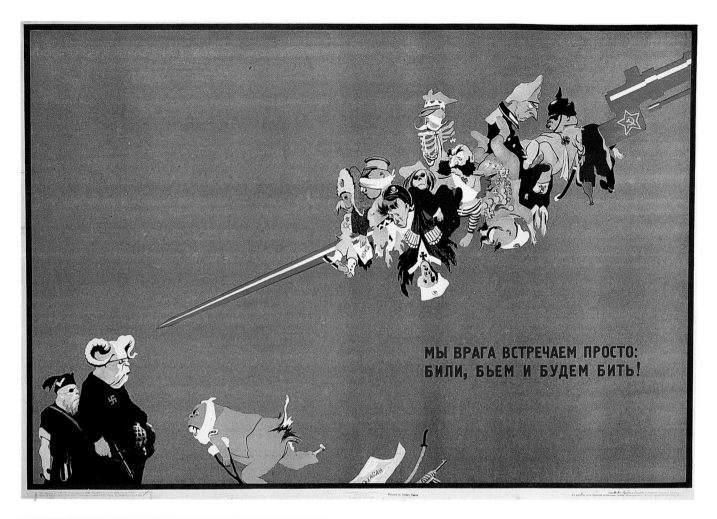

МЫ ВРАГА ВСТРЕЧАЕМ ПРОСТО:
БИЛИ, БЬЕМ И БУДЕМ БИТЬ!

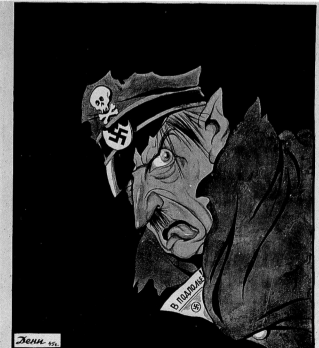

никуда не скрыться изуверу!
получит он должную меру!
всё живое его ненавидит!
он пощады себе не увидит!

235. We meet the enemy simply: We smashed him today; we smashed him in the past; we will smash him in the future.
U.S.S.R. 1939. Boris Prorokov.

The long bayonet of Soviet power, which has skewered the country's enemies in the past—among them a German officer, tsarist and White Russian soldiers, and a Pole—is threatening the likely enemies of the future: a Nazi bully with his Italian sidekick. A Japanese has fallen off the blade and is running away, a reference to the undeclared war between Russia and Japan along the Mongolian-Manchurian border.

This and the following three posters are examples of caricature posters, which often used comic-strip techniques to develop their message.

236. There is no place for the monster to hide.
U.S.S.R. 1945. Viktor N. Deni.

237. Tit for Tat.
U.S.S.R. 1941. Kukryniksy Group.

The text reads: "Force us to remove our hats, and we'll remove both your hat and your head."

ДОЛГ ПЛАТЕЖОМ КРАСЕН

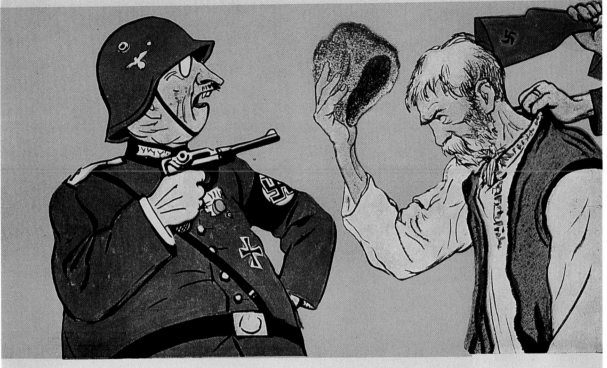

Днем фашист сказал крестьянам:
„Шапку с головы долой!"

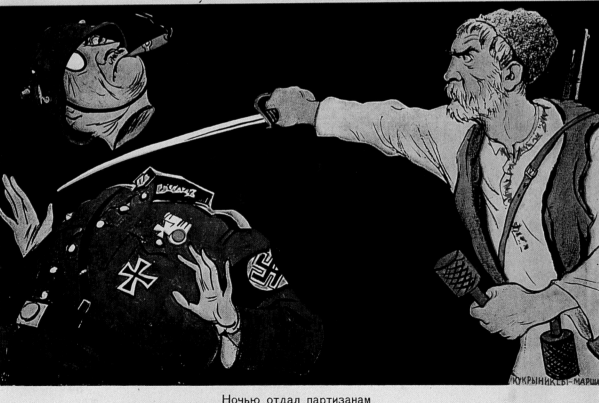

Ночью отдал партизанам
Каску вместе с головой.

Художник Кукрыниксы. Редактор Е. Поволоцкая. Государственное издательство Отпечатано в типогр. «Красный печатник» Гос. издательства
Л160573. Изд. № 5388. Объем ¼ б. л. Цена 35 коп. «ИСКУССТВО» «Искусство». Москва, ул. 25 Октября, 5. Зак. 1064. Тир. 100.000.
Москва 1941 Ленинград

238. The Red Army's broom will sweep away all the filth!
U.S.S.R. 1943. Viktor N. Deni.

Deni, who had worked as an illustrator before the revolution, was an artist of great versatility. Here he uses an uncomplicated cutout style for the colorful background and his major figure, who might have stepped out of any illustration for a popular fairy tale. But the Nazis who are swept away by the soldier's iron broom, are drawn in the nervous, sophisticated style Demi often used for his political cartoons. His portrait of Hitler is a further example of this second style (Poster 236).

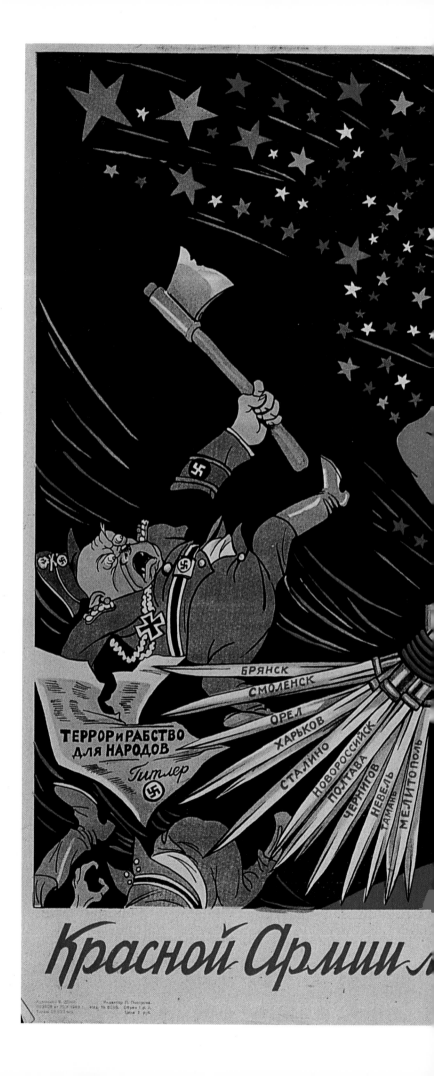

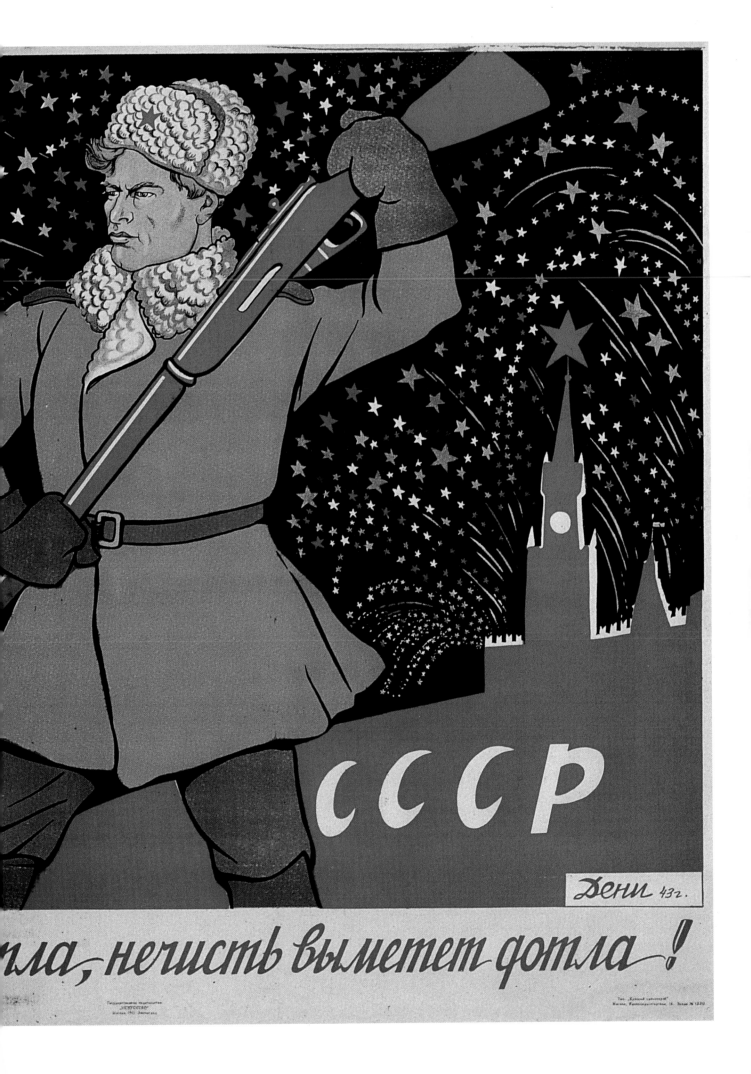

СССР

Дени 43г.

...гла, нечисть выметет дотла!

16.
The New Order

By the end of 1941, with German advance units for a time almost within sight of Moscow, Hitler dominated the greater part of continental Europe, including large areas of European Russia. The effort of organizing the conquered territories, satellites, and allies into a militarily and economically coherent block served above all to strengthen Germany's strategic position, help her carry on the war in the East, and—when the tide began to turn—defend "Fortress Europe." Foreign raw materials and oil were essential for these tasks, as were the seven and a half million foreign workers who volunteered or were forced to work in German war factories and came to make up one-fifth of the total work force in the war economy. But the message of a "New Order," which was spread throughout Europe to justify the new system, was not entirely hypocritical and self-seeking. It reflected the ideals of a segment of the Nazi leadership that hoped for a regeneration of Europe along "Nordic" or "Germanic" principles, cobbled together from scraps of pseudo-heathen and medieval lore, which somehow were to co-exist with the industrial mass society ennobled by National Socialism and the modern centralized state.

The appeal for foreign support of this phantom did not always fall on deaf ears. Few non-Germans wholeheartedly accepted National Socialism, but in every part of Europe there were some people who disliked the levelling forces of industrialization and the nation-state and longed to return to regional differences, dialects, and cultures; they were frightened by modernization, which introduced foreign ways and made the world homogeneous. These groups provided a receptive audience for German cultural and political propaganda, but the message they received was too contradictory for any practical results to be impressive. The legions made up of volunteers from France, The Netherlands, Belgium, and Norway and deployed in Russia proved as insignificant a contribution to the strength of the New Order as did the writings and lectures of corporative and anti-Semitic intellectuals from the same countries.

A less destructive and egocentric system than National Socialism, and one not subject to the pressures of world war, might have been able to fuse the reactionary, authoritarian segments of European society into a European-wide force of some vitality. As it was, the efforts to construct a New Order led by a Germany that was merely the first among racially pure equals were feeble and constantly swamped by the demands of the war and by the brutal insistence on eradicating human beings whom even idealistic Nazis deemed inferior to Germans. The conflict in National Socialism between ideology and realistic self-interest was exemplified most drastically by German occupation policies in the east. Appeals to cooperate with the Germans and join in their fight against Russia, bolshevism, and the Jews were well received among Poles, Ukrainians, and in the Baltic states. More than 500,000 volunteers eventually served as "Eastern Troops" and as guard units in concentration and extermination camps. But the reality of National Socialist rule, ranging from humiliation and starvation to random killings and systematic mass murder, turned many potential supporters of the New Order into neutrals and even opponents. National Socialism was the most destructive political force in modern history, but it was so in part because it was self-destructive as well.

239. Hands off!
Germany. c.1943. Erik.

A giant hand reaches out for Europe, but will be impaled on the swords of the German armed forces, which have first conquered and now defend the continent. The poster, printed by German authorities in The Netherlands, seeks to create among the Dutch a sense of European community under German leadership.

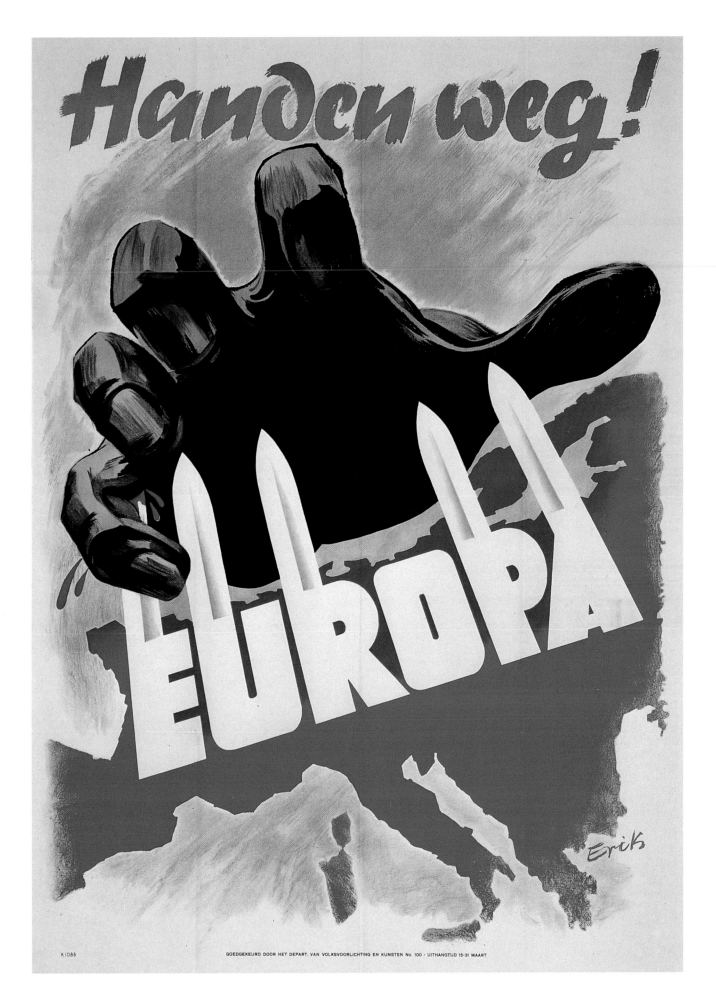

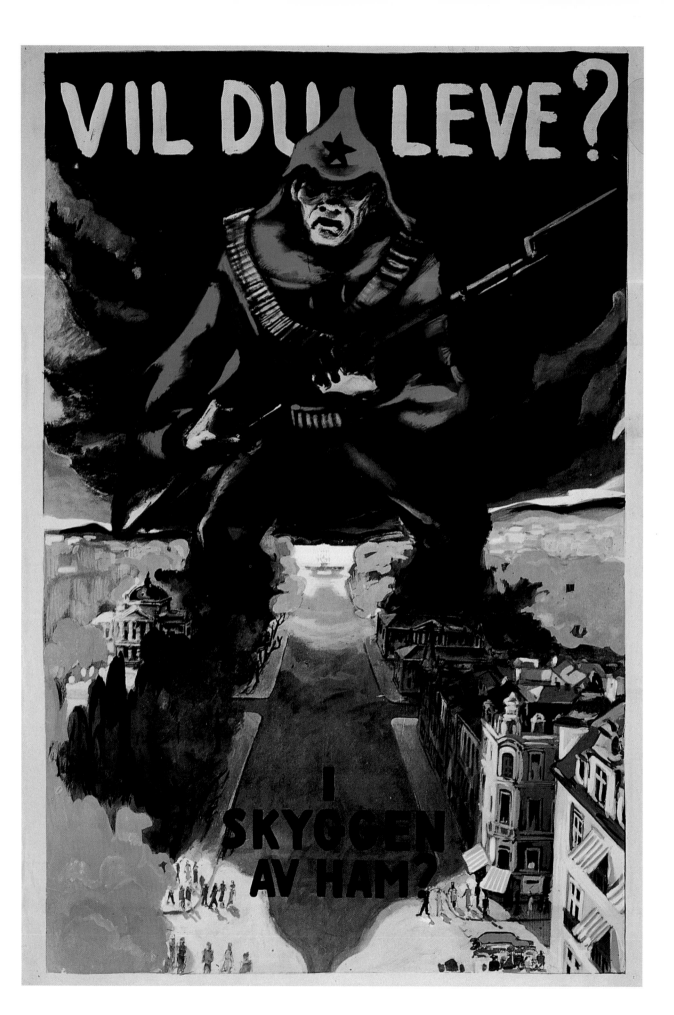

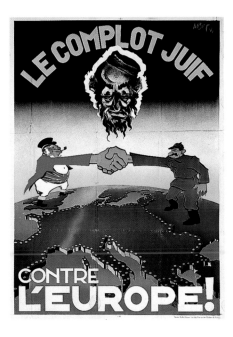

241. The Jewish plot against Europe!
Belgium. 1941. Abel

The brooding face of the eternal Jew hovers over John Bull and Stalin, who are uniting to destroy Europe. The armor-plated continent (which incidentally is shown to include the neutral countries of Sweden, Switzerland, and Spain) expands into the blood-stained East. The poster dates from the early stages of the Russian campaign. Lithuania, Latvia, and Estonia have already been overrun, and German power has reached the Black Sea.

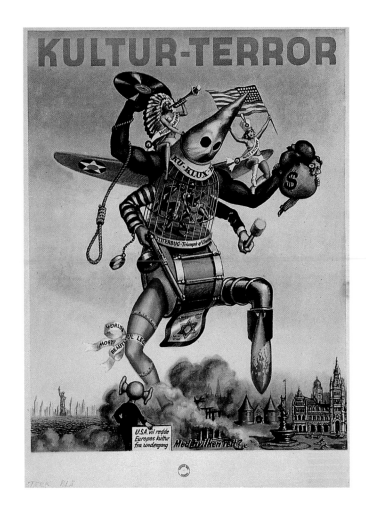

242. Cultural terror.
The Netherlands. 1944. Leest Storm.

Emerging from the distant world of skyscrapers, a four-armed monster, one of its legs a blood-stained bomb, the other the "world's most beautiful leg," is about to smash the treasures of European civilization. From its Ku Klux Klan hood to its bomber wings, jitter-bugging blacks, and Star of David loincloth, it represents the primitiveness, hypocrisy, and destructiveness of American life. The little man with funnel-shaped ears in the foreground—a frequent character in poster campaigns against the illegal listening to Allied radio broadcasts—points the lesson: This monstrous country claims to save European civilization!

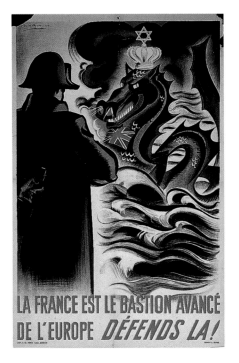

240. Do you want to live?
Norway.

A peaceful, prosperous town is being threatened by the armed giant of bolshevism. The poster, which effectively combines large masses with interesting detail, would have been more convincing if the German alternative to Russian domination had not been so obviously as bad if not worse.

243. France is the first bastion of Europe. Defend her!
France. 1944. Giral.

In this poster, Napoleon stands guard against invasion. The Star of David and the Union Jack that decorate the sea-monster play on French anti-semitism and dislike of the British. The solidity of Napoleon's figure, and thus the poster's impact, are spoiled by the inclusion of a realistic detail: Napoleon's hand, grasping a telescope, behind his back.

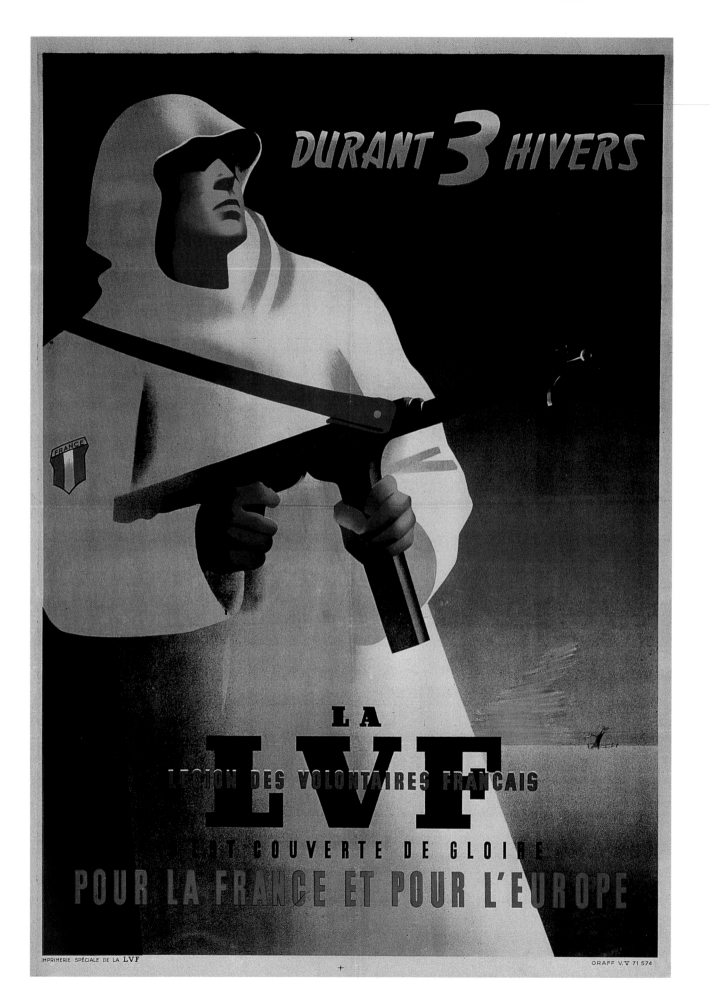

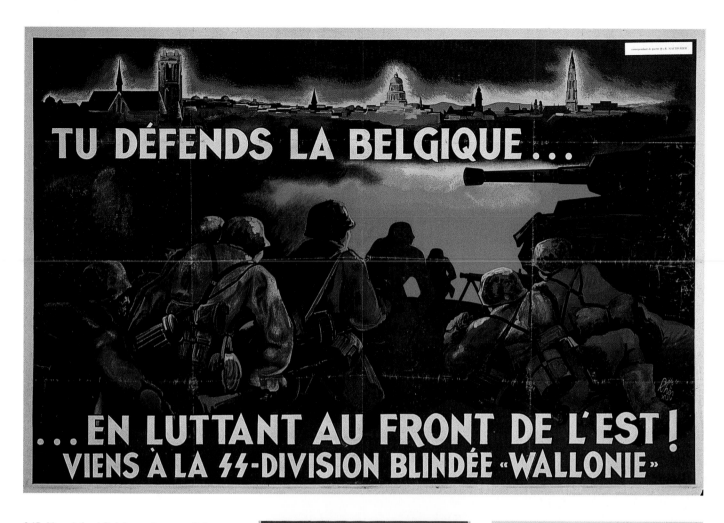

TU DÉFENDS LA BELGIQUE...

...EN LUTTANT AU FRONT DE L'EST!
VIENS À LA ⚡⚡-DIVISION BLINDÉE «WALLONIE»

245. You defend Belgium when you fight on the eastern front!
Belgium. 1943. Rhn.

The poster's incongruous image of men rushing into a fiery abyss is more realistic than is its slogan.

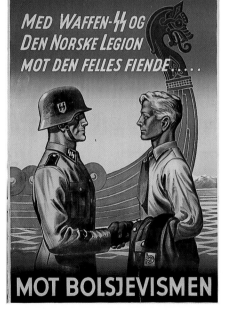

MED WAFFEN-⚡⚡ OG
DEN NORSKE LEGION
MOT DEN FELLES FIENDE...

MOT BOLSJEVISMEN

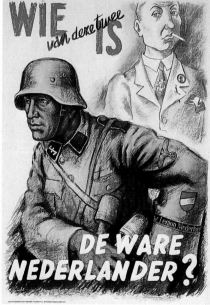

WIE van deze twee IS

DE WARE
NEDERLANDER?

244. For three winters the Legion of French Volunteers has covered itself with glory for France and for Europe.
France. 1944.

This elegantly stylized design is in the vein of French commerical art of the 1930s.

246. With the Waffen-SS of the Nordic Legion.
Norway.

The SS system and the Norwegian people are symbolized by nearly identical figures—an older German and a younger Norwegian together setting out to save Europe.

247. Who of these two is the true Netherlander?
The Netherlands. 1943. Lou Manché.

The effete civilian with patriotic symbols on his jacket and tie cannot match the volunteer of the Dutch Legion.

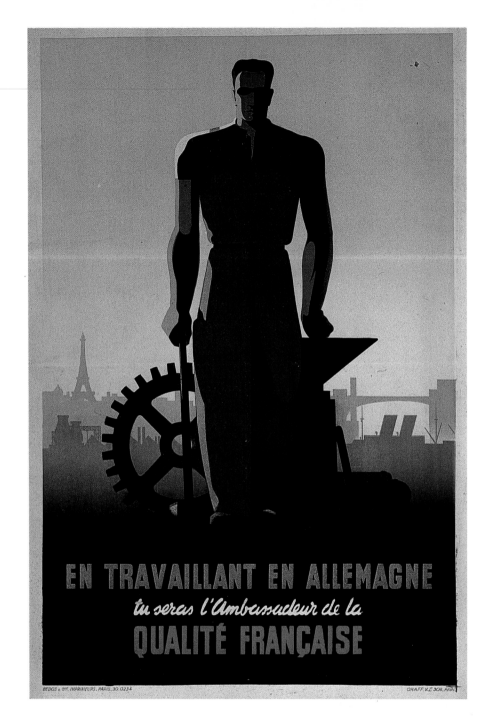

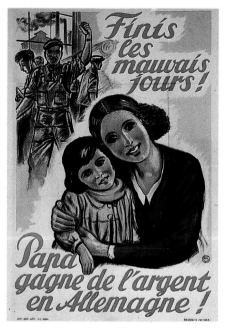

248. When you work in Germany, you will be the ambassador of French workmanship. France. c.1943.

249. The bad days are over! Father is earning money in Germany. France. 1943. Mjölnir (Hans Schweitzer).

Two posters recruiting French workers for German industry. The second is the work of the leading Nazi poster designer, Hans Schweitzer (Mjölnir), who for reasons of discretion does not sign his well-known name but instead uses a logo. His efforts at creating a French atmosphere are not convincing, and the little girl must be one of his very rare black-haired characters meant to be sympathetic.

250. To work for a better future. Germany. 1943.

251. Germany freed you from bolshevism. Now commit yourself to the resurrection of your homeland! Germany. 1942.

252. Who else is dissatisfied? Germany. 1944.

These three posters address the population of the conquered Polish and Ukrainian territories. The question, in the third poster, is asked by the head of the "Commission on Improving the Condition of Political Prisoners" of Soviet concentration camps. The unknown artist's close attention to details of uniform and clothing, and his careful physiognomic studies are to be noted.

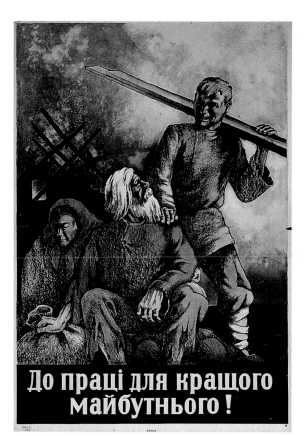

До праці для кращого майбутнього !

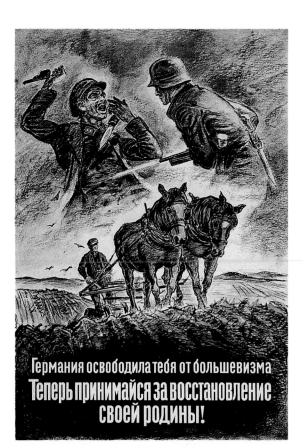

Германия освободила тебя от большевизма
Теперь принимайся за восстановление своей родины!

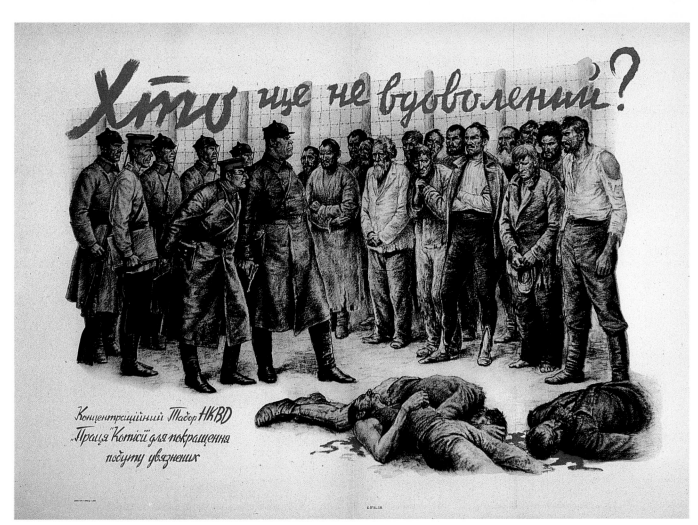

Хто ще не вдоволений?

Концентраційний Табор НКВД
"Праця" Котісй для покращення
побуту ув'язнених

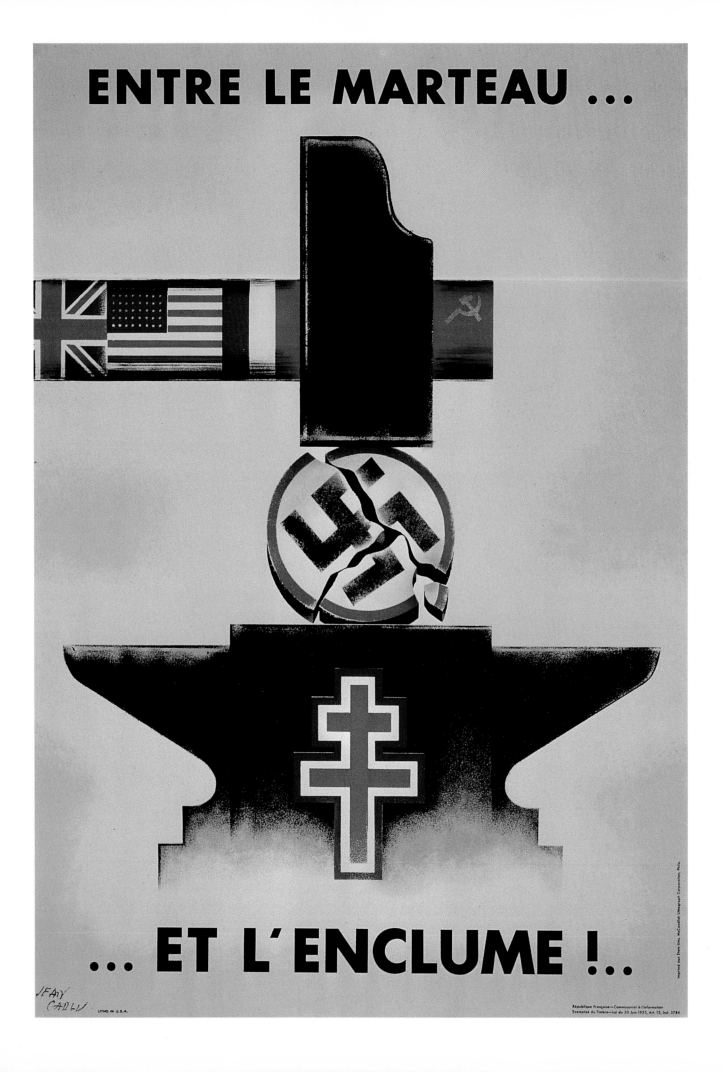

ENTRE LE MARTEAU ...

... ET L'ENCLUME !..

253. Between hammer and anvil!
France. c.1944. Jean Carlu.

254. We'll get them, the Huns!
Belgium. 1944. Jacques Richez.

255. Liberty. Beloved Liberty.
France. c.1944. Natasha Carlu.

These posters call for resistance to the Germans. The poster on the upper right, published in Belgium after British forces entered Brussels and Antwerp in the first week of September 1944, directly addressed the liberated population. The other two, designed and printed in the United States, were intended as much for consumption in the United States as in Europe. The superimposition of two national symbols in the third poster does not save it from succumbing to a surfit of chic theatricality.

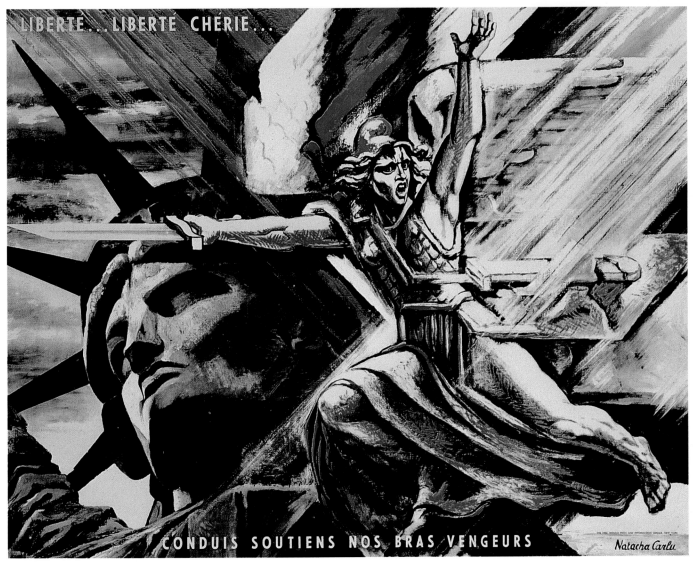

AVIS

En vue d'inciter la population à entrer dans les groupes de résistance, les puissances ennemies tentent de répandre dans le Peuple Français la conviction que les membres des groupes de résistance, en raison de certaines mesures d'organisation et grâce au port d'insignes extérieurs, sont assimilés à des soldats réguliers et peuvent de ce fait se considérer comme protégés contre le traitement réservé aux francs-tireurs.

A l'encontre de cette propagande il est affirmé ce qui suit :

Le Droit International n'accorde pas, aux individus participant à des mouvements insurrectionnels sur les arrières de la Puissance Occupante, la protection à laquelle peuvent prétendre les soldats réguliers.

Aucune disposition, aucune déclaration des puissances ennemies ne peuvent rien changer à cette situation.

D'autre part, il est stipulé expressément, à l'article 10 de la Convention d'Armistice Franco-Allemande que les ressortissants français qui, après la conclusion de cette Convention, combattent contre le REICH ALLEMAND, seront traités par les troupes allemandes comme des francs-tireurs.

La puissance occupante, maintenant comme auparavant, considérera, de par la loi, les membres des groupes de résistance comme des francs-tireurs. Les rebelles tombant entre leurs mains ne seront donc pas traités comme prisonniers de guerre, et seront passibles de la peine capitale conformément aux lois de la guerre.

DER OBERBEFEHLSHABER WEST

256. Announcement.
Germany. 1943-44.

Proclamations and announcements—posters consisting entirely of text— were widely used in both world wars, and because they contained information that could be of vital importance the public usually paid more attention to them than to posters consisting mainly of images. This announcement, by the German Commander-in-Chief in France, declares that civilians fighting against German forces are not protected under the laws of war.

257. Announcement.
Germany. 1944.

The announcement in German and Dutch, issued a few days after the British airborne attempt to capture the Rhine bridges at Arnheim and Nymwegen, threatens reprisals against districts in which acts of sabotage occur, and advises municipalities to protect the means of communication and transportation in their areas.

258. Announcement.
Germany. 1945.

Six weeks before the German surrender, SS authorities in The Netherlands announced the public execution in Haarlem of "a number of terrorists and saboteurs" in retaliation for the attempted murder of a Dutch policeman. The legend in small type underneath the black border states that it is a punishable offence to tear off or damage the poster.

BEKANNTMACHUNG — BEKENDMAKING

Für die Zerstörung oder Beschädigung von Eisenbahnanlagen, Fernsprechkabeln und Postämtern mache ich die gesamte Einwohnerschaft der Gemeinde verantwortlich, in deren Bezirk die Tat begangen wird.

Die Bevölkerung solcher Gemeinden hat daher damit zu rechnen, dass zur Vergeltung auf Eigentum gegriffen und Häuser oder Häusergruppen zerstört werden.

Ich rate den Gemeinden, in ihrem Bezirk durch Einsetzung von Streifen oder auf andere wirksame Weise für einen ausreichenden Schutz der Verkehrs- und Nachrichtenmittel zu sorgen.

Der Reichskommissar für die besetzten niederländischen Gebiete,

SEYSS INQUART

Den Haag, 24. September 1944.

Voor de vernieling of beschadiging van Spoorweg-installaties, Telefoongeleidingen en Postkantoren stel ik de geheele bevolking der gemeente aansprakelijk, op welker gebied de daad wordt gepleegd.

De bevolking van zulke gemeenten moet dus rekening daarmede houden, dat ter vergelding de hand op eigendommen zal worden gelegd en dat er huizen of groepen van huizen zullen worden vernield.

Ik beveel den gemeentebesturen aan, door patrouilles of op andere doeltreffende wijze voor voldoende bescherming van de verkeers-inrichtingen en van de middelen voor de berichtgeving zorg te dragen.

De Rijkscommissaris voor de bezette Nederlandsche gebieden,

SEYSS INQUART

Den Haag, 24 September 1944.

Bekanntmachung — Bekendmaking

Der Höhere ⚡⚡- und Polizeiführer Nordwest gibt bekannt:

Wegen des feigen Mordanschlags auf einen niederländischen Polizeibeamten in Haarlem am 1. März 1945 wurde am 7. d. M. eine Anzahl Terroristen und Saboteure öffentlich standrechtlich erschossen.

De Höhere ⚡⚡- und Polizeiführer Nordwest maakt bekend:

Ten gevolge van den laffen moordaanslag op een Nederlandschen politie-ambtenaar in Haarlem op 1 Maart 1945 werd op 7 dezer een aantal terroristen en saboteurs in het openbaar standrechtelijk doodgeschoten.

Abreissen oder beschädigen dieses Plakates ist strafbar.

Afscheuren of beschadigen van dit plakaat is strafbaar.

17.

Home Fronts

The defeat and systematic subjugation of nations, the mass murder of segments of the populations, the heavy bombing of cities, and continuing, if never very effective, resistance to the New Order added up to a war at home that greatly differed from the static First World War with its clearly demarcated fighting front and its homefront. In September 1939 Goebbels defined the demands that total war would place on the nation by formulating the basic theme that German propaganda would now express: "The Fighting and Sacrificing Homefront." German posters dictated the sacrifice of the individual for the common good and the fusing of all Aryan Germans into a world-conquering phalanx. Allied posters, on the other hand, elevated the principle of democracy and justice into moral absolutes that demanded every personal and social effort. The intrusion of the war into civilian life was further manifested by Nazi and Allied posters warning against internal enemies—spies who reported to the enemy—and in German posters against traitors who broke the common front by listening to enemy broadcasts and repeating their lies.

Despite the differences between the two wars, certain imperatives in both marked the posters with homefront themes: the need to produce and conserve materiel and food, the recruiting of soldiers and civilian workers, and the maintenance of morale. In addition, posters of both wars emphasized the necessary identification between workers at home and soldiers in combat, an identification that had greater immediacy for the combatants in Europe than in America.

In the United States and Britain, conscription of men was augmented by posters calling for earlier voluntary enlistment and by intensive poster and propaganda campaigns directed at bringing middle-class women who had not previously been employed into the work force. By 1941, registration of women began in Britain for work in munitions industries, the auxiliary military services, civil defense, and the land army, and, by 1943, conscription applied to most 19 to 30-year-old women. The United States, with no registration or conscription for women, relied on posters and advertisements to direct women into the armed services and war industries. Although women were heavily involved in labor services in the Soviet Union and in Germany, neither country made much direct use of posters to enlist them. At the height of the invasion of Russia, and later of Germany, women, men, and youths were regularly portrayed together as defenders of the homelands.

259. Your work ensures victory!
Germany. 1944. Theo Matejko.

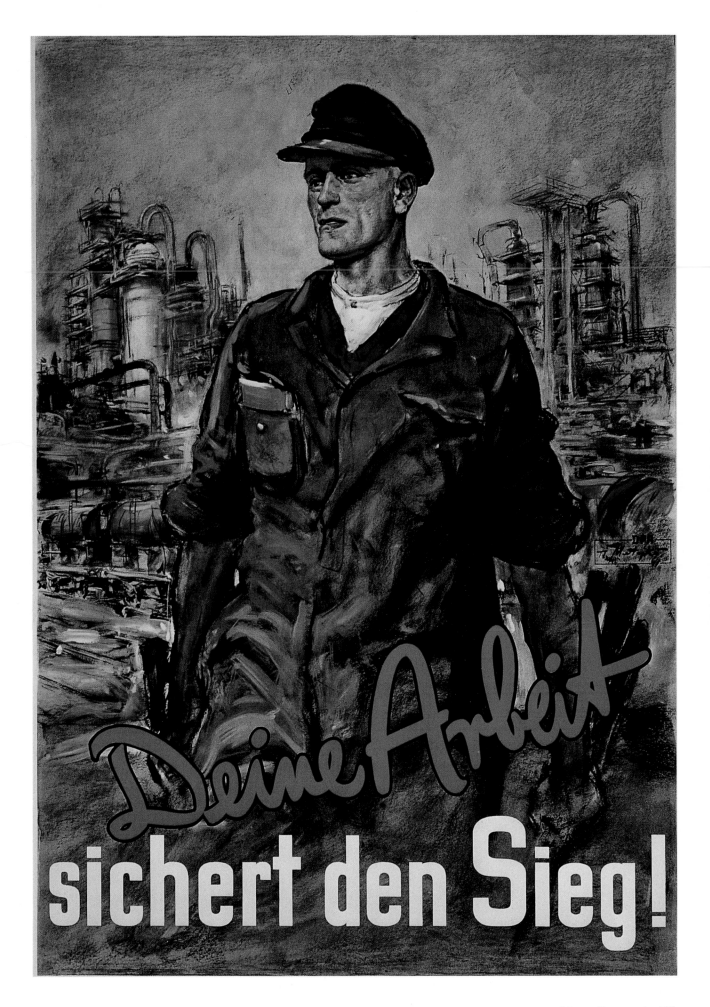

260. ". . . pass the ammunition."
U.S.A. Frederic Stanley.

Poster 259 and 260, demonstrating the vital link between industrial and
military power, are conceptually complementary and yet convey radically
different messages. The German poster, rooted in a painterly tradition, de-
picts the sober determination of the worker against an inferno-like industrial
backdrop, while the U.S.A. Army Ordnance poster, marked by a form of
photographic realism, reveals brash confidence in American power.

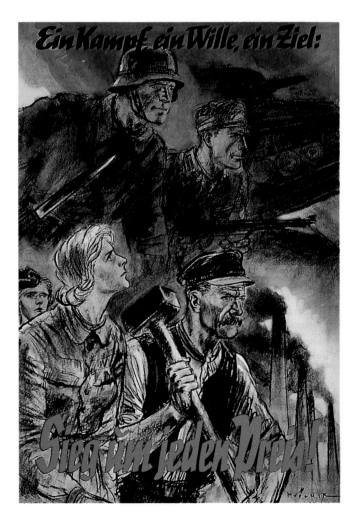

261. One struggle, one will, one goal: victory at any cost!
Germany. 1942. Mjölnir (Hans Schweitzer).

Mjölnir's stereotypical figures appeared throughout the war. The Message
of the Week poster of April 29, 1942 featured this ambivalent version of
his vision of German fortitude and willpower. Although published before the
Russian campaign and the defeat at Stalingrad when the German empire
was at its height, Mjölnir's civilians show no enthusiasm, but rather wear the
stern expressions that were often found in his work (Figure 1; Poster 186).

262. Traitor.
Germany. 1944. Max Spielmanns.

An ingenious use of typeface and juxtaposition
of dark and light sends the message that listen-
ing to foreign broadcasts from London and
Moscow constitutes treason.

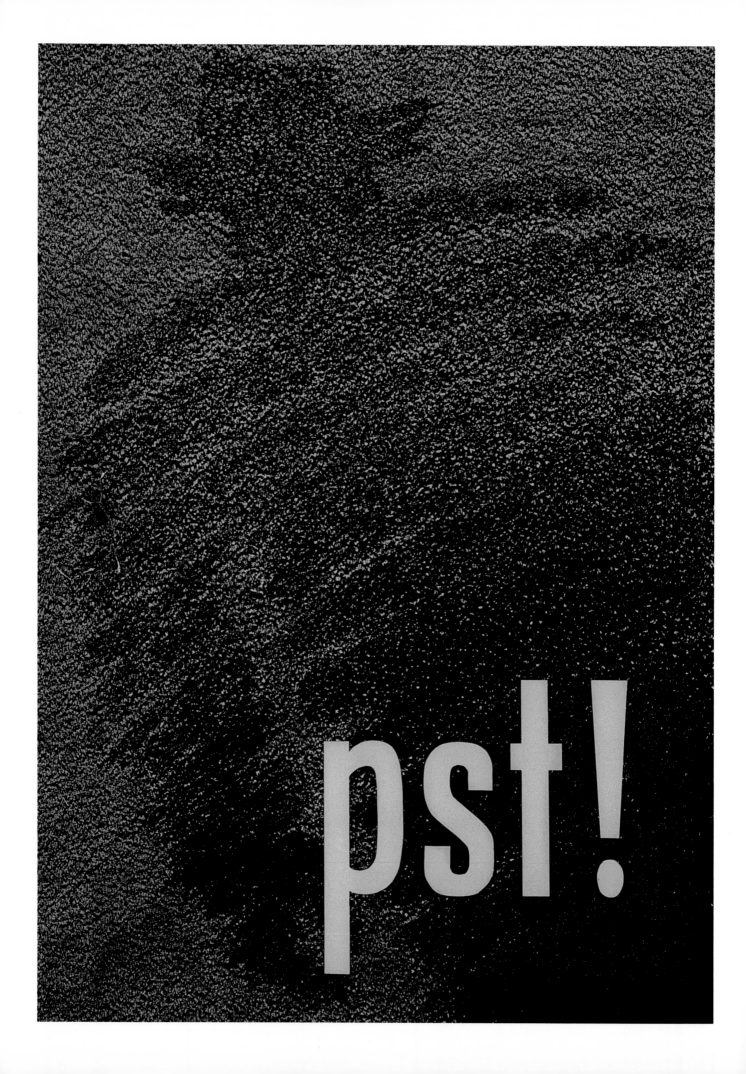

263. Shhh!.
Germany. 1943.

264. The enemy overhears!
Germany. 1943.

This brilliantly subtle two-color poster carried an unsettling double message that made it one of the best remembered posters in Germany from the war and provided a motif for a series of other posters. The menacing shadow was meant to represent a foreign spy—as the second poster explicitly states—but also served as a foreboding reminder of the neighborhood informer who denounced friends and acquaintances for a careless or critical word.

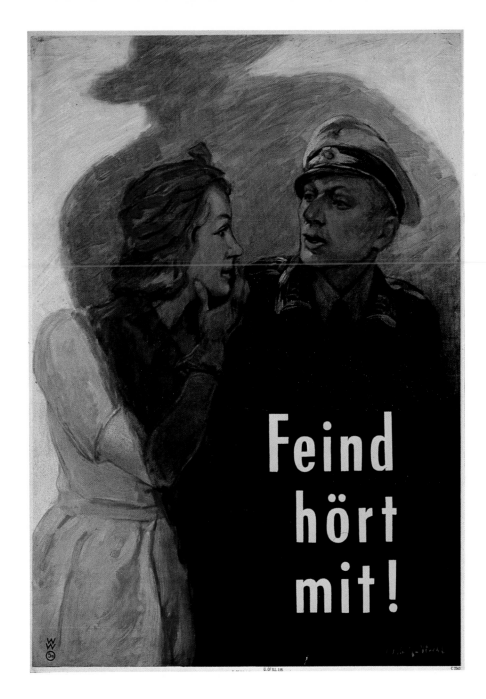

265. A few careless words may end in this—
Great Britain. Norman Wilkinson.

266. Keep mum, she's not so dumb!
Great Britain. c.1940. G. Lacoste.

The threat of invasion after Dunkirk combined with the high toll of ships sunk by U-boats produced fears of a Fifth Column of German spies operating in Britain—here shown as a glamorous vamp. Not needing to maintain internal control against defeatism, Allied posters warning against careless words were often more light-hearted and humorous than their German counterparts.

267. Thousands of women needed now . . .
Great Britain. c.1943.

268. Women of Britain. Come into the factories.
Great Britain.

269. Women in the war. We can't win without them.
U.S.A. 1942.

*Allied posters enlisting women into the war effort—"for the duration"—
shouted their message that women's work was indispensable to victory. One
British poster echoed the pitch of factory work offering a new exciting life
that Scott had asserted in his 1917 poster (Poster 85). In the other, women
join men in the call to military duty, rather than standing aside as in Keal-
ey's 1915 poster (Poster 68). The need for the young woman, standing in
her pragmatic trenchcoat, to enter the military auxiliary is emphasized by
the group of men from all of the armed services who are rushing through
the subway on their way to combat. U.S. posters recruiting women for war
work regularly showed photographs of women in industrial plants, where
two million women employed by 1942 and five million by 1945 made the
nickname "Rosie the Riveter" a household term, although it was rapidly for-
gotten as the women were laid off when the shipyards closed or veterans
returned to their jobs. This photomontage poster with its focus on "Rosie's"
strong hands is far removed from the "Christie girl" of the First World War
or the pin-ups of the Second.*

270. Be a Marine . . . Free a Marine to fight.
U.S.A. 1945.

Indicative of changing attitudes towards women is the serious resolve of the woman officer and the gritty portrayal of marines in action in the U.S. Marine Corps poster.

271. A tractor in the field is worth a tank in battle.
U.S.S.R. 1942. Viktor Ivanov and Olga Burova.

Continuing the unreality of social realism, Ivanov and Burova's placid landscape gives no hint of the desperate conditions in Russia in the spring of 1942, picturing instead a productive, orderly country where women competently manage the land while tanks, troops, and planes roll to the front.

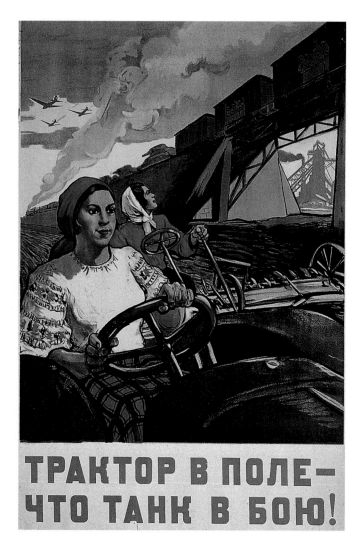

ТРАКТОР В ПОЛЕ— ЧТО ТАНК В БОЮ!

BE A MARINE...
Free a Marine to fight
U.S. MARINE CORPS WOMEN'S RESERVE

272. You, too, must help!
Germany. 1941. Theo Matejko.

The Labor Service Law of 1935 and 1939 requiring young women as well as young men to work in industrial and agricultural jobs was not systematically enforced because of Hitler's and Göring's opposition to German women working, and because Germany utilized forced labor from the occupied territories. This recruiting poster portrays cheerful young women as nurse, farm laborer, and industry worker engaged, under the watchful protection of the omnipresent German helmet, in the early triumphant war effort, which was later to become a bitter struggle for survival.

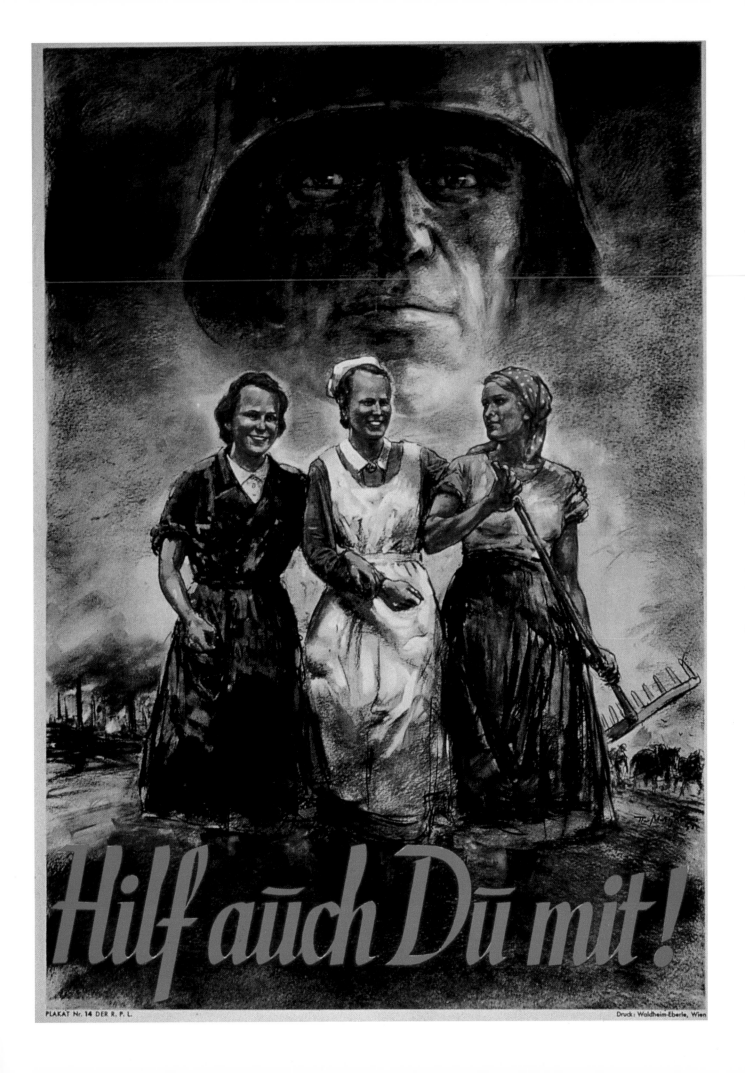

Hilf auch Du mit!

PLAKAT Nr. 14 DER R. P. L. Druck: Waldheim-Eberle, Wien

18.

The United States at War

In the spring of 1941, the U.S. government enlisted advertising and publicity agencies in a bond campaign intended both to raise money and to generate American support for the war against Germany that was almost certain to come. After Pearl Harbor, Roosevelt, anxious to avoid the exaggerated rhetoric of the First World War, directed the Office of War Information to disseminate information, not propaganda. This distinction, however, was easier to state than implement, particularly as competing government and private agencies became involved in promoting the war.

A wider range of media was now used than had been available in the previous war. The outpouring of newsreels, films, magazines, and comic books were probably more effective means of communicating ideas about the war than were posters. Nonetheless, many hundreds of posters were created. They ran the gamut from sophisticated attacks on Nazi ideology by well-known artists for the Museum of Modern Art, to crass racist caricatures often commissioned by local industry. Beneath the general banner of democracy, the posters express contradictions and inconsistencies resulting from the complexity of waging war on two sides of the globe, in which ideological issues significantly differed. In Europe, the United States fought to defend its allies against a Nazi empire motivated by a radical racist ideology. In the Pacific, Japanese expansion was also accompanied by a belief of racial superiority, but many Americans were themselves driven by hatred of the "sub-human Jap." That their animosity was more than paper-deep was demonstrated by the hysterical and unconstitutional deportation of Japanese-Americans from their homes on the Pacific Coast to internment camps. Given this contradiction, it is not surprising that posters directed against the Nazis rarely dwelled on their racist atrocities and that anti-Japanese posters were often filled with crude and sinister racist caricatures. In contrast to the denigration of the Japanese, G.I.s were generally presented in U.S. posters as tough, sweaty, yet glamorous Anglo-Saxons.

273. Avenge December 7.
U.S.A. 1942. Bernard Perlin.

The Japanese surprise attack at Pearl Harbor provided the rallying cry for war, even more than the sinking of the Lusitania in 1915 had crystallized anti-German attitudes. This poster is remarkable in its concise evocation of the event and of the American outrage that followed.

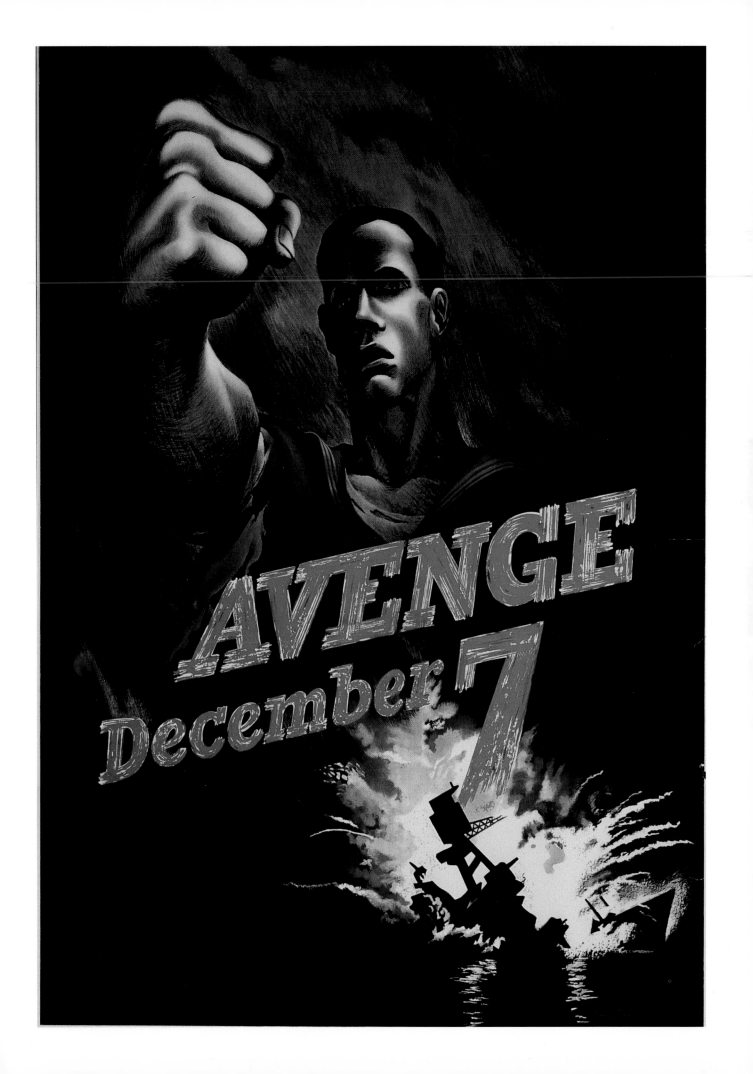

274. This is the enemy.
U.S.A. 1943.

In one of a series of vivid ideological posters that educated the public on Nazi beliefs and policies, the Nazi "dagger of honor" slashing through the Bible strangely forms an inverted crucifix.

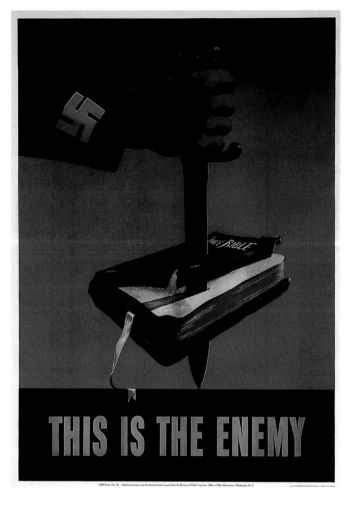

275. Buy more war bonds and stamps.
U.S.A.

The Museum of Modern Art cooperated with various agencies and competitions to promote aesthetic standards in war posters.

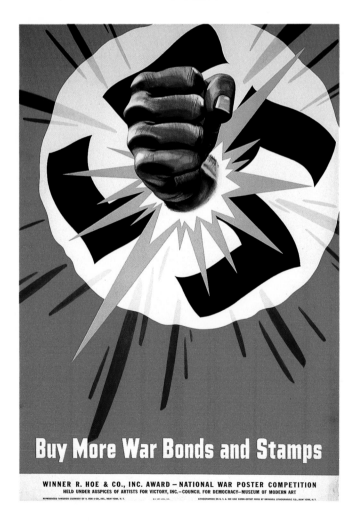

276. This is Nazi brutality.
U.S.A. 1942. Ben Shahn.

Shahn, famous for didactic paintings expressing his sense of social and political injustice in America, seemed predestined to be a strong voice in this country's propaganda. The posters he produced for the Office of War Information are among the most art-historically sophisticated posters produced during the war. Derived from Goya's "The Prisoner," this ominous view of massive manacled hands, dark muffled head, claustrophobic brick walls, and stormy skies expresses both timeless human brutality and particular contemporary atrocities.

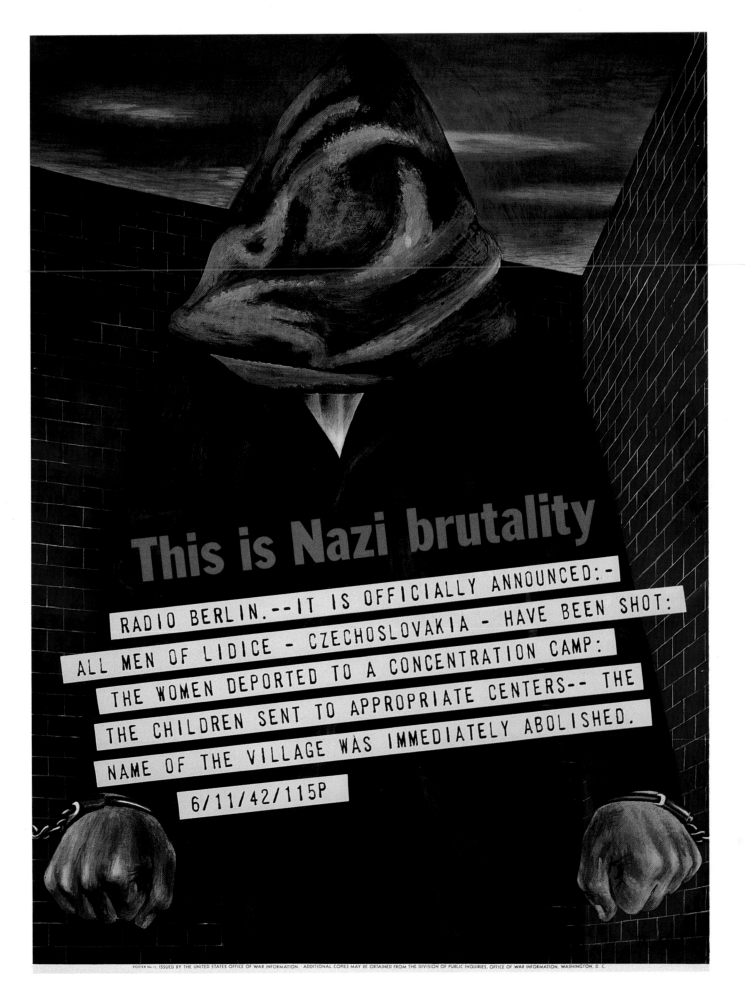

This is Nazi brutality

RADIO BERLIN.--IT IS OFFICIALLY ANNOUNCED:- ALL MEN OF LIDICE - CZECHOSLOVAKIA - HAVE BEEN SHOT: THE WOMEN DEPORTED TO A CONCENTRATION CAMP: THE CHILDREN SENT TO APPROPRIATE CENTERS-- THE NAME OF THE VILLAGE WAS IMMEDIATELY ABOLISHED.

6/11/42/115P

POSTER No. 11, ISSUED BY THE UNITED STATES OFFICE OF WAR INFORMATION. ADDITIONAL COPIES MAY BE OBTAINED FROM THE DIVISION OF PUBLIC INQUIRIES, OFFICE OF WAR INFORMATION, WASHINGTON, D. C.

277. Jap . . . you're next!
U.S.A. 1944. James Montgomery Flagg.

Flagg here painted a muscular and aggressive version of his famous First World War recruiting poster of Uncle Sam, which was actually a self-portrait.

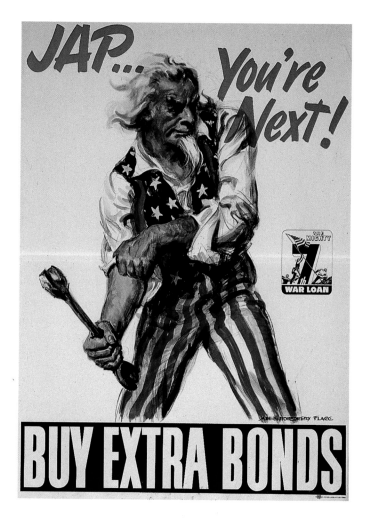

278. If you worked as hard and as fast as a Jap, we'd smash Tokio [sic] a lot quicker.
U.S.A. 1943.

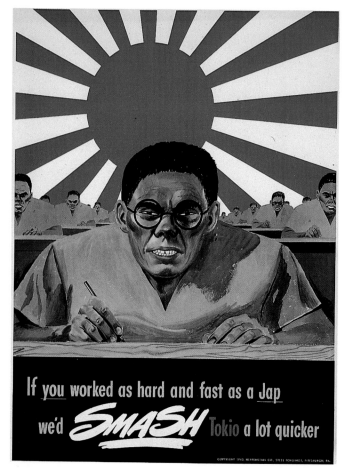

279. Civilian Exclusion Order No. 41.
U.S.A. 1942.

By Executive Order 9066 in February 1942, the War Department was given the power to exclude civilians from designated military areas. The order was used specifically to deport Japanese-Americans from the West Coast as was indicated in this notice of May 5, 1942 disseminated in the San Francisco area.

NOTICE

Headquarters
Western Defense Command
and Fourth Army

Presidio of San Francisco, California
May 5, 1942

Civilian Exclusion Order No. 41

1. Pursuant to the provisions of Public Proclamations Nos. 1 and 2, this Headquarters, dated March 2, 1942, and March 16, 1942, respectively, it is hereby ordered that from and after 12 o'clock noon, P. W. T., of Monday, May 11, 1942, all persons of Japanese ancestry, both alien and non-alien, be excluded from that portion of Military Area No. 1 described as follows:

> All of that portion of the City and County of San Francisco, State of California, within that boundary beginning at the intersection of Presidio Avenue and Sutter Street; thence easterly on Sutter Street to Van Ness Avenue; thence southerly on Van Ness Avenue to O'Farrell Street; thence westerly on O'Farrell Street to St. Joseph's Avenue (Calvary Cemetery); thence northerly on St. Joseph's Avenue to Geary Street; thence westerly on Geary Street to Presidio Avenue; thence northerly on Presidio Avenue to the point of beginning.

2. A responsible member of each family, and each individual living alone, in the above described area will report between the hours of 8:00 A. M. and 5:00 P. M., Wednesday, May 6, 1942, or during the same hours on Thursday, May 7, 1942, to the Civil Control Station located at:

> 1530 Buchanan Street,
> San Francisco, California.

3. Any person subject to this order who fails to comply with any of its provisions or with the provisions of published instructions pertaining hereto or who is found in the above area after 12 o'clock noon, P. W. T., of Monday, May 11, 1942, will be liable to the criminal penalties provided by Public Law No. 503, 77th Congress, approved March 21, 1942, entitled "An Act to Provide a Penalty for Violation of Restrictions or Orders with Respect to Persons Entering, Remaining in, Leaving or Committing Any Act in Military Areas or Zones," and alien Japanese will be subject to immediate apprehension and internment.

4. All persons within the bounds of an established Assembly Center pursuant to instructions from this Headquarters are excepted from the provisions of this order while those persons are in such Assembly Center.

> J. L. DeWITT
> Lieutenant General, U. S. Army
> Commanding

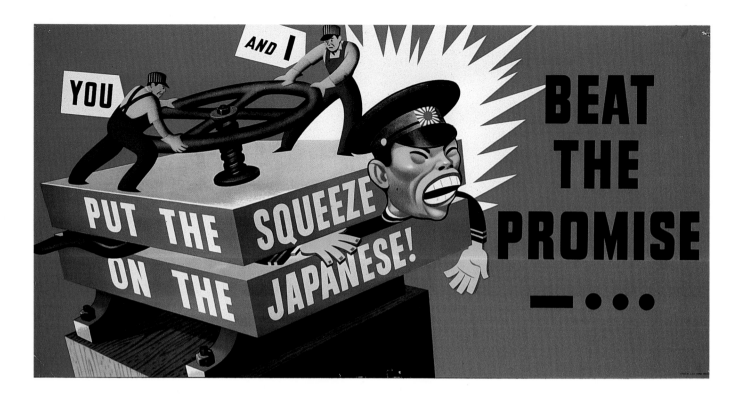

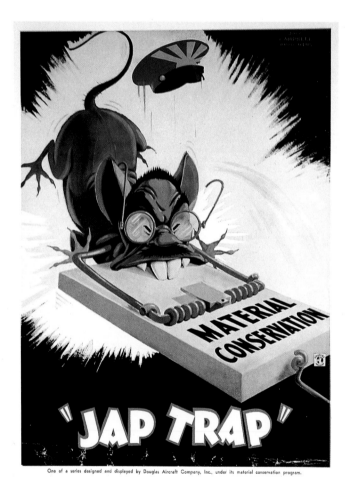

One of a series designed and displayed by Douglas Aircraft Company, Inc., under its material conservation program.

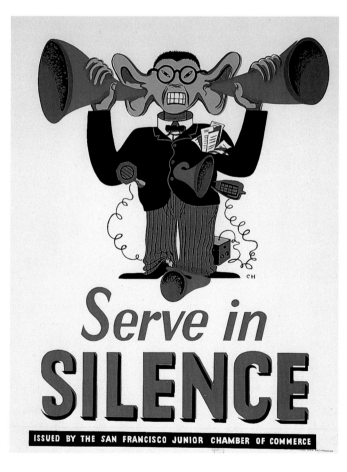

280. Put the squeeze on the Japanese!
U.S.A.

281. "Jap trap."
U.S.A. Jack Campbell.

282. Serve in silence.
U.S.A. C.H.

283. Careless matches aid the Axis.
U.S.A. 1942.

Caricatures ridiculing Japanese as rats, apes, menacing monsters, or comic characters with huge teeth and glasses were used for so many kinds of cautionary and exhortatory posters that they became one of the most pervasive images of the war. Poster 278, however, suggested a fear behind these portrayals: could Americans match the Japanese willingness to work and sacrifice for the national honor?

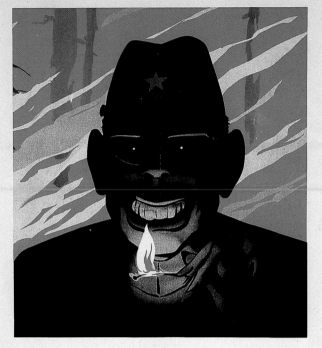

careless matches aid the Axis

PREVENT FOREST FIRES !

284. The war's not over 'til our last man is free.
U.S.A. 1944.

Displayed in New York subways, this poster, with its painterly realism, carried the grim reminder of the war that was far removed for most Americans. After three years of combat, the Japanese soldier was here shown as a formidable opponent.

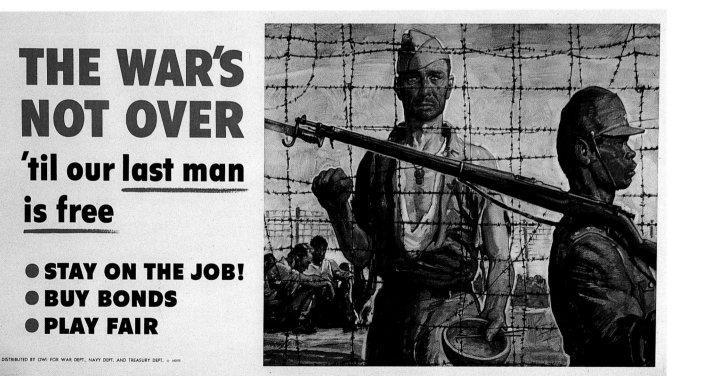

THE WAR'S NOT OVER 'til our last man is free

● STAY ON THE JOB!
● BUY BONDS
● PLAY FAIR

DISTRIBUTED BY OWI FOR WAR DEPT., NAVY DEPT. AND TREASURY DEPT. © 44MS

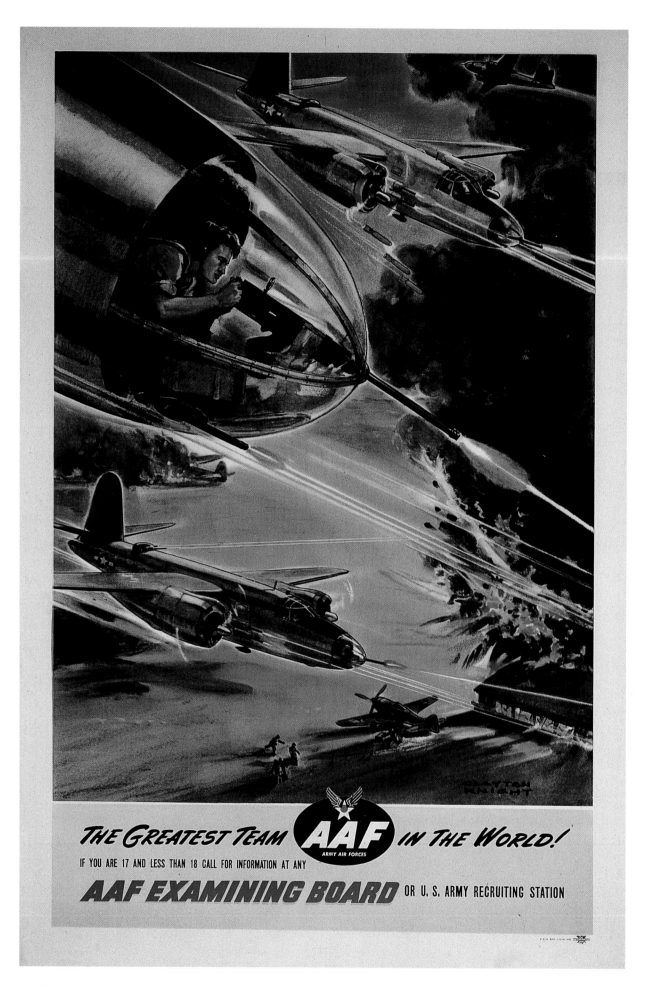

285. The greatest team in the world!
U.S.A. 1944. Clayton Knight.

*This highly romantic depiction of American
planes strafing an enemy air field is one of
many posters that glorified the new power of
air forces in the European and Pacific theaters.*

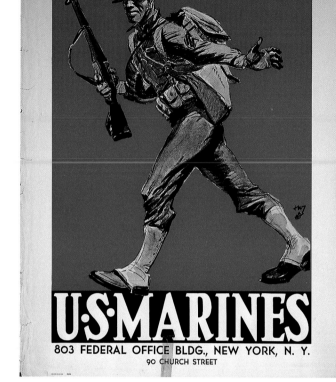

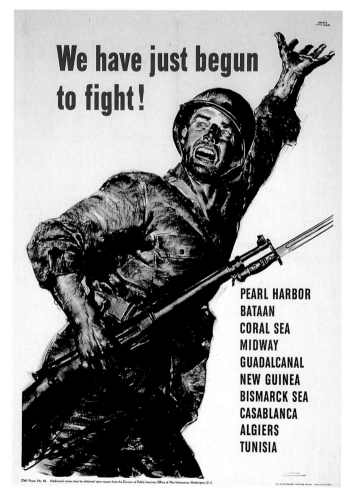

286. U.S. Marines.
U.S.A. 1941.

287. We have just begun to fight!
U.S.A. 1943.

*Despite the effectiveness of air power, foot soldiers remained an essential
force in every campaign. American poster designers, however, found them
more ambiguous, less-rewarding subjects than the technological glamour
that seemed to surround pilots and their planes. Poster 287 is virtually a
copy of Faivre's infantryman of 1916 (Poster 53) and its roll call of victories
recalls the litany of First World War battles. Poster 286, probably published
before the U.S. entered the war, presents a jaunty, First World War image
when compared to the stark visions of worn-out men in jungle swamps and
burial fields later in the war.*

Don't let him down

BUY WAR BONDS-KEEP THEM

© BETHLEHEM STEEL COMPANY

288. Don't let him down.
U.S.A.

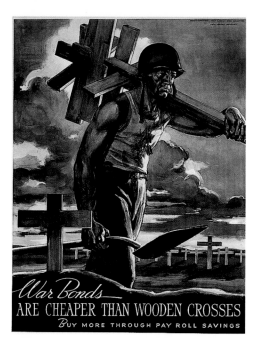

289. War bonds are cheaper than wooden crosses.
U.S.A. 1944. Sgt. Ardis Hughes.

290. Next! Japan.
U.S.A. 1944.

The artist who created this anguished but tenacious American soldier anticipating the coming invasion could not have known how accurately his symbolic bomb over Japan foretold August 1945.

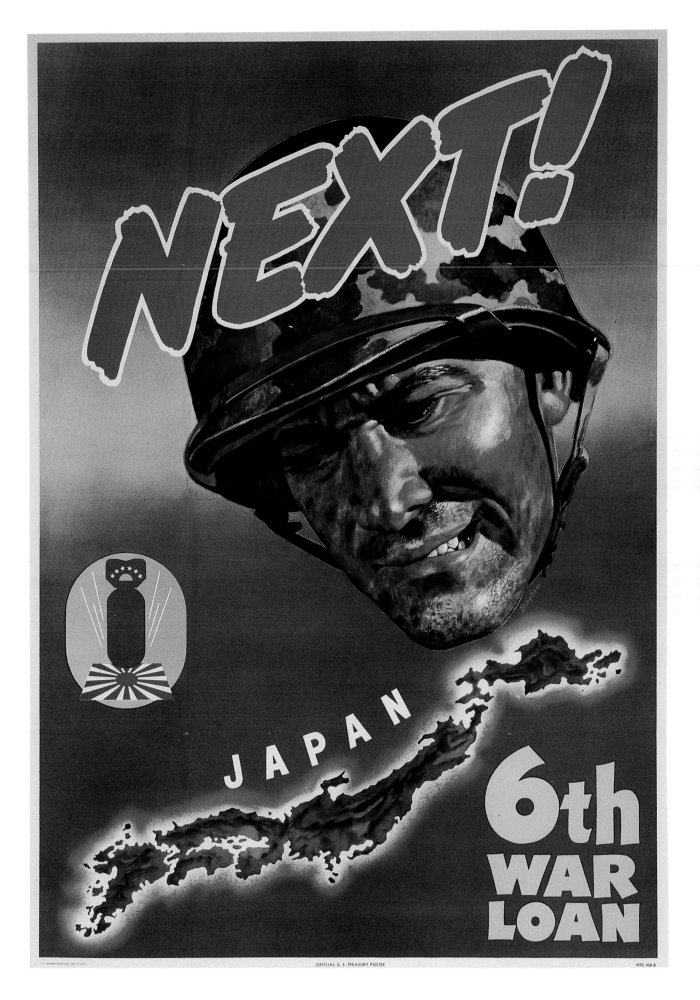

19.

The Last Year

After the landings in Normandy, the main objective of Allied propaganda at home was to maintain civilian support of the war at a high level, which meant specifically continuing to observe war-time economic regulations and to buy war bonds. German propaganda had a more difficult task. Although some people still pinned their hopes on a secret weapon, on Allied disunity, and on Hitler's genius, most now recognized that the war had been lost, and lost with a degree of physical and moral degradation that few could have imagined just two or three years earlier. The retreat of German forces on the major fronts and the annihilation of German cities from the air made the intense danger to the nation and to each individual existence apparent to all. The official denial of this recognition in broadcasts, newspapers, and posters played a part in preventing people from giving up. But society in general was more cohesive and passive, and the repressive power of the National Socialist system more immune to external pressure and enemy action, than many had expected. The administrative machinery of the state still functioned in the ruins; men and women were executed for listening to enemy broadcasts or leaving their unit or workplace on the very days that surrender talks were under way. A terrified, disciplined people continued to work and fight until space, soldiers, and equipment had run out.

At first glance very little of this is evident in German posters of the time. We recognize once more what a partial witness—both incomplete and prejudiced—the poster is. An appeal to members of the Hitler Youth to join the army (Poster 296), with its heroic masculinity, blood-red banner, and flight of stylized Focke-Wulf fighters overhead (no more than a memory by the second half of 1944), does not by itself reflect the country's desperate condition. On its own, the poster seems as martial and self-confident as any recruiting poster. It needs to be placed in historical context—why in 1944 must sixteen-year-olds have fought in the army?—and it needs to be compared with its predecessors before the evidence can be unlocked by

means of the grim and solemn expressions on the young men's faces (either the artist's unconscious comment on the German condition now, or his deliberate appeal to the boys' unconscious recognition of the truth).

The last posters calling on civilians to resist to the end, printed on cheap paper in one or two colors (Fig. 1), blended almost seamlessly with the first announcements of the Allied occupying forces. A new phase in history and in the history of the poster had begun. The military government poster in occupied Germany, and the liberation or reconstruction poster elsewhere, were forerunners of the political party poster, which within a year or two was to experience a massive revival.

291. Invasion!
Great Britain. 1944.

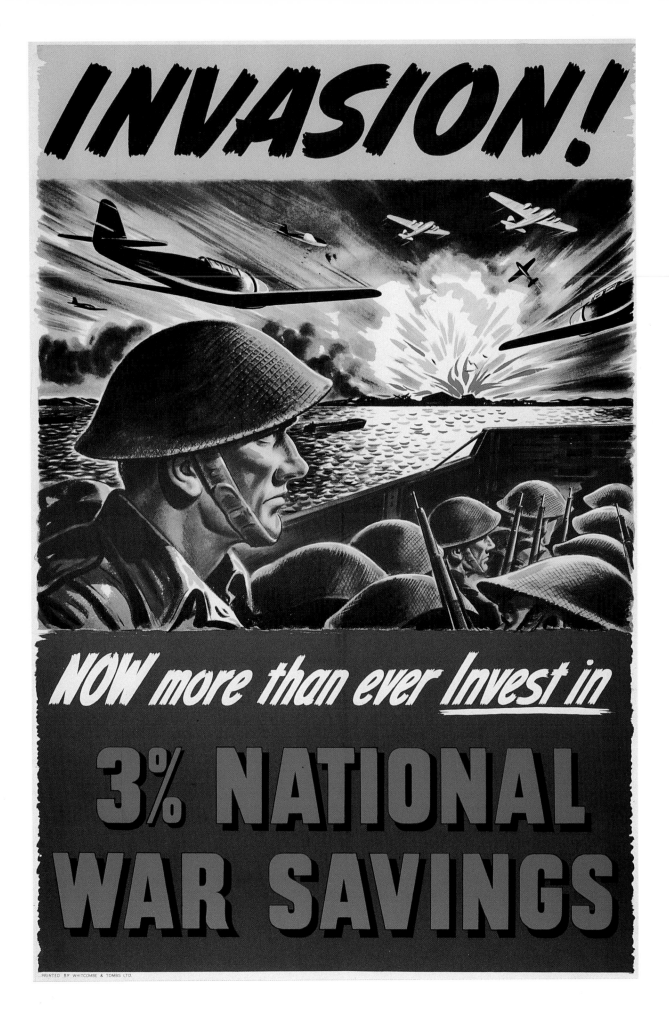

292. Victory of the Allies is assured.
Great Britain. 1943.

293. Forward to victory.
Great Britain.

The first of these two representations of modern war, issued after the Allied landings in Sicily and Calabria in the summer of 1943, offers a relatively realistic depiction of the large-scale landing operations employed in the second half of the war. The other, its attention to the details of tank construction notwithstanding, seems more like an updated version of the popular image of a Victorian cavalry charge.

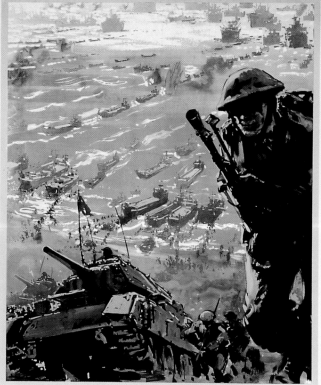

The Mediterranean Invasion. British troops, tanks guns pouring ashore from landing craft.

VICTORY OF THE ALLIES IS ASSURED

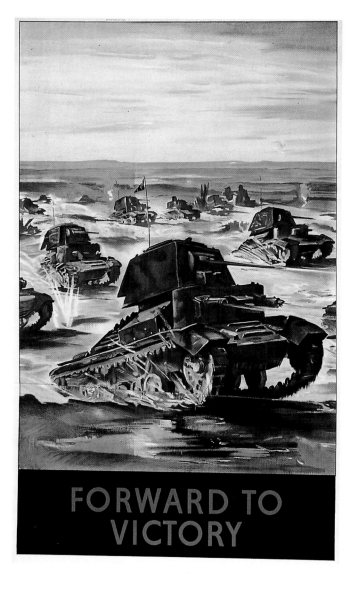

294. Infantry. The queen of battle.
Germany. 1944.

The poster, designed in 1943 but not printed until September 1944, was issued by the Army, and for that reason was more purely military, less ideological than posters produced by the propaganda ministry or the party. But note the similarity in the officer's posture and the position of his hands to Eber's apotheosis of Hitler as the eternal German soldier (Poster 203).

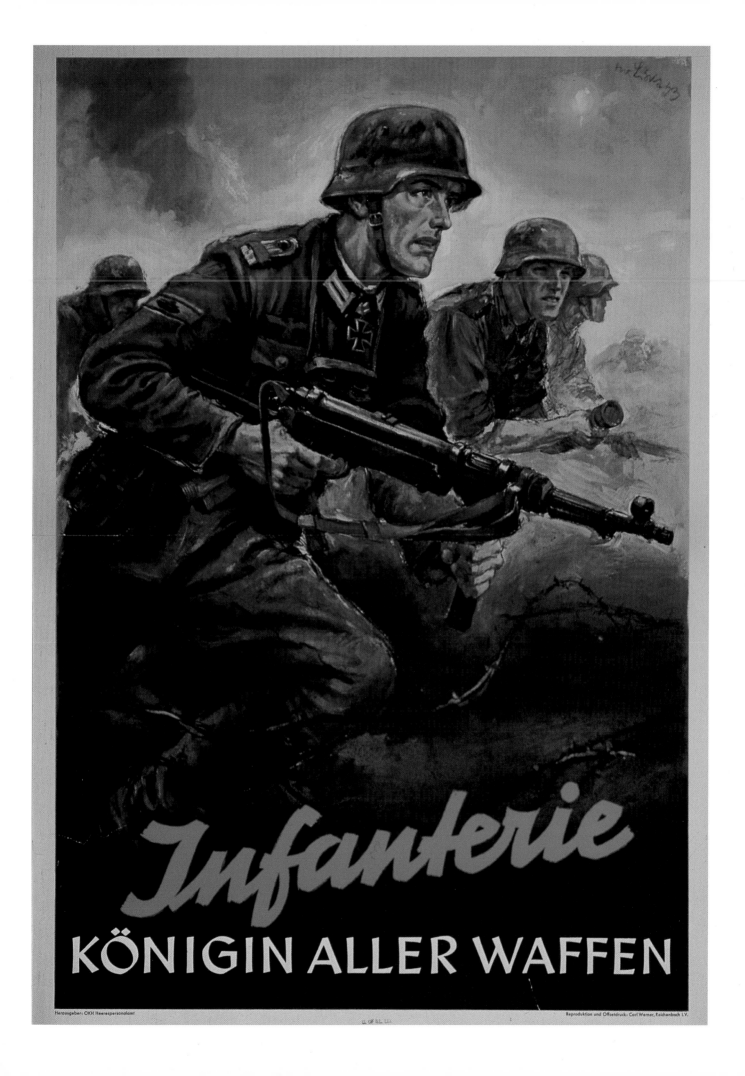

Infanterie

KÖNIGIN ALLER WAFFEN

Herausgeber: OKH Heerespersonalamt

Reproduktion und Offsetdruck: Carl Werner, Reichenbach i.V.

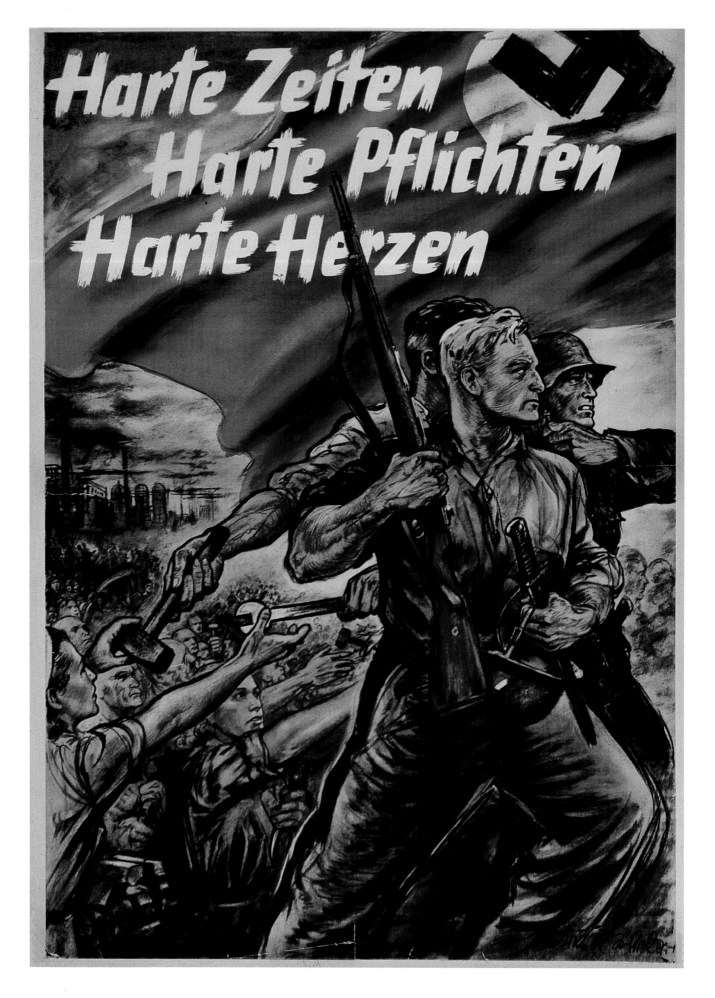

295. Hard times. Hard duties. Hard hearts.
Germany. 1943.

After the surrender of the Sixth Army at Stalin-
grad early in 1943, a harsher, less overtly con-
fident note gradually came to the fore in Ger-
man propaganda. The expressions of the two
men in the foreground are an example. The
text declaiming that hard times require people
to harden their hearts—a justification fre-
quently advanced by members of the Einsatz-
gruppen and others who took part in the exter-
mination of Jews and the murder of prisoners of
war—began a new stage in the brutalization of
German society by National Socialism.

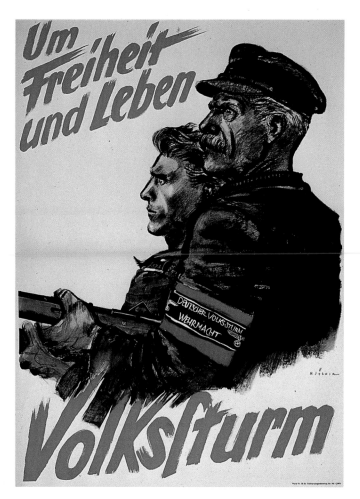

296. Hitler Youth. The young war volunteers.
Germany. 1944. Ahrle.

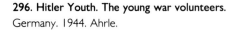

Since February 1943, students in secondary schools who had passed their
fifteenth birthday were liable for auxiliary service in anti-aircraft units. In
the last year of the war an increasing number of boys were enrolled in
front-line units and the Volkssturm or Home Guard.

297. For freedom and life. Home Guard.
Germany. 1944. Mjölnir (Hans Schweitzer).

Not only was freedom now at stake, but the very life of the nation and
people. Mjölnir's poster of November 1944 proclaimed the formation of the
Volkssturm, the last draft of adolescent and over-age civilians, armed with
light infantry weapons and identified by armbands with the legend "German
Volkssturm–Wehrmacht" and the National Socialist eagle and swastika.
Only an extreme of cynical nihilism could send such men against trained,
heavily equipped troops, but, at least in the final months of the war, many
Volkssturm units quietly disbanded or melted away as desertion became
general.

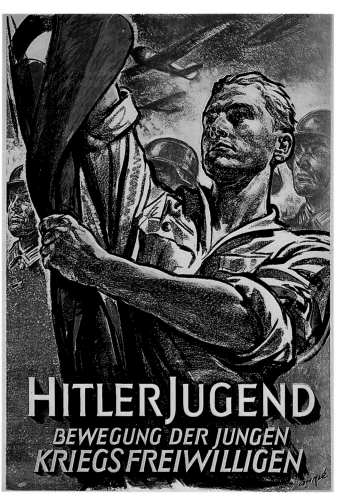

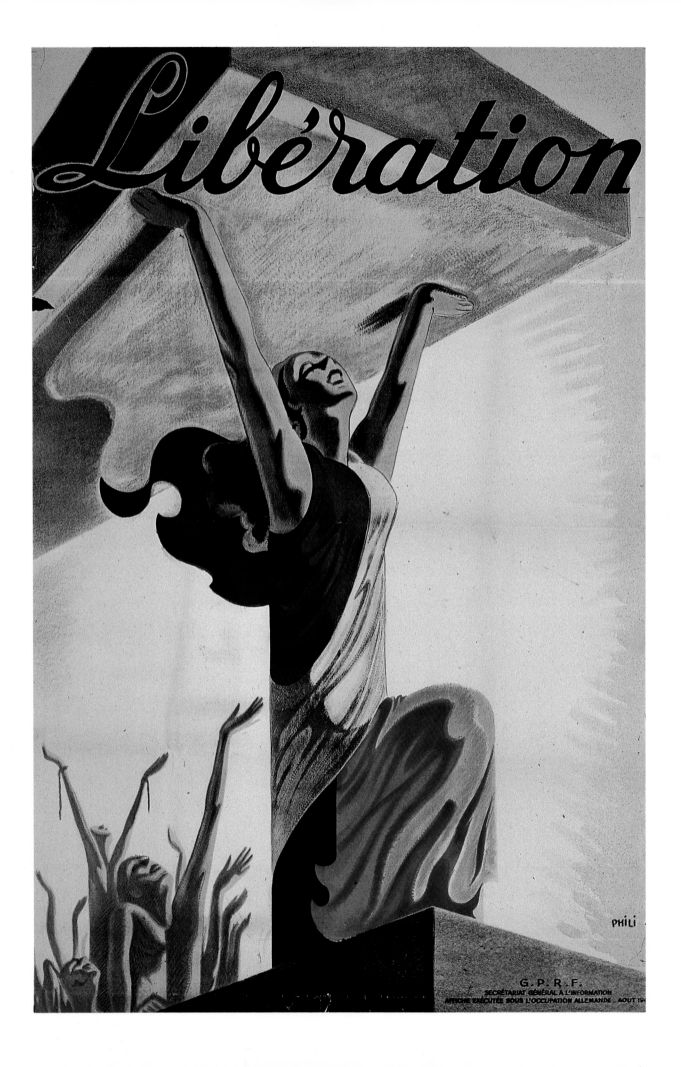

298. Liberation!
France. 1944.

A technically competent if rather operatic design that did not call for a particular action or attitude but rather gave visual expression to a universally known fact. The poster was the pictorial equivalent of a victory parade.

299. Free Holland welcomes the soldiers of the Allies.
Great Britain. 1944. Pat Keely.

The poster was printed in advance of the liberation of The Netherlands, but could not be used until the spring of 1945.

300. We will raise the flag of victory over Berlin.
U.S.S.R. 1944. Viktor Ivanov.

In this cosmetic version of social realism all soldiers smile as they march through the Brandenburg Gate.

301. The end.
East Germany. 1945.

Printed in the Soviet zone of Germany in November 1945, the poster shows the baroque Church of Our Lady in Dresden as it once had been, and superimposed the rubble and a few buttresses of what was all that remained of it after twelve years of Hitler's rule and the Allied air raids of February 1945.

302. Help the repatriated political prisoners.
Belgium. 1945. K. Peiser.

A returning prisoner looks ahead to the future. Behind him loom a skull wearing a cap with the SS death's head insignia and a wall that bears the names of German concentration and extermination camps.

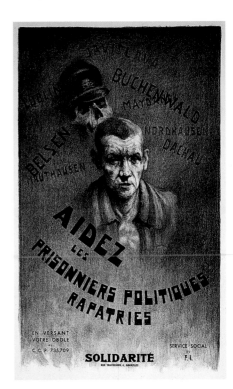

303. Reconstruct.
France. 1945. Roland Ansieau.

Cut-outs of workers and equipment superimposed on the photograph of a town in ruins combined in an appeal for help to finance the task of rebuilding.

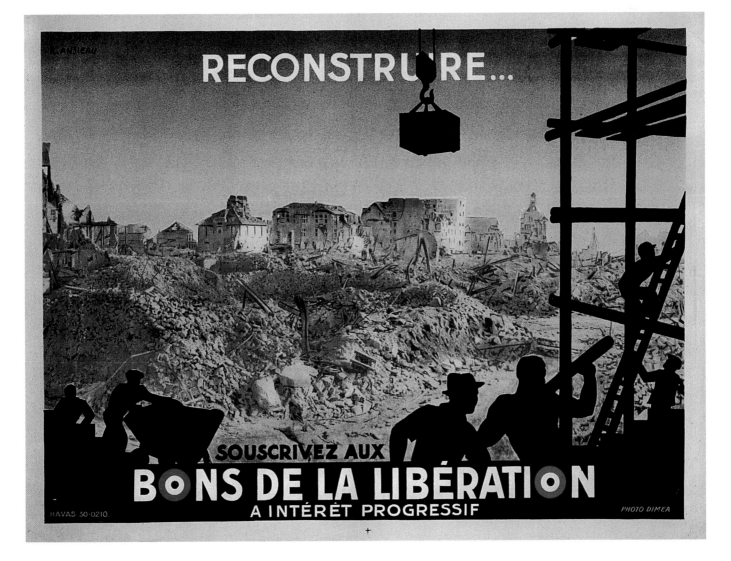

Epilogue:
After 1945

Since the end of the Second World War, the role of the political and commercial poster has diminished. Television now dominates the range of images directed at the mass public, and in overtaking the poster this new medium has also affected its design. Especially in Western Europe, posters employed by political parties in election campaigns over the past thirty years have often looked like frames from a television interview or current affairs program. On the whole, this has meant adopting the weaknesses of television without benefitting from its strengths of movement and immediacy. Presumably it is thought that for the contemporary audience a pretended television image is better than none at all. Or, possibly, many designers and their employers now see and think in television terms.

The designers of the following posters move in a contrary direction. Some continue in an earlier style of storytelling with its roots in the European and American comic strip, or employ realistic images or abstract forms—often in symbolic ways—to make their point. Others experiment with collages, photography, or adapt pop art and other current styles and fashions for their purpose. In the clash of ideologies and political interests, the poster is a less significant force than it once was, but it continues to live because, unlike film and television, it can visualize political messages in an immobile aesthetic form.

304. Students against nuclear weapons.

The symbol of our times blots out the sun. The sky, which a nuclear blast has turned to fire, is structured in rectangular blocks that suggest the precision and inhumanity of science. The poster was produced by the International Union of Students, an organization that fell under communist control in the late 1940s and that sponsored some of the best posters of the Cold War (see also Poster 308).

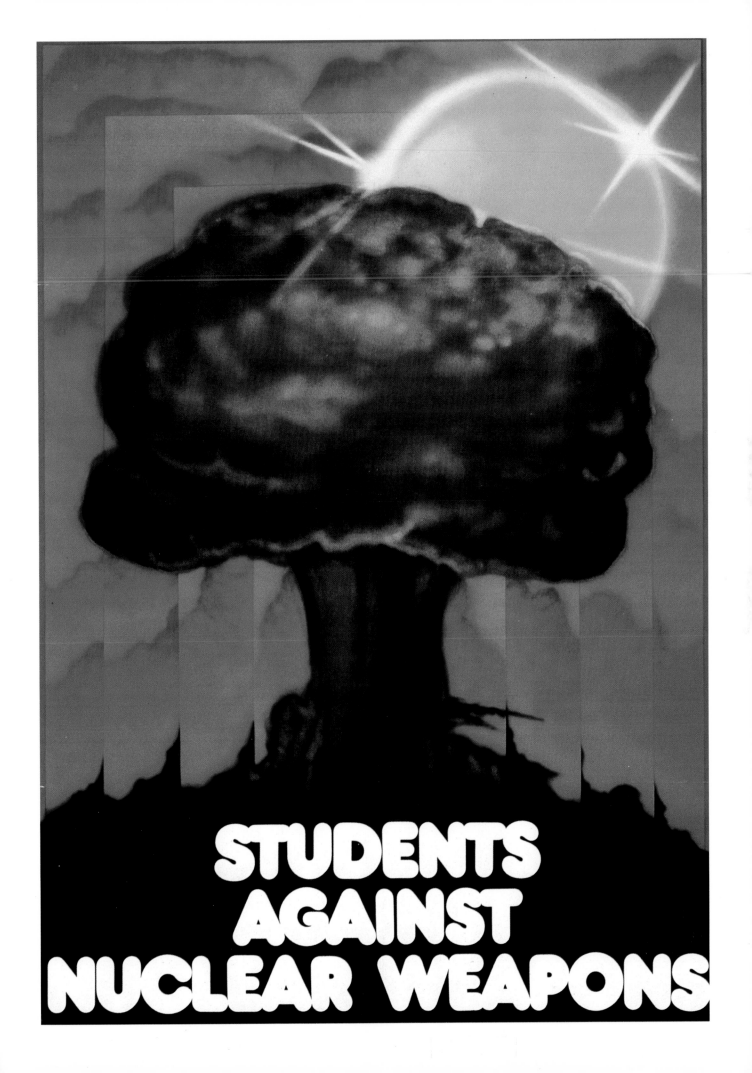

STUDENTS
AGAINST
NUCLEAR WEAPONS

305. No! France will not become a colony.
France. 1952.

A few years earlier, this communist image of an octopus with dollar signs for eyes, climbing onto the shores of France, would have made an excellent Nazi poster.

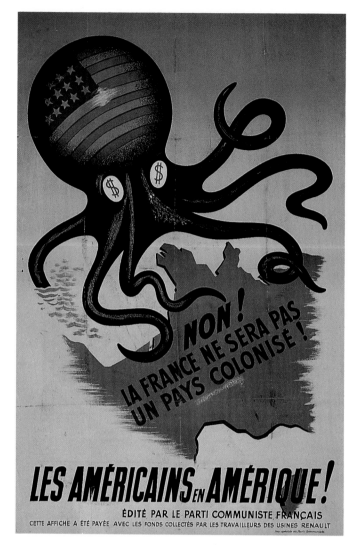

306. For your holiday, visit the Soviet Union, land of liberty.
France. c.1952.

Between 1950 and 1956, an agency of the French government, "Paix et Liberté," with political backing from the moderate left to the Gaullists, published anti-communist journals, sponsored radio programs, and printed some two hundred posters. Communist hypocrisy about the nature of Stalinist repression provided one of the posters' most effective themes.

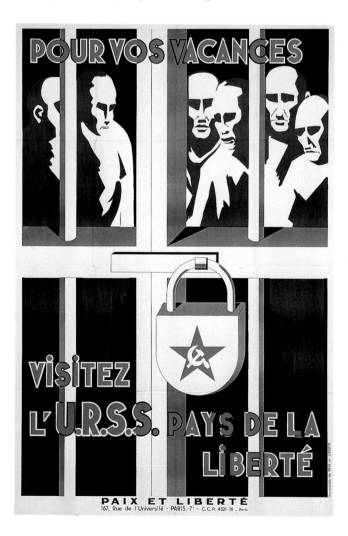

307. Against German remilitarization.
Czechoslovakia. 1951.

In this poster the German people on both sides of the border are peaceful and welcome the fraternal support of their Czech and Polish neighbors, who are protected by the Soviet army. American and West German big business, however, is rearming West Germany and anti-communist emigres from the East. An American is releasing rats wearing Nazi caps from the sewer of Landsberg prison. With a hand dripping blood, Eisenhower gives the Nazi salute, which is returned by the Social Democratic and Conservative leaders of West Germany. The fact that the artist did not refrain from replacing the stars in the American flag held by Adenauer with a swastika, makes the poster a particularly compelling witness to the honesty and decency of the political system that sponsored it.

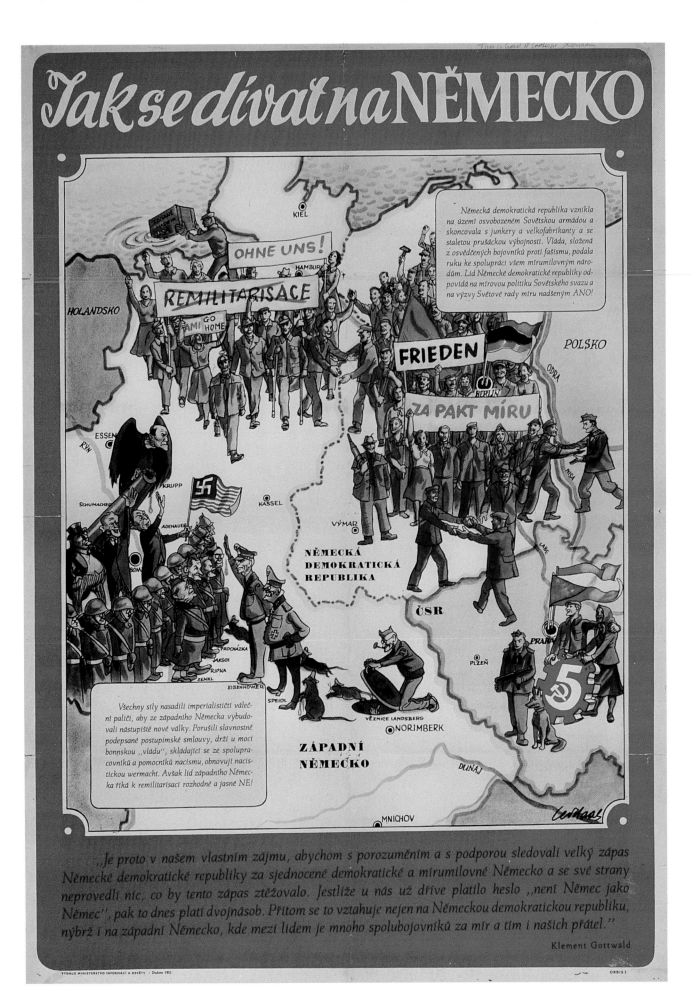

308. Korea must be reunified!

Another excellent poster published by the International Union of Students identifies American power as the force dividing Korea.

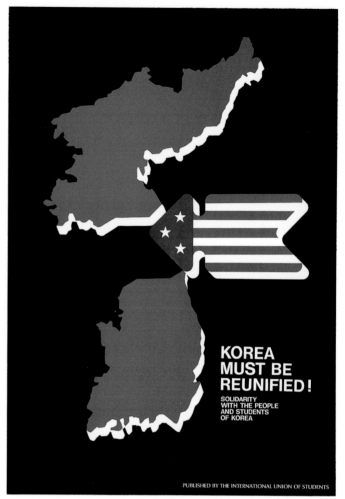

309. The support of the Vietnamese people and their victory will halt American aggression.
France. 1968. Rapho.

The photograph of the crying Vietnamese child, ripped into strips like ragged frames of a film, suggests both destruction and movement toward a better future.

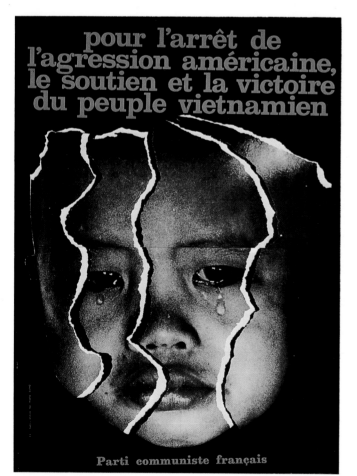

310. Green breaks through! Show your colors.
West Germany. Holger Matthies.

Technically sophisticated posters with powerful symbols often expressed the agenda of the German environmental party, the Greens.

Grün **bricht** **durch!**
FARBE BEKENNEN

311. Solidarity. The future of Poland.
France. 1976.

This is a French version of a famous Solidarity poster.

312. Workers of the world, forgive me.
East Germany. 1990.

Proletarier aller Länder

vergebt mir
JUNGE UNION POTSDAM

Junge Union der Geschäftsstelle des CDU - Kreisverbandes - Potsdam, Straße der Jugend 22

Editorial Note and Acknowledgments

The three editors have shared in all aspects of the work that has gone into the making of this book. Each has also assumed particular responsibility for some of its contents: Beth Irwin Lewis for chapters 5, 7, 9–11 and 17–18; Paul Paret for chapters 6, 12, and 14; and Peter Paret for chapters 1–4, 8, 13, 15–16, and 19, the prologue and epilogue, and the introductory essay.

We gratefully acknowledge the assistance we received from the following colleagues: Della van Heyst and Nora Sweeny of the Stanford Alumni Association, who initiated the project and supported its early stages; John Raisian and Charles G. Palm, Director and Deputy Director of the Hoover Institution, who made the holdings of the Hoover Archives available to us, and provided us with the best possible environment in which to study and write; Anne van Camp, Archivist, and the staff of the Hoover Archives, especially Elena Danielson, Associate Archivist, on whose expertise and unfailing readiness to help we relied far too much. It is no exaggeration to say that without Dr. Danielson the book could not have been written. We also want to thank Elena G. Millie, Curator, Poster Collection, Library of Congress, Agnes F. Peterson, Curator, West European Collection, Hoover Institution Library, and Terence Emmons, Professor of History, Stanford University, who helped us interpret a number of posters; Walter H. Lippincott, Jr., Director of Princeton University Press, whose confidence in our approach to the material helped overcome any number of obstacles; Elizabeth Powers and Tim Wardell, who edited the manuscript, and Mike Burton, who designed the book. Above all, we owe a debt of gratitude to our good friend Joanna Hitchcock, then Executive Editor, Humanities, Princeton University Press, now Director of the University of Texas Press, who was instrumental in bringing the project to Princeton, and helped with suggestions and advice as the manuscript gradually became a book.

Bibliographical Note

In the extensive literature on posters, we have found the following works especially interesting and helpful. We do not in every instance agree with their dating, attributions, and interpretations, but gratefully acknowledge the stimulation and information they have given us.

Barnicoat, John. *A Concise History of Posters*. London, 1972.

Bohrmann, Hans, ed. *Politische Plakate*. Dortmund, 1984.

Cantwell, John D. *Images of War: British Posters 1939–45*. London, 1989.

Carr, Raymond, intro. *Images of the Spanish Civil War*. London, 1986.

Coffey, John W., II. *American Posters of World War One*. Williamstown, MA., 1978.

Darracott, Joseph, ed. *The First World War in Posters*. New York, 1974.

Gervereau, Laurent, and Denis Peschanski. *La Propagande sous Vichy, 1940–1944*. Paris, 1990.

Harper, Paula, and Marcia Cohn Growdon. *War, Revolution and Peace*. Hoover Institution Archives, 1971.

Judd, Denis. *Posters of World War Two*. London, 1972.

Kampfer, Frank. *Der Rote Keil: Das Politische Plakat, Theorie und Geschichte*. Berlin, 1985.

Logan, R. A., ed. *The Great Patriotic War: A Collection of World War II Soviet Propaganda Posters*. University of Guelph Library, 1984.

Malhotra, Ruth. *Politische Plakate, 1914–1945*. Hamburg, 1988

Möller, Lise Lotte, Heinz Spielmann, and Stephan Waetzoldt, eds. *Frühe Plakate in Europa und den U.S.A.: Ein Bestandkatalog*. 4 vols. Berlin, 1973–1980.

Paret, Peter. "God's Hammer—A National Socialist Propagandist." *Proceedings of the American Philosophical Society*, vol. 136, No. 2 (1992).

Das Plakat. Berlin, 5–12 Jhg., 1914–1921.

Rawls, Walton. *Wake up, America! World War I and the American Poster*. New York, 1988.

Rickards, Maurice. *Posters of Protest and Revolution*. New York, 1970.

———. *Posters of the First World War*. London, 1968.

Rupp, Leila. *Mobilizing Women for War: German and American Propaganda, 1939–1945*. Princeton, 1978.

Schoch, Rainer, et al. *Politische Plakate der Weimarer Republik, 1918–1933*. Darmstadt, 1980.

Schockel, Erwin. *Das politische Plakat: Eine psychologische Betrachtung*. 2nd ed. Munich, 1939.

Stanley, Peter. *What Did You Do in the War, Daddy?* Melbourne, 1983.

White, Stephen. *The Bolshevik Poster*. New Haven, 1988.

Yass, Marion. *This Is Your War*. London, 1983.

List
of Posters

Poster measurements are given in inches, with height followed by width.

Before 1914

1. Excursions sur les côtes. . . France. Before 1891. Gustave Fraipont. 45 × 30. FR1411.
2. Encre L. Marquet. La meilleure de toutes les encres. France. 1892. Eugène Grasset. 48 × 32. FR895.
3. Folies Bergère—La Loïe Fuller. France. 1893. Jules Chéret. 48 × 34. The Museum of Modern Art.
4. Lait pur . . . stérilisé. France. 1894. Théophile-Alexandre Steinlen. 55 × 39.6. Library of Congress C.Fr.S74.13.
5. Sarah Bernhardt. American Tour. France. 1895. Alphonse Mucha. 80 × 31. Library of Congress C.Czech.M82.1.
6. His Majesty's Coldstream Guards. Great Britain. After 1902. Ernest Ibbetson. 32 × 25. UK477.
7. Voina v vozdukhe. Russia. 1914. 23 × 16. RU/SU365.
8. Hermann Scherrer. Sporting-Tailor. Germany. 1907. Ludwig Hohlwein. 49 × 36. GE1892.
9. Métallurgique—König der Berge. Germany. 1908 or earlier. Carl Moos. 49 × 36. GE738.
10. Salem Aleikum. Salem Gold Cigaretten. Germany. c. 1913. 35 × 23. GE312.

1 The Outbreak of War

11. Ordre de mobilisation générale. France. 1909/1914. 36 × 28. FR873.
12. Pour le triomphe souscrivez à l'emprunt national. France. c.1915. Sem (Serge Goursat). 45 × 31. FR428.
13. Vo vsekh zalakh rossiiskago blagorodnago sobraniia. Russia, 1914. Vladimir Vasnetsov. 48 × 37. RU/SU682.
14. Velikaia evropeiskaia voina. Velikii boi russkago bogatyria s zmeei nemetskoi. Russia, c.1915. 22 × 17. RU/SU175.
15. Germanskii antikhrist. Russia. 1914–15. 22 × 16. RU/SU736.
16. Belges êtes vous prêts? Tout et tous pour la patrie. Belgium. 1914. James Thiriar. 39 × 25. BE6.
17. Das Geheimnis von Lüttich. Unser Bombenerfolg. Germany. 1914. 44 × 16. GE33A.
18. The "Scrap of paper." Great Britain. 1915. 29 × 19. UK244.
19. Which ought *you* to wear? Great Britain. 1914–15. 30 × 20. UK507.
20. Step into your place. Great Britain. 1915. 20 × 30. UK192.
21. Follow me! Your country needs you. Great Britain. 1914. E.K. 28 × 18. UK208.
22. Belgian Red Cross Fund. Great Britain. 40 × 30. UK923A.
23. Rote Kreuz-Sammlung 1914. Germany. 1914. Ludwig Hohlwein. 36 × 25. GE200.
24. Feldpostbriefe. Beyers-Tinten. Germany. c.1915. Carl Tips. 19 × 27. GE45.
25. Hier wird Kriegsanleihe gezeichnet! Germany. 1918. Lucian Bernhard. 15 × 22. GE550.
26. Tavaszi Részvénysör . . . Hungary. 1914. Foldes. 49 × 38. HU95.

2 The Enemy

27. Remember Belgium. U.S.A. 1918. Ellsworth Young. 36 × 20. US1238.
28. Red Cross or Iron Cross? Great Britain. David Wilson. 30 × 20. UK915.
29. Men of Britain! Will you stand this? Great Britain. 1915. 40 × 30. UK197.
30. To prevent this—buy War Savings Certificates now. Great Britain. 1918. F. Gregory Brown. 40 × 25. UK104A.
31. Help stop this. U.S.A. 1918. Adolph Treidler. 28 × 20. US1508.
32. Destroy this mad brute. Enlist. U.S.A. c.1917. H. R. Hopps. 42 × 28. US2003A.
33. Irishmen avenge the Lusitania. Great Britain. 1915. W.E.T. 30 × 19. UK524.
34. Enlist. U.S.A. 1915. Fred Spear. 32 × 23. US1991.
35. The freedom of the sea. Great Britain. c.1915. Wilmot Lunt and W. F. B. 29 × 20. UK1401.
36. "Wir Barbaren!" Germany. 1916. Louis Oppenheim. 25 × 20. GE27.
37. Gute Bücher—gute Kameraden. Germany. 1916. Arnold Weise. 36 × 23. GE353.
38. Denkt an unsere braven Feldgrauen. Weihnachten 1915. Germany. 1915. C. Schmidt. 38 × 28. GE316.
39. Vier Bremer Soldatenheime hinter der Front. Germany. c.1915. Magda Koll. 35 × 25. GE267.

3 Combat

40. Pour le drapeau! Pour la victoire! France. 1917. Georges Scott. 48 × 32. FR442.
41. [no title] U.S.A. 1918. Edwin Howland Blashfield. 54 × 37. US5151, pt. 1 & 2.
42. Voennyi 5 ½% zaem. Russia. 1916. Vassily Vereshchagin. 39 × 26. RU/SU1231.
43. "To the last man and the last dollar!" U.S.A. 1917–18. S. Begg. 28 × 22. US772.3.
44. Gebt für die U-Boot-Spende. Germany. 1917. Willy Stöwer. 26 × 19. GE73A.
45. Podpishites' na voennyi 5 ½%. Russia. 1916. Ernst Gerling. 40 × 30. RU/SU706A.

46. Journée du poilu. France. 1915. Maurice Neumont, 47 × 31. FR654.

47. At Neuve Chapelle your friends need you. Be a man. Great Britain. c.1915. Frank Brangwyn. 30 × 20. UK475.

48. His Liberty Bond paid for in full. U.S.A. 1917. William Allen Rogers. 26 × 21. US1046A.

49. Second Red Cross War Fund. U.S.A. c.1918. McClelland Barclay. 32 × 22. US175.

50. Aidez-nous à soigner nos blessés. France. Lucien Jonas. 48 × 31. FR413.

51. 25 Juin 1916. Journée Serbe. France. 1916. Théophile-Alexandre Steinlen. 47 × 31. FR525.

52. Pour le dernier quart d'heure . . . , aidez-moi! France. 1918. Sem (Serge Goursat). 32 × 47. FR447.

4 Self-Images

53. On les aura! France. 1916. Jules Abel Faivre. 45 × 31. FR793.

54. Fate tutti il vostro dovere! Italy. c.1917. Achille Luciano Mauzan. 39 × 27. IT17B.

55. Speshite kupit'! Russia. 1916. G. Semenov. 29 × 20. RU/SU1054.

56. Put it into national war bonds. Great Britain. 1918. 30 × 20. UK63A.

57. On les aura. France. 1916. Charles Toche. 26 × 21. FR260.

58. Helft uns siegen! Germany. 1917. Fritz Erler. 56 × 37. GE364B, pt. 1 & 2.

59. Und Ihr? Austria. 1917. Alfred Roller. 37 × 25. AU20.

60. Und Ihr? Germany. Fritz Erler. 23 × 17. GE731A.

61. Zeichnet die achte Österr. Kriegsanleihe. Austria. 1918. W. Kühn. 42 × 27. AU30.

62. Debout dans la tranchée que l'aurore éclaire, le soldat rêve à la victoire et à son foyer. France. c.1917. Jean Droit. 47 × 32. FR399A.

63. Come on! U.S.A. 1918. Walter Whitehead. 30 × 20. US1031.

64. On ne passe pas! France. 1918. Maurice Neumont. 45 × 32. FR669A.

5 Appeals to Serve

65. Take up the sword of justice. Join now. Great Britain. 1915. 6 × 30. UK205A.

66. Britain needs you at once. Great Britain. 1915. 30 × 19. UK184.

67. Who's absent? Is it you? Great Britain. 1915. 29 × 20. UK189.

68. Women of Britain say—"Go!" Great Britain. 1915. E. Kealey. 30 × 20. UK194B

69. An appeal to you. Great Britain. 1915. 39 × 25. UK220.

70. Join the brave throng that goes marching along. Great Britain. 1915. Gerald Wood. 6 × 29. UK179A.

71. "The sword is drawn. The Navy upholds it!" U.S.A. c.1917. Kenyon Cox. 42 × 28. US2303.

72. It's up to you. Protect the nation's honor. U.S.A. c.1917. Schneck. 42 × 28. US2002.

73. It takes a man to fill it. U.S.A. 1918. Charles Stafford Duncan. 41 × 28. US2289A.

74. I want you for the Navy. U.S.A. 1917. Howard Chandler Christy. 41 × 27. US2284.

75. Enlist. On which side of the window are you? U.S.A. 1917. Laura Brey. 38 × 26. US2000.

76. Treat 'em rough! Join the tanks. U.S.A. 1918. August Hutaf. 40 × 33. US2077.

77. These men have come across. They are at the front now. U.S.A. c.1917. Francis Xavier Leyendecker. 11 × 21. US2165.

78. We need you! U.S.A. c.1917. 25 × 38. US2043.

79. "The spirit of woman-power." U.S.A. c.1917. Paul Honoré. 40 × 30. US5089.

80. Belgian Red Cross. Great Britain. Charles Buchel. 30 × 20. UK909B.

81. The greatest mother in the world. U.S.A. 1918. Alonzo E. Foringer. 42 × 28. US199A.

82. "I summon you to comradeship in the Red Cross." U.S.A. 1918. Harrison C. Fisher. 40 × 30. US164.

83. We need you. U.S.A. 1918. Albert Sterner. 41 × 31. US160A.

84. National Service. Women's Land Army. Great Britain. 1917. H. G. Gawthorn. 29 × 20. UK747.

85. These women are doing their bit. Great Britain. c.1917. Septimus E. Scott. 30 × 30. UK664.

86. Vse dlia voiny! Russia. 1916. 37 × 28. RU/SU1220A.

87. Deutsche Frauen helft zum Siege! Germany. 1918. Ferdy Horrmeyer. 40 × 28. GE264.

88. Yes sir—I am here! U.S.A. c.1918. Edward Penfield. 38 × 26. US2074.

89. If you want to fight! U.S.A. 1918. Howard Chandler Christy. 40 × 30. US2319.

90. The woman's hour has struck. U.S.A. 1917. Poucher. 41 × 28. US5084.

91. We give our work, our men, our lives if need be. U.S.A. 1917. 41 × 27. US5085.

92. Woman suffrage. U.S.A. Evelyn Rumsey Cary. 41 × 23. US5086.

6 War Loans

93. You buy war bonds. We did our bit. Great Britain. 1914–18. Bert Thomas. 30 × 20. US774.

94. Women! Help America's sons win the war. U.S.A. 1917. R. H. Porteous. 30 × 20. US1157.

95. I am telling you. U.S.A. 1918. James Montgomery Flagg. 30 × 20. US1511.

96. Die Zeit ist hart, aber der Sieg ist sicher. Germany. 1917. Bruno Paul. 25 × 18. GE1777.

97. USA Bonds. Weapons for liberty. U.S.A. 1918. Joseph C. Leyendecker. 30 × 20. US1175.

98. Zeichnet fünfte Österreichische Kriegsanleihe. Austria. 1916. A. S. 48 × 34. AU100.

99. Sottoscrivete al Prestito. Italy. c.1917. Giovanni Capranesi. 39 × 27. IT20A.

100. Zeichnet 5 ½% dritte Kriegsanleihe. Austria. c.1916. Erwin Puchinger. 50 × 37. AU301.

101. Das ist der Weg zum Frieden—die Feinde wollen es so! Germany. c.1918. Lucian Bernhard. 26 × 19. GE250.

102. Liberté. France. c.1917. Jules Abel Faivre. 47 × 31. FR440.

103. That liberty shall not perish from the earth. U.S.A. 1918. Joseph Pennell. 41 × 30. US1244.

104. Feed the guns with war bonds and help to end the war. Great Britain. 1918. Bert Thomas. 30 × 20. UK83.

105. Help them. U.S.A. 1918. Casper Emerson, Jr. 30 × 20. US1509.

106. Turn your silver into bullets at the post office. Great Britain. c.1915. 30 × 30. UK7.

107. Zeichnet 7. Kriegsanleihe. Austria. 1917. Alfred Offner. 26 × 36. AU74.

108. Hilft uns im Kampfe um den Frieden! Austria. 1918. Moldovany. 50 × 37. AU292.

109. Pour la France versez votre or. France. 1915. Jules Abel Faivre. 47 × 31. FR647.

110. Lend your five shillings to your country and crush the Germans. Great Britain. 1915. D. D. Fry? 30 × 20. UK19.

111. Souscrivez à l'emprunt. France. 1918–20. René Prejelan. 30 × 44. FR590.

7 Food and Industry

112. Durch Arbeit zum Sieg! Durch Sieg zum Frieden! German. 1917. Alexander M. Cay. 38 × 26. GE276.

113. Rivets are bayonets. U.S.A. c.1918. John E. Sheridan. 38 × 25. US4020.

114. Teamwork builds ships. U.S.A. c.1918. William Dodge Stevens. 36 × 48. US3980.

115. On the job for victory. U.S.A. c.1918. Jonas Lie. 29 × 39. US4019.

116. The ships are coming. U.S.A. c.1918. James H. Daugherty. 30 × 20. US4011.

117. Aluminium, Kupfer, Messing, Nickel, Zinn ist genug im Lande! Germany. 1917. Louis Oppenheim. 19 × 25. GE183A.

118. Sammelt ausgekämmtes Frauenhaar! Germany. 1918. Jupp Wiertz. GE189.

119. Sammelt Obstkerne zur Ölgewinnung. Germany. 1915–16. Julius Gipkins. 23

× 17. GE69A.

120. National Egg Day. Great Britain. Wippell. 30 × 20. UK776.

121. Soignons la basse-cour. France. G. Douanne. 22 × 15. FR237.

122. Francais, économisez le gaz. France. Jeanne Fapournoux. 31 × 14. FR226.

123. Food is ammunition—don't waste it. U.S.A. c.1918. John E. Sheridan. 28 × 21. US2886A.

124. War gardens over the top. U.S.A. 1919. Maginel Wright Enright. 29 × 23. US3045.

125. We risk our lives to bring you food. Great Britain. 1917. J. P. Beadle. 30 × 20. UK780B.

8 The End of the War

126. L'emprunt de la libération. France. 1918. Jules Abel Faivre. 31 × 44. FR407B.

127. L'emprunt national. France. c.1919. L. Jonoy? 47 × 29. FR693.

128. Journée des régions libérées. France. c.1919. Auguste Leroux. 48 × 32. FR720.

129. Helden von der Front! Die Heimat grüsst euch! Seid herzlich willkommen! Germany. 1918–1919. Walter Ditz. 44 × 33. GE1726A.

130. Volksspende für die deutschen Kriegs- und Zivil-Gefangenen. Germany. 1918–1919. Ludwig Hohlwein. 17 × 12. GE431A.

131. Helft den Gefangenen! Germany. 1918–1919. W. Dittrich. 30 × 21. GE32.

132. Sur la terre ennemie, les prisonniers russes meurent de faim. France. 1917. Théophile-Alexandre Steinlen. 45 × 32. FR552.

133. Ludendorff-Spende für Kriegsbeschädigte. Germany. 1918. Ludwig Hohlwein. 28 × 36. GE56D.

134. Per la patria i miei occhi. Per la pace il vostro denaro. Italy. 1918. A Ortelli. 39 × 27. IT16A.

135. Permanent blind relief war fund. U.S.A. 1918–19. Albert Sterner. 22 × 27. US3270.

136. L'association générale des multilés de la guerre. France. 1917. Georges Dorival. 46 × 31. FR514.

137. Journée nationale des tuberculeux. France. c.1919. Lucien Levy-Dhurmer. 32 × 45. FR503.

138. Journée des régions libérées. France. 1919. Théophile-Alexandre Steinlen. 46 × 31. FR855.

139. Opfertag. Spendet in die Opferschale! Zeichnet ins Opferbuch! Germany. 1918. Walter Ditz. 21 × 16. GE701A.

9 Revolutions

140. Zaem svobody. Russia. 1917. B. M. Kustodiev. 39 × 26. RU/SU1225.

141. God proletarskoi diktatury. Oktiabr'

1917-Oktiabr' 1918. U.S.S.R. 1918. Alexander Apsit. 40 × 26. RU/SU801.

142. Obmanutym brat'iam. U.S.S.R. 1918. Alexander Apsit. 43 × 28. RU/SU1546.

143. Da zdravstvuet Krasnaia Armiia! U.S.S.R. 1919. 43 × 28. RU/SU2088A.

144. Bud'na strazhe. U.S.S.R. 1920. Dimitri S. Moor. RU/SU1326.

145. Esli ne khotite vozvrata k proshlomu. U.S.S.R. 1920. 21 × 28. RU/SU1336.

146. Da zdravstvuet krasnaia 3-kh millionnaia armiia!! U.S.S.R. 1919. Skif (A. Apsit). 28 × 42. RU/SU1021.

147. Drei Worte: Ungestörte Demobilmachung—Aufbau der Republik—Frieden. Germany. 1918–1919. Heinrich Richter-Berlin. 29 × 37. GE2357.

148. Wer schützt uns vor dem Zusammenbruch? Das bewaffnete Proletariat! Germany. c.1919–1920. 40 × 30. GE585.

149. Christliches Volk! Darf Spartakus deine Kirchen niederreissen? Germany. 1919. Hermann Keimel. 39 × 29. GE3466.

150. Tretet ein in den Grenzschutz Ost! Schützt die Heimat gegen Bolshewismus! Germany. 1919. Lucian Benhard. 37 × 26. GE2356.

151. Ostpr. Freiwilligenkorps. Germany. 1919. FVZ. 20 × 18. GE704.

152. Zeitfreiwillige heraus! Germany. 1919. AS. 34 × 25. GE529.

153. Halt! Zurück wer deutsche Arbeit stören will. Germany. 1919. Albert Birkle. 37 × 28. GE528.

154. Kamerad, komm zum Detachement Tüllmann! Germany. 1919. Wustrau. 37 × 26. GE506.

155. Auch du sollst beitreten zur Reichswehr. Germany. 1919. Julius Ussy Engelhard. 48 × 36. GE1841.

156. Und du? Germany. 1932. Ludwig Hohlwein. 34 × 24. GE1694.

157. Räder müssen rollen für den Sieg. Germany. c.1942. von Axster-Heudtlass. 23 × 16. GE1122.

158. Die Front spricht zur Heimat. Germany. c.1941. Mjölnir (Hans Schweitzer). 33 × 23. GE1060.

159. He's watching you. U.S.A. 1942. Glenn Grohe. 14 × 10. US6001A.

160. Vörös parlamentet! Szavazzatok Socialdemokratára. Hungary. 1919. Biró. 50 × 37. HU385.

161. Mosakodnak! Hungary. 1919. 50 × 37. HU369.

162. [no text] Hungary. 1919. Manno Miltiades. 50 × 37. HU384.

10 The Soviet Union

163. Long live the Third Communist International! U.S.S.R. 1920. Sergei Ivanov. 26 × 35. RU/SU807.

164. Na pomoshch' shkole! U.S.S.R. 1923. 28 × 42. RU/SU1374.

165. Negramotnyi tot zhe slepoi. U.S.S.R. 1920. Aleksei A. Radakov. 37 × 26.

RU/SU1317.

166. Sol'em udarnye otriady v skvoznye udarnye brigady. U.S.S.R. 1931. Leningrad Artists Collective. 41 × 28. RU/SU1963.

167. B'em po lzheudarnikam. U.S.S.R. 1931. 28 × 43. RU/SU1748.

168. Pomni o golodaiushchikh! U.S.S.R. 1921. 31 × 24. RU/SU539.

169. Udarnuiu uborku bol'shevistskomu urozhaiu. U.S.S.R. 1934. Maria Voron. 41 × 28. RU/SU1843.

170. Udarim po kulaku agitiruiushchemu za sokrashchenie poseva. U.S.S.R. 1930. 29 × 21. RU/SU1611.

171. Religiia—iad, beregi rebiat. U.S.S.R. 1930. N. B. Terpsikhorov. 28 × 21. RU/SU650.

172. Trudiashchaiasia zhenshchina na bor'bu za sotsialism na bor'bu s religiei. U.S.S.R. 1931. B. Klinch and Koslinskii. 41 × 28. RU/SU1598.

173. Eshche vyshe znamia Leninizma—znamia mezhdunarodnoi proletarskoi revoliutsii. U.S.S.R. 1932. N. Kochergin. 30 × 40. RU/SU2309.

174. Pobednogo shestviia piatiletki ne ostanovit' imperialistam! U.S.S.R. 1930. Konstantin Eliseev. 40 × 28. RU/SU1777.

175. Edinym frontom na shturm kapitalizma. U.S.S.R. 1935. A. Keil (Ék Sándor). 38 × 24. RU/SU569.

176. Chtob iz etoi lapy vypal nozh—Antifashistskogo fronta sily mnozh. U.S.S.R. 1938. Mikail M. Cheremnykh. 37 × 24. RU/SU1839.

11 Germany and National Socialism

177. Die Gefahr des Bolschewismus. Germany. 1919. Rudi Feld. 37 × 27. GE657.

178. Bolschewismus bringt Krieg, Arbeitslosigkeit und Hungersnot. Germany. 1918. Julius Ussy Engelhard. 48 × 35. GE1858A.

179. Frauen! Sorget für Frieden und Brot! Wählet und werbt für die Wahl! Germany. 1919. Lucian Bernhard. 28 × 38. GE2363.

180. Frauen und Männer, wollt Ihr das Glück Eurer Familie, Eurer Kinder, sichern, dann wählt nur Christliche Volkspartei, Zentrum. Germany. 1920. Julius Gipkens. 47 × 33. GE1853.

181. Verraten durch die S.P.D. Wählt Kommunisten! Germany. 1930. A. Malsov (Victor Slama). 28 × 19. GE1740.

182. Bahn frei für Liste 1. Sozialdemokraten. Germany. 1930. 46 × 33. GE2015B.

183. Jede Stimme gesichert gegen Bürgerkrieg und Inflation!! Germany. 1932. 33 × 23. GE1900A.

184. Das Dritte Reich? Nein! Germany. 1932. Rimar. 33 × 23. GE793.

185. Einen bessern findst du nicht. Germany. 1932. Walter von Ruckteschell. 28 × 19. GE1679.

186. Unsere letzte Hoffnung: Hitler. Germany. 1932. Mjölnir (Hans Schweitzer). 34 × 24. GE792.

187. Appell am 23. Februar 1933. Germany. 1939. Elk Eber. 36 × 25. GE1244.

188. Erster nationalsozialistischer Reichsjugendtag. Germany. 1932. Ludwig Hohlwein. 33 × 24. GE959.

189. Die NSDAP sichert die Volks-Gemeinschaft. Germany. Ahrle. 33 × 23. GE944.

190. Der ewige Jude. Germany. 1937. Hans Stalüter. 33 × 24. GE985.

191. "Bolshewismus ohne Maske." Germany. 1937. Herbert Agricola. 34 × 23. GE975.

192. Germany's modern architecture. Germany. c.1936–37. 40 × 25. GE2475.

193. Speed along German Reichsautobahnen. Germany. c.1936–37. Robert Zinner. 40 × 25. GE2451.

12 The Spanish Civil War

194. ¡Adelante. Luchardores de la libertad! Spain. c.1936. 45 × 31. SP122.

195. 1° ganar la guerra. ¡Menos Palabras vanas! Spain. 1937. Parrilla. 39 × 27. SP31.

196. La FAI. En el frente sangriento, en el frente del trabajo. Lucha por la humanidad. Spain. c.1937. 39 × 27. SP100.

197. El generalisimo. Spain. c.1937. Pedrero. 40 × 28. SP107.

198. Aidez à la Resistance Espagnole. France. c.1937. Arguello. 22 × 15. FR875.

199. Assassins! Spain. c.1938. Lleo. 39 × 27. SP38.

200. El comunismo destruye la familia. Spain. c.1937. 40 × 28. SP12.

201. Lo que hay . . . detrás del comunismo. Spain. c.1937. 40 × 28. SP10.

202. Disciplina. Spain. c.1937. Martinez Ortiz. 36 × 27. SP6.

13 Early Stages

203. Der Meldegänger. Germany. 1942. Elk Eber. 38 × 25. GE2449.

204. Der alte Hass—das alte Ziel! Germany. 1939. 34 × 47. GE3702.

205. Chamberlains Werk! Germany. 1939. 34 × 47. GE3704.

206. In den Staub mit allen Feinden Gross-Deutschlands! Germany. 1940. Mjölnir (Hans Schweitzer). 33 × 23. GE1059.

207. Der Frontsoldat sieht auf dein Opfer! Germany. 1940. M. Rothgaengel. 33 × 25. GE1103.

208. Journée Franco-Britannique. France. 1939. Jean Carlu? 30 × 44. FR1132.

209. Mightier yet! Great Britain. 15 × 10. UK2798A.

210. "We shall not flag." Great Britain. 1940. 25 × 19. UK3421.

211. La France a perdu une bataille! Mais la France n'a pas perdu la guerre! Great Britain. 1940. 17 × 22. FR1032.

212. No surrender! Holland—the home of a free people. Great Britain? 1940? Winfield. 44 × 28. NE44.

213. The life-line is firm, thanks to the Merchant Navy. Great Britain. Charles Wood. 30 × 20. UK1779.

14 The Air War

214. De jour et de nuit, les bombardiers de la RAF. attaquent les dépôts d'essence et les centres industriels des Nazis. Great Britain. c.1945. W. Krogman. 40 × 30. UK3731D.

215. "This time we're all in the front line." Great Britain. 1940. 26 × 19. UK2465.

216. Forward to victory. Great Britain. Marc Stone. 40 × 25. UK2750.

217. "Never was so much owed by so many to so few." Great Britain. c.1940. 30 × 20. UK3427A.

218. Tout va très bien . . . Madame la Marquise. Belgium. c.1940. 48 × 32. BE103.

219. London County Council ARP. Great Britain. c.1941. F. Bernard Clark . 30 × 20. UK2255.

220. The new incendiary bomb is heavier . . . Great Britain. c.1941. 30 × 20. UK2032.

221. Finger weg! Jeder Blindgänger bedeutet Lebensgefahr! Germany. 1944. Walter Biederman. 23 × 16 in GE1202.

222. Kannst Du das verantworten? Du hilfst dem Feind! Germany. 1942. Ludwig Hohlwein. 33 × 23. GE1106.

223. Licht—Dein Tod! Germany. c.1944. Schmitt. 34 × 24. GE1162.

224. RAF hammer blows on Nazi key industries. Great Britain. 1943. 29 × 19. UK1791.

225. "V1 . . . Ja, Johnny—en dat is nog maar het begin!" Germany. 1944. Erik. 15 × 11. GE2659.

15 The Invasion of Russia

226. V bogatyrskikh podvigakh vnuchat vizhu dedovskuiu slavu! U.S.S.R. 1943. D. Shmarinov. 21 × 26. RU/SU2142.

227. Ot narodnoi mesti ne uiti vragu! U.S.S.R. 1941. I. Rabichev. 40 × 26. RU/SU2217.

228. Otomstim! U.S.S.R. 1941. I. Rabichev. 36 × 24. RU/SU2164.

229. Vsia nadezhda na tebia, krasnyi voin! U.S.S.R. 1943. Viktor Ivanov and Olga Burova. 23 × 34. RU/SU2204.

230. Bei vraga, kak ego bili ottsy i starshie brat'ia—matrosy oktiabria! U.S.S.R. 1941. S. Boim. 24 × 37. RU/SU2175.

231. "I vrazhoiu zloiu krov'iu voliu okropite!" Smert' fashistskim gadam! U.S.S.R. 1942. I. Tsybul'nyk. 22 × 34. RU/SU2168.

232. Zashchitim rodnuiu Moskvu! U.S.S.R. 1941. B. A. Mukhin. 35 × 22. RU/SU2206.

233. P'em vodu rodnogo Dnepra. U.S.S.R. 1943. Viktor Ivanov. 36 × 23. RU/SU2207.

234. Slava osvoboditeliam Ukrainy! U.S.S.R. 1943. D. Shmarinov. 37 × 26. RU/SU2165.

235. My vraga vstrechaem prosto: bili, b'em i budem bit'. U.S.S.R. 1939. Boris Prorokov. 24 × 34. RU/SU1840.

236. Nikuda ne skryt'sia izveru! U.S.S.R. 1945. Viktor N. Deni. 27 × 21. RU/SU2194.

237. Dolg platezhom krasen. U.S.S.R. 1941. Kukryniksy Group. 18 × 12. RU/SU2111.

238. Krasnoi Armii metla, nechist' vymetet dotla! U.S.S.R. 1943. Viktor N. Deni. 24 × 29. RU/SU2201.

16 The New Order

239. Handen weg! Germany. c.1943. Erik. 42 × 30. GE2678.

240. Vil du leve? I skygge av ham? Norway. 44 × 30. NO37.

241. Le complot juif contre l'Europe! Belgium. 1941. Abel 45 × 33. BE104.

242. Kultur-terror. The Netherlands. 1944. Leest Storm. 25 × 19. NE224.

243. La France est le bastion avancé de l'Europe. Défends la! France. 1944. Giral. 47 × 31. FR1111.

244. Durant trois hivers, la Légion des volontaires français s'est couverte de gloire pour la France et pour l'Europe. France. 1944. 43 × 31. FR1121.

245. Tu défends la Belgique . . . en luttant au front de l'Est! Belgium. 1943. Rhn. 33 × 49. GE1935.

246. Med Waffen-SS og den Norske Legion. Norway. 40 × 28. GE1986.

247. Wie van deze twee is de ware Nederlander? The Netherlands. 1943. Lou Manché. 22 × 16. GE2589.

248. En travaillant en Allemagne, tu seras l'ambassadeur de la qualité française. France. c.1943. 22 × 15. FR1037.

249. Finis les mauvais jours! Papa gagne de l'argent en Allemagne! France. 1943. Mjölnir (Hans Schweitzer). 24 × 16. FR1055.

250. Do pratsi dlia krashchogo maibut'nogo! Germany. 1943. 34 × 24. GE1954.

251. Germaniia osvobodila tebia ot bol'shevizma. Teper prinimaisia za vosstanovlenie tvoei rodiny! Germany. 1942. 33 × 23. GE1127.

252. Khto shche ne vudovolenii? Germany. 1944. 24 × 34. GE1952.

253. Entre le marteau . . . et l'enclume! France. c.1944. Jean Carlu. 21 × 15. FR1385A.

254. On les aura, les Boches! Belgium. 1944. Jacques Richez. 22 × 14. BE31.

255. Liberté. . . . Liberté chérie. . . . France. c.1944. Natasha Carlu. 23 × 30. FR1395.

256. Avis. Germany. 1943–44. 30 × 22. GE1939.

257. Bekanntmachung. Germany. 1944. 20 × 25. GE2577.

258. Bekanntmachung. Germany. 1945. 12 × 16. GE2612.

17 Home Fronts

259. Deine Arbeit sichert den Sieg! Germany. 1944. Theo Matejko. 33 × 23. GE1222.

260. ". . . pass the ammunition." U.S.A. Frederic Stanley. 39 × 28. US8434.

261. Ein Kampf, ein Wille, ein Ziel: Sieg um jeden Preis! Germany. 1942. Mjölnir (Hans Schweitzer). 33 × 23. GE1098.

262. Verräter. Germany. 1944. Max Spielmanns. 26 × 19. GE1177.

263. Pst! Germany. 1943. 33 × 23. UK3687A.

264. Feind hört mit! Germany. 1943. 23 × 16. GE1188.

265. A few careless words may end in this— Great Britain. Norman Wilkinson. 30 × 20. UK1962.

266. Keep mum, she's not so dumb! Great Britain. c.1940. G. Lacoste. 15 × 10. UK3511.

267. Thousands of women needed now . . . Great Britain. c.1943. 30 × 20. UK1770.

268. Women of Britain. Come into the factories. Great Britain. 29 × 19. UK1905.

269. Women in the war. We can't win without them. U.S.A. 1942. 39 × 28. US2751.

270. Be a Marine . . . Free a Marine to Fight. U.S.A. 1945. 38 × 28. US2780.

271. Traktor vo pole—chto tank v boiu! U.S.S.R. 1942. Viktor Ivanov and Olga Burova. 35 × 22. RU/SU2159.

272. Hilf auch Du mit! Germany. 1941. Theo Matejko. 34 × 24. GE1070.

18 The United States at War

273. Avenge December 7. U.S.A. 1942. Bernard Perlin. 40 × 28. US6034.

274. This is the enemy. U.S.A. 1943. 28 × 20. US6023.

275. Buy more war bonds and stamps. U.S.A. 34 × 24. US1874.

276. This is Nazi brutality. U.S.A. 1942. Ben Shahn. 38 × 28. US6032.

277. Jap . . . you're next! U.S.A. 1944. James Montgomery Flagg. 28 × 20. US1822.

278. If you worked as hard and as fast as a Jap, we'd smash Tokio [sic] a lot quicker. U.S.A. 1943. 24 × 18. US6773.

279. Civilian Exclusion Order No. 41. U.S.A. 1942. 22 × 14. US6912.

280. Put the squeeze on the Japanese! U.S.A. 30 × 15. US6784.

281. "Jap trap." U.S.A. Jack Campbell. 13 × 10. US6242.
282. Serve in silence, U.S.A. C.H. 22 × 17. US5960.
283. Careless matches aid the Axis. U.S.A. 1942. 24 × 18. US6137.
284. The war's not over 'til our last man is free. U.S.A. 1944. 11 × 21. US6017.
285. The greatest team in the world! U.S.A. 1944. Clayton Knight. 38 × 25. US2688.
286. U.S. Marines. U.S.A. 1941. 40 × 30. US2648.
287. We have just begun to fight! U.S.A. 1943. 22 × 16. US6030B.
288. Don't let him down. U.S.A. 20 × 23. US1752.
289. War bonds are cheaper than wooden crosses. U.S.A. 1944. Sgt. Ardis Hughes. 28 × 22. US1776.
290. Next! Japan. U.S.A. 1944. 40 × 28. US1817B.

19 The Last Year

291. Invasion! Great Britain. 1944. 30 × 20. UK2475.
292. Victory of the Allies is assured. Great Britain. 1943. 30 × 20. UK2762B.
293. Forward to victory. Great Britain. 40 × 25. UK2749.
294. Infanterie. Königin aller Waffen. Germany. 1944. 33 × 23. GE1918.
295. Harte Zeiten. Harte Pflichten. Harte Herzen. Germany. 1943. 34 × 24. GE1228.
296. Hitlerjugend. Germany. 1944. Ahrle. 33 × 23. GE1217.
297. Um Freiheit und Leben. Volkssturm. Germany. 1944. Mjölnir (Hans Schweitzer). 33 × 23. GE1207.
298. Libération. France. 1944. Phili. 45 × 30. FR1113.
299. Free Holland welcomes the soldiers of the Allies. Great Britain. 1944. Pat Keely. 29 × 29. UK3894.
300. Vodruzim nad Berlinom znamia pobedy! U.S.S.R. 1944. Viktor Ivanov. 35 × 22. RU/SU2169.
301. Das Ende. East Germany. 1945. 17 × 12. GE1419.
302. Aidez les prisonniers politiques rapatries. Belgium. 1945. K. Peiser. 48 × 29. BE24.
303. Reconstruire. France. 1945. Roland Ansieau. 24 × 32. FR1086.

Epilogue: After 1945

304. Students against nuclear weapons. 33 × 23. INT559.
305. Non? La France ne sera pas un pays colonisé! France. 1952. 47 × 30. FR1497.
306. Pour vos vacances visitez l'U.R.S.S., pays de la liberté. France. c.1952. 44 × 30. FR1645.
307. Jak se divat na nemecko. Czechoslovakia. 1951. 34 × 24. CS48.
308. Korea must be reunified! 23 × 16. INT435.
309. Pour l'arrêt de l'agression américaine, le soutien et la victoire du peuple vietnamien. France. 1968. Rapho. 30 × 22. FR1321.
310. Grün bricht durch. Farbe bekennen. West Germany. Holger Matthies. 33 × 23. GE3462.
311. Solidarnosc. L'avenir de la Pologne. France. 1976. 25 × 35. FR1542.
312. Proletarier aller Länder vergebt mir. East Germany. 1990. 16 ½ × 11 ¾.

Index

of Artists

Numbers after the artist names refer to poster numbers, except where a figure number is indicated.